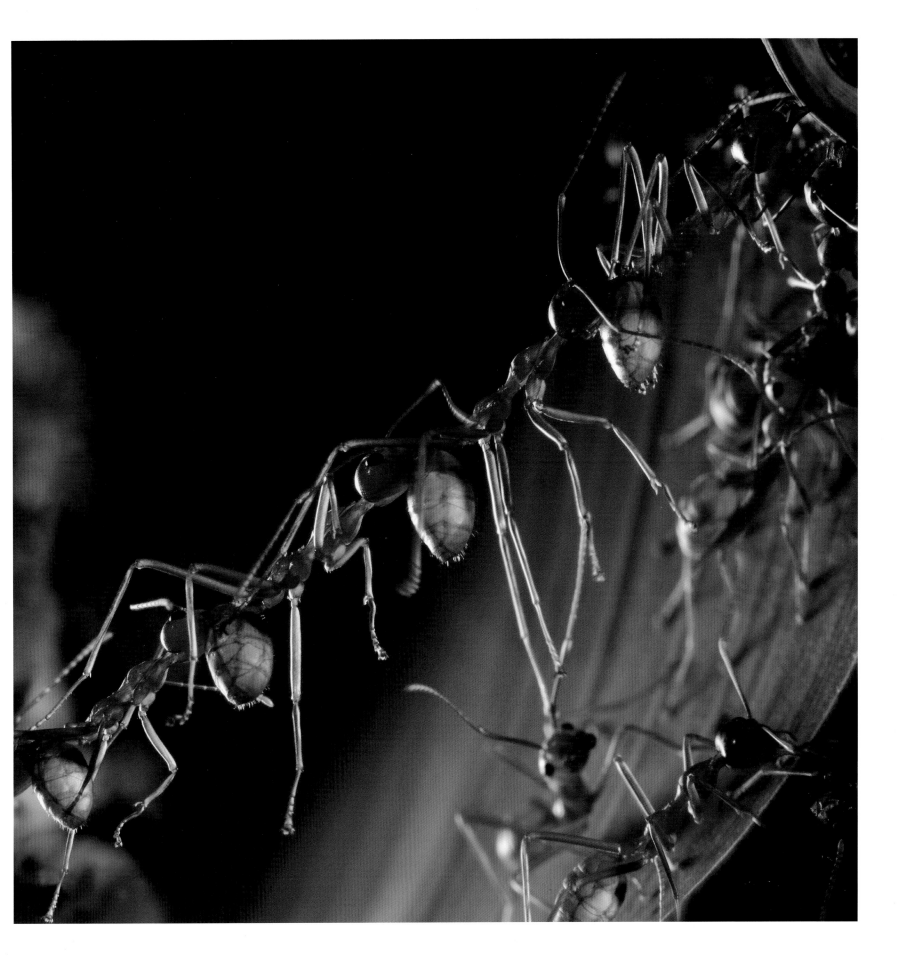

Alan Henderson has had a fascination for invertebrates his entire life. He has successfully combined this with his other passion, macrophotography, and his images have been published around the world. Alan operates Minibeast Wildlife from the tropical paradise of Kuranda, Queensland.

FRONTISPIECE
Weaver ants
6 X LIFE-SIZE

Weaver Ants (*Oecophylla smaragdina*) display amazing team work. They use their bodies as bridges and tensioning tools to pull their leaf nests together. These ants have specialized waists that allow other ants to grip and hold them securely. Their feet, too, are fit for the task, having more grip than many other species of ant, enabling them to cling on under great tension.

OPPOSITE
Millipede
16 X LIFE-SIZE

MINIBEASTS

TRUE RULERS OF OUR WORLD AND THE KEY TO OUR SURVIVAL

Alan Henderson

EXISLE
PUBLISHING

To Deanna, for your endless support and assistance.
My partner in everything.

First published 2018

Exisle Publishing Pty Ltd

PO Box 864, Chatswood, NSW 2057, Australia
226 High Street, Dunedin, 9016, New Zealand
www.exislepublishing.com

Copyright © 2018 in text and photos: Alan Henderson

Alan Henderson asserts the moral right to be identified as the author of this work.

All rights reserved. Except for short extracts for the purpose of review, no part of this book may be reproduced, stored in a retrieval system or transmitted in any form or by any means, whether electronic, mechanical, photocopying, recording or otherwise, without prior written permission from the publisher.

A CiP record for this book is available from the National Library of Australia.

ISBN 978 1 925335 84 2

Designed by Mark Thacker of Big Cat Design

Typeset in Myriad Pro Light 9 on 12pt

Printed in China

This book uses paper sourced under ISO 14001 guidelines from well-managed forests and other controlled sources.

10 9 8 7 6 5 4 3 2 1

→

Jewels of the rainforest
3.5 × LIFE-SIZE
Few beetles match the stunning array of metallic colours exhibited by the Rainbow Stag Beetle (*Phalacrognathus muelleri*). The colours aren't due to pigments, but a multilayered nanostructure within the surface of the beetle's exoskeleton which refracts the light.

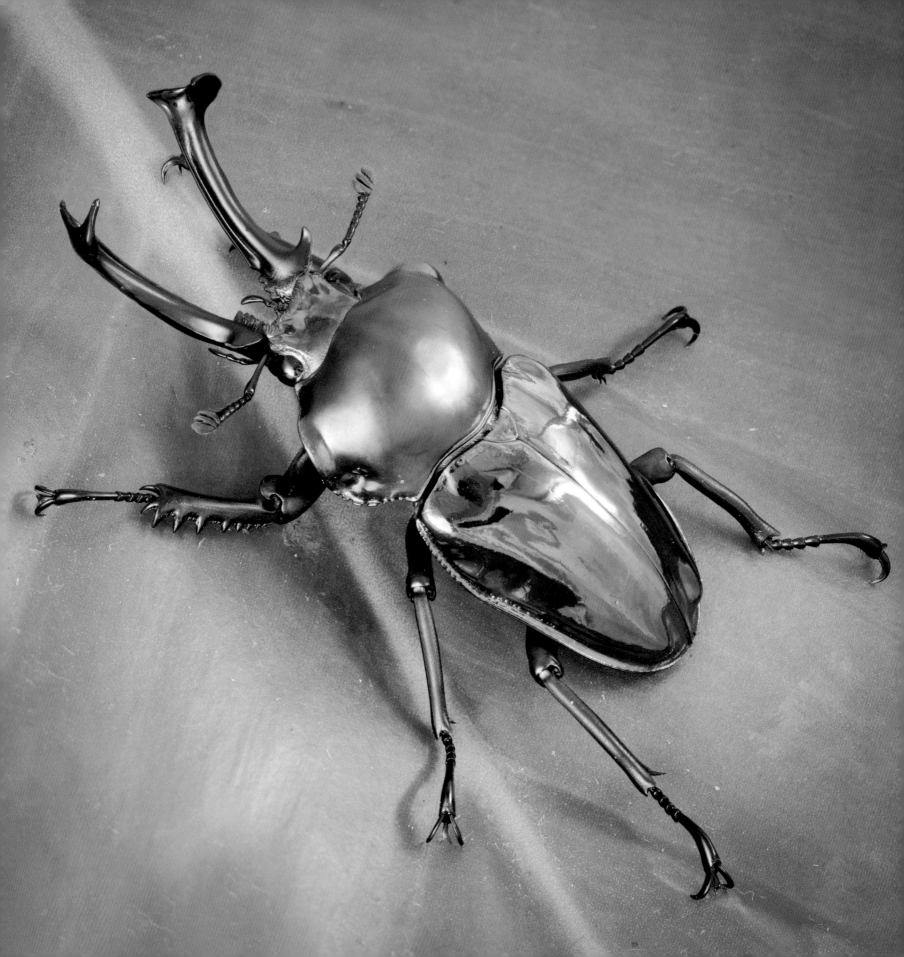

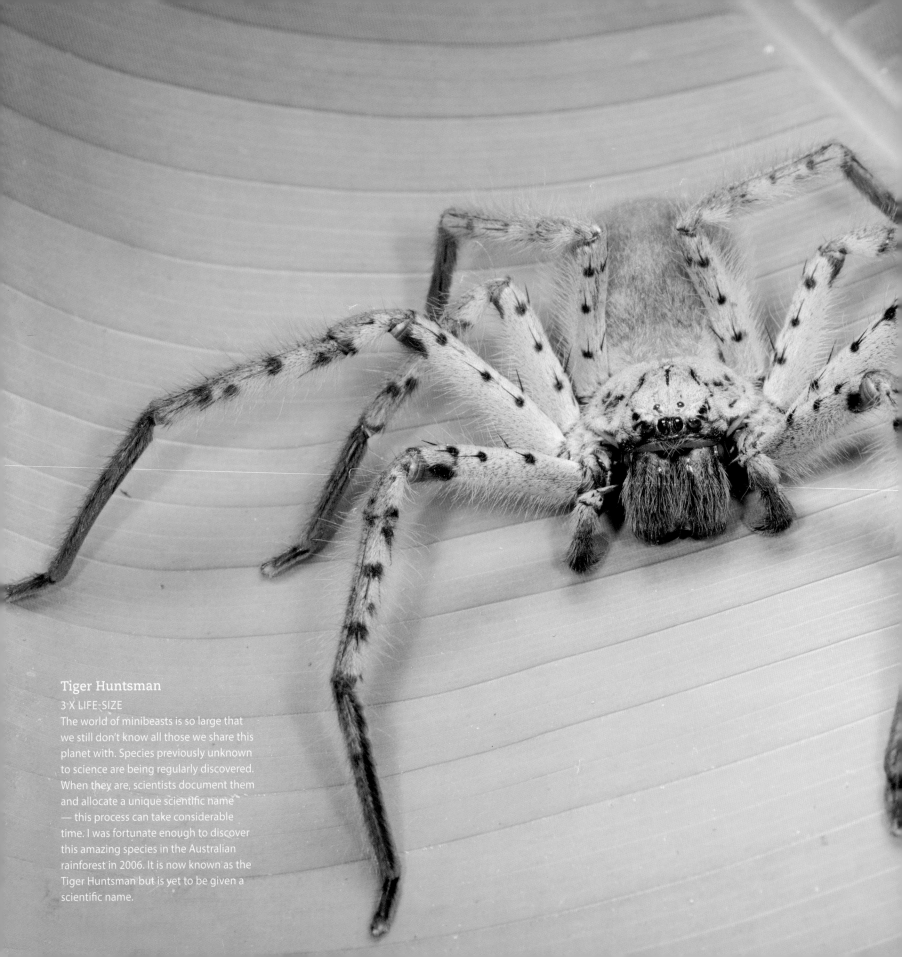

Tiger Huntsman
3 X LIFE-SIZE

The world of minibeasts is so large that we still don't know all those we share this planet with. Species previously unknown to science are being regularly discovered. When they are, scientists document them and allocate a unique scientific name — this process can take considerable time. I was fortunate enough to discover this amazing species in the Australian rainforest in 2006. It is now known as the Tiger Huntsman but is yet to be given a scientific name.

CONTENTS

	INTRODUCTION	8
1	TOOLS OF THE TRADE	12
2	STRIKING COLOUR	24
3	THE REAL TRANSFORMERS	36
4	SHAPE AND FORM	42
5	LIFE ON THE WING	54
6	FACE TO FACE	64
7	NOW YOU SEE ME	81
8	LIFE AQUATIC	92
9	THE PRETENDERS	102
10	THE MATING GAME	116
11	THE NURSERY	130
12	THE UNDERWORLD	140
13	TEAM MINIBEAST	152
	INDEX	158
	ACKNOWLEDGMENTS	160

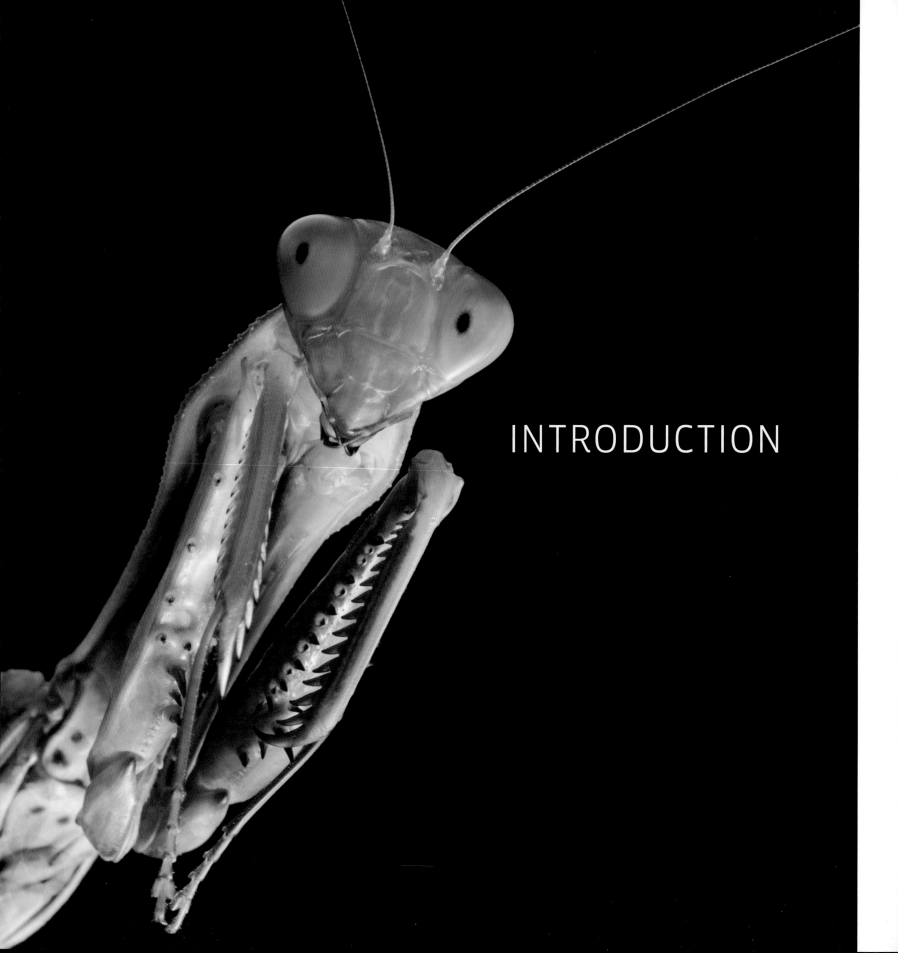

INTRODUCTION

INTRODUCTION

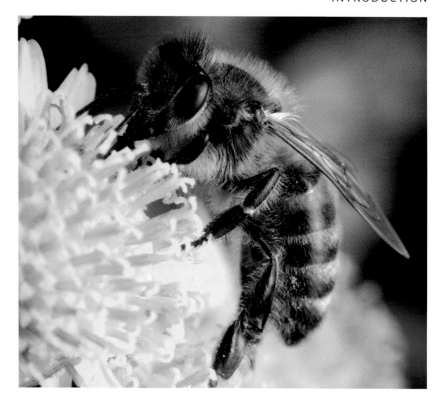

← **Mantis**
5 X LIFE-SIZE
An encounter with a praying mantis as a child was a truly influential moment in my life. These small predators have such character, and that sense of connection has stayed with me ever since.

→ **Honeybee**
8 X LIFE-SIZE
Minibeasts perform many critical roles which are essential to our survival. Pollination is one of these roles. However, like many minibeasts, Honeybees (*Apis mellifera*) have been suffering a global decline in their numbers.

My earliest memories of minibeasts are as a young boy. I was four or five years old, entertaining myself while visiting an older aunt. I would wander into the back garden, avoiding the onset of boredom brought about by listening to the chatting adults inside the house. I'd walk around, looking at the leaves of the plants to see what I could find. It was the discovery one day of a praying mantis tackling a honeybee that gripped me. I was enthralled by the epic battle unfolding before me. This small green creature with such engaging eyes was taking on a bee, an animal I had been taught was dangerous. I'd been stung and knew the pain, yet this small green creature was eating it! Alive!

From that moment the world of tiny animals opened up and completely took me in. Once-dull visits to my aunt became exciting opportunities to delve into the untapped zoological wonders of the back garden. In fact, I was unable to go on any outing at all without diving for the garden plants and searching for praying mantises and other wondrous creatures. I had begun a lifelong safari like no other, and the world of minibeasts was only too happy to oblige.

The minibeasts I first discovered as a child are just some of the small marvels that busily run our world right under our noses. Billions of them play critical roles every single day, often without thought or acknowledgment from most of humanity. They make up about 95 per cent of animal life on Earth and are found everywhere across the world. They live in almost every habitat, and they have owned this planet for hundreds of millions of years.

As small as these animals are, they are critically important. Without them, the world as we know it would come to a grinding halt. The roles they play are linked to all other living things. Plants rely on them as pollinators so they can reproduce. Without them, it's not just forests and natural habitats we would lose, but many of the crops we eat as well. They break down all sorts of wastes and return the nutrients back into the soil. They control each other's numbers and are food for larger animals.

In school, we are taught the simple food chain that links animals and plants together. This one eats this, then this one eats that one, and so on. Continue that pattern another one hundred times, overlap the connections, cross-connect them, and you'll get a little closer to a real-life food web, containing myriad species all interconnected. Minibeasts are the links that hold these connections together. These communities of interacting animals and plants are called ecosystems, and without minibeasts, ecosystems begin to fail.

So, what are minibeasts? The word 'minibeast' isn't a scientific term, but a commonly used name that refers generally to invertebrates. This group of animals includes insects, arachnids (spiders and scorpions and their relatives), myriapods (centipedes and millipedes), crustaceans (woodlice, landhoppers, crayfish and crabs), molluscs (snails and slugs) and many others. These are animals that do not have a backbone, or any internal skeleton for that matter. Many of them have rigid outer-skeletons (exoskeletons) supporting their bodies and, as a result, the ways in which they grow and develop are very different to the way we do. Others have soft bodies with nothing but muscle to support them.

Growth for those with exoskeletons is achieved by ecdysis — moulting their old exoskeleton. As they emerge, their new exoskeleton is soft and rubbery and is

expanded by fluid pressure before setting hard at their new larger size. For some this process can take just minutes; for others it takes an hour or so to complete. It is obviously a very vulnerable time for these animals, as they are relatively defenceless against predators, and any disturbance might cause them to become trapped in their old exoskeleton, which can result in deformation or death.

Some insects undergo an even more dramatic type of development known as metamorphosis. This is where the larval form of the insect completely changes structure during a stage called pupation, emerging as an adult. This is the way butterflies develop.

Minibeasts are equipped with a multitude of specialized body parts that enable them to sense their world, move about and obtain food. These include such structures as antennae, wings, fangs and mandibles. Some have eyes with thousands of lenses, while others have eyes on stalks, and some have no eyes at all. Some can produce silk, others produce sound. Some are capable of travelling vast distances, while others spend their entire lives in one spot. The world of minibeasts is incredibly diverse.

As the threat and consequences of climate change are finally being recognized, another less publicized crisis is looming on our planet. This is the rapid decline of invertebrate numbers — and it is occurring throughout the world. As with climate change, we humans seem to be the catalysts for these declines. Although these critically important animals have survived for hundreds of millions of years, studies have revealed alarming trends in recent years showing we are losing some of our most important fauna at astonishing rates. One study, from Stanford University in the United States, has shown a 45 per cent decline in invertebrate numbers over a 35-year period. During the same 35 years, the human population has doubled. Scientists believe the decrease in invertebrates is due to two main factors: habitat loss and climate disruption on a global scale.

Apart from losing key species which may have a drastic effect on our ecosystems and food security, we are also losing a potential goldmine of groundbreaking medical drugs. Numerous research programs are now showing that minibeasts are an incredibly valuable resource, and some might even harbour cures to cancer and other human ailments within their bodies. It is crucial that we acknowledge the importance of these animals and act accordingly.

The total captivation I developed for minibeasts as a boy has stayed with me my entire life. I still wander around looking at the leaves of plants, but these days it is more often in rainforests rather than my old aunt's garden, and I'm more often than not carrying my camera. My discovery of macrophotography has enabled me to take another step closer to these amazing animals, and when I look through the lens I feel as though I have truly entered their world. The naked eye often doesn't do these animals justice, but the level of detail and complexity revealed through macrophotography allows true appreciation of these remarkable animals.

I hope you come to appreciate them as much as I do.

INTRODUCTION

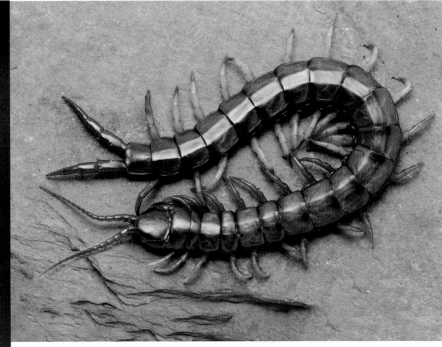

FROM LEFT:

Inside out
1.2 X LIFE-SIZE
A Sydney Funnel-web (*Atrax robustus*) moulting. Invertebrates with exoskeletons need to shed periodically in order to grow. It is a very vulnerable time where they are soft and quite defenceless.

Phyllium
1.5 X LIFE-SIZE
A leaf with legs. This Leaf Insect (*Phyllium monteithi*) is just one of many invertebrates that have evolved extremely effective camouflage. These animals even act the part by swaying back and forth like a leaf in the wind.

Scorpion
2 X LIFE-SIZE
Many minibeasts are venomous, such as this Bark Scorpion (*Centruroides limbatus*). They have the ability to inject toxins through bites or stings to subdue their prey or to defend themselves. But most venoms are not harmful to humans and research is revealing that components of some may be very beneficial in the development of new medical drugs and treatments.

Peppermint Stick Insect
8 X LIFE-SIZE
The diversity that has evolved within minibeasts is incredible. This Peppermint Stick Insect (*Megacrania batesii*) has an unusual method of protection. It has glands which produce a chemical that smells just like peppermint. If threatened, it sprays the antagonist from two nozzles located just behind its head. While the chemical smells nice to us, it has a burning effect on sensitive areas, particularly in the face of a small predator.

Centipede
2 X LIFE-SIZE
Centipedes have been roaming the earth for around 430 million years. This Giant Centipede (*Ethmostigmus rubripes*) is a fierce predator of the forest floor. Its body shape and many legs enable it to move efficiently through its habitat to find food.

TOOLS OF THE TRADE

Every species of minibeast alive on Earth today is a success story. They are the product of millions of years of evolutionary refinement. Each species has become perfectly adapted to living in its particular habitat and, as a result, has developed the perfect set of tools with which to do so. Whether it be to walk, fly, feed or defend themselves, such skills enable these remarkable animals to survive and, in doing so, carry out the roles they play within the Earth's ecosystems, which are vital to our own species' wellbeing and survival.

Many of the features of these animals are truly remarkable — they are so different to our own and enable these animals to perform feats of acrobatics and strength that humans could not achieve in our wildest dreams. Specialized feet that appear to defy gravity, eyes that see 360 degrees, and heads that can completely swivel around are all normal attributes in the minibeast world. Some hunting spiders have feet that seem to allow them to walk upside down on our ceilings or even upon glass. This impressive ability is due to a specialized structure on each foot, made up of thousands of tiny branching hairs that are so small and numerous they enable attraction at a molecular level. This attraction is known as Van der Waals force.

Sensing the environment around them is critically important to minibeasts, enabling them to find food and mates, and to detect danger. There are obvious ways in which they do this, such as vision. However, minibeasts have an array of other sensors that aid them in painting a clear picture of their world. Insects have antennae that come in a vast array of shapes and sizes, and which are very sensitive to airborne chemicals that allow them to find mates and food. Sensory hairs also play a very important role. There are many types of specialized hairs; some are finely tuned to detect air vibration and allow the animals to accurately detect prey in complete darkness without even needing to use their eyes.

Whirligig Beetles (Gyrinidae) live upon the surface of ponds and streams and are familiar to many people as they rapidly whirl in circles upon the surface. They have remarkable divided eyes, with an upper section taking in the sights from above the water and a lower section viewing beneath the water to give them a complete picture of the world around them.

Weaver Ants (*Oecophylla* spp.) have taken things a step further. These ants use live leaves as the outer walls of their nests, binding them together using teamwork and silk. The ants use themselves as bridges and ladders, gripping onto one another to pull the leaves together. This alone is an impressive feat, which is made all the more remarkable when you consider that the tools used to produce silk are not found on the ants, but instead produced by the larvae — the baby ants. Once the ants have the leaves positioned correctly, worker ants collect a larva each and, by tapping it with their antennae, they prompt the little white grubs to secrete silk from their mouth parts. The worker ants move them up and down, binding and sealing the holes in the leaves. When a larva runs out of silk, the workers simply retrieve another until the job is complete.

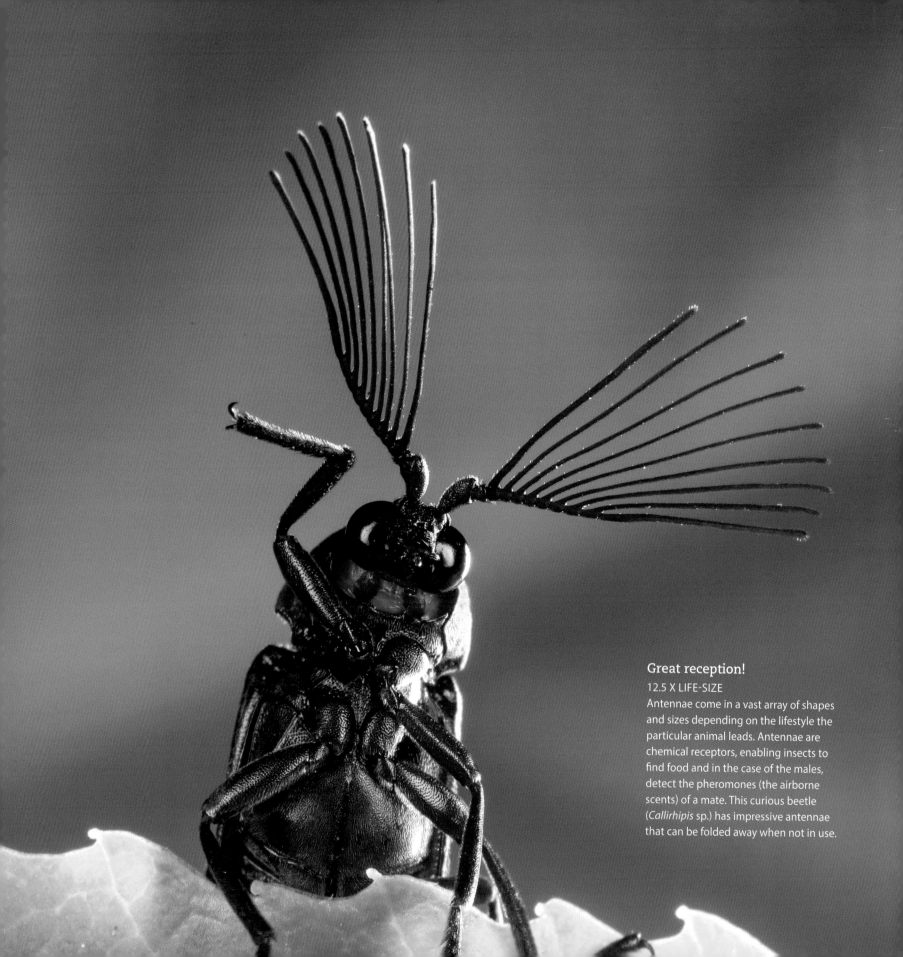

Great reception!
12.5 × LIFE-SIZE
Antennae come in a vast array of shapes and sizes depending on the lifestyle the particular animal leads. Antennae are chemical receptors, enabling insects to find food and in the case of the males, detect the pheromones (the airborne scents) of a mate. This curious beetle (*Callirhipis* sp.) has impressive antennae that can be folded away when not in use.

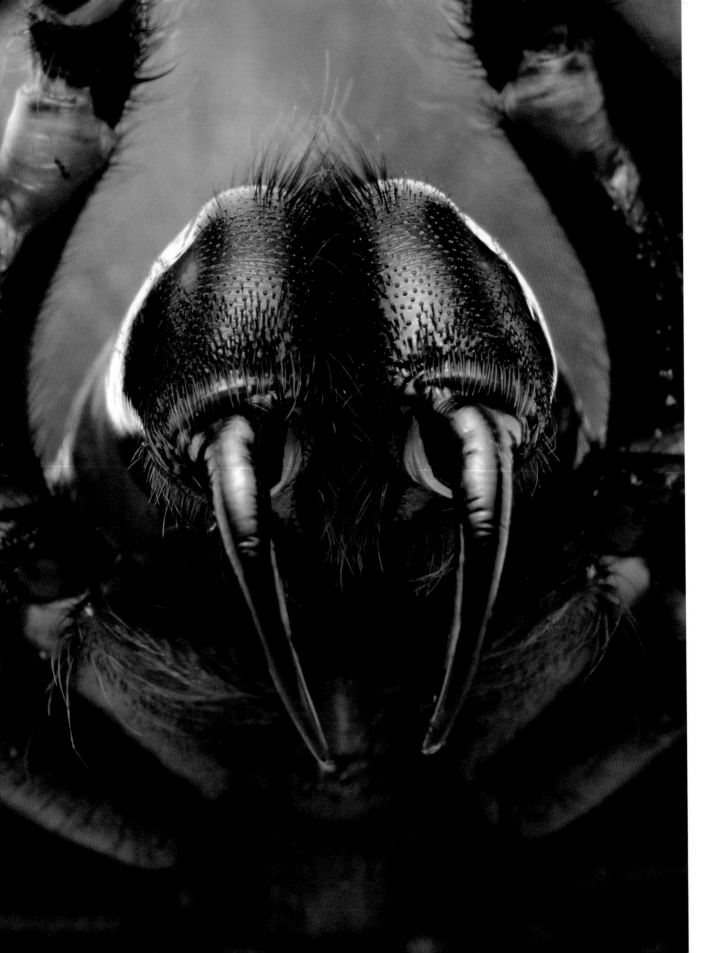

←

Weapons fit for task
14 X LIFE-SIZE
The enormous downward striking fangs of a Sydney Funnel-web (*Atrax robustus*). These spiders prey on ground-dwelling invertebrates, some of which are heavily armoured. The spider's fangs must be able to penetrate the armour in order to effectively capture them.

→

Leg speed
17 X LIFE-SIZE
The long legs of this Grey Tiger Beetle (*Cicindela* sp.) are built for speed. The invertebrate land speed record is held by the *Cicindela hudsoni*, which was clocked at 2.5 metres per second (9 kilometres per hour or 5½ miles per hour). Scaled up, this is equivalent to a human running at about 350 kilometres per hour (218 miles per hour)! In fact, these tiger beetles run so fast that they actually lose the ability to see once they start moving. They have to visually lock on to their prey first or run in short bursts to re-orient themselves as they chase their food.

TOOLS OF THE TRADE

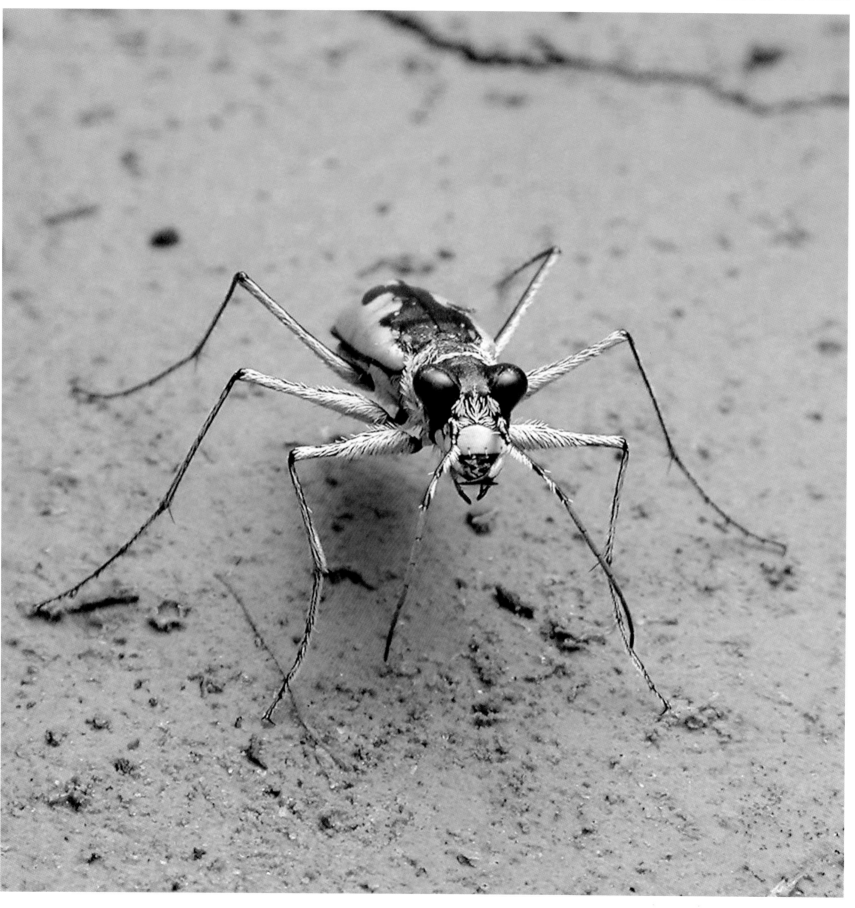

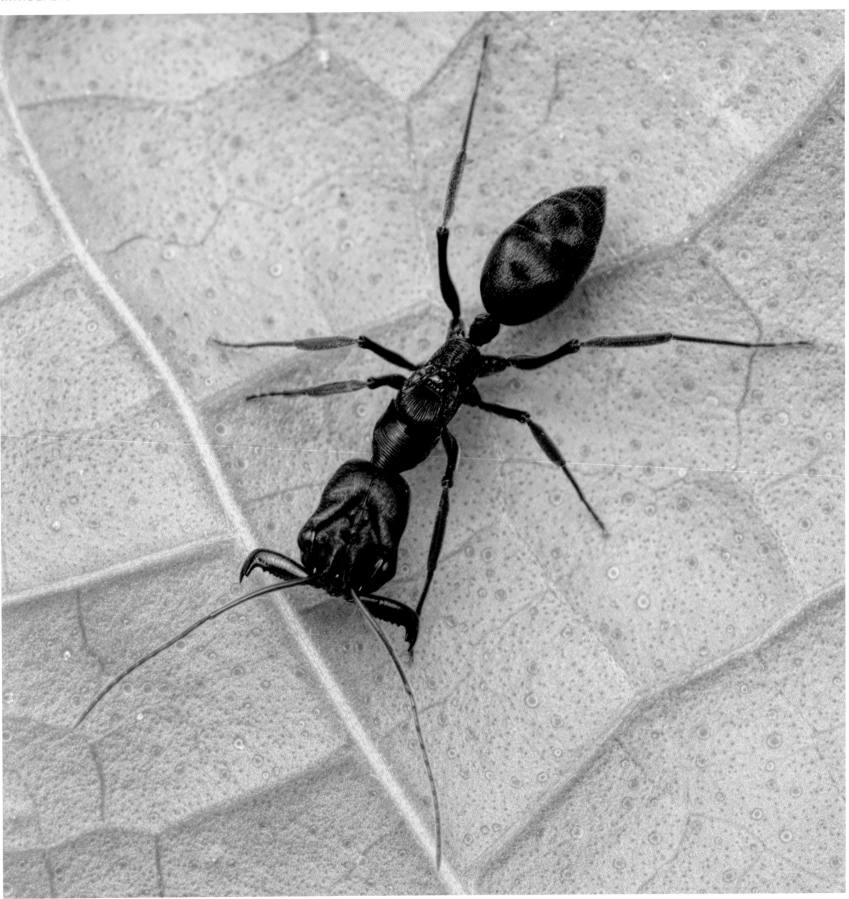

←
Trap-jaws
13 X LIFE-SIZE

Trap-jaw Ants (*Odontomachus* spp.) have unique jaws that lock open at 180 degrees and are used to stun prey and deter predators. Their jaws slam shut with incredible force — such force, in fact, that it can catapult them into the air. Their jaws also hold the record for the fastest moving predatory appendages in the animal kingdom: they can close in just 130 microseconds, at speeds of over 200 kilometres per hour (124 miles per hour).

→
Battle gear
5 X LIFE-SIZE

A male Rhinoceros Beetle (*Xylotrupes ulysses*) showing off its impressive horns. Competition for females is fierce for these beetles, and males must jostle and battle using these appendages for the right to mate. While larger males with bigger horns will usually win these tussles, sometimes smaller, more agile males will sneak by and mate unnoticed.

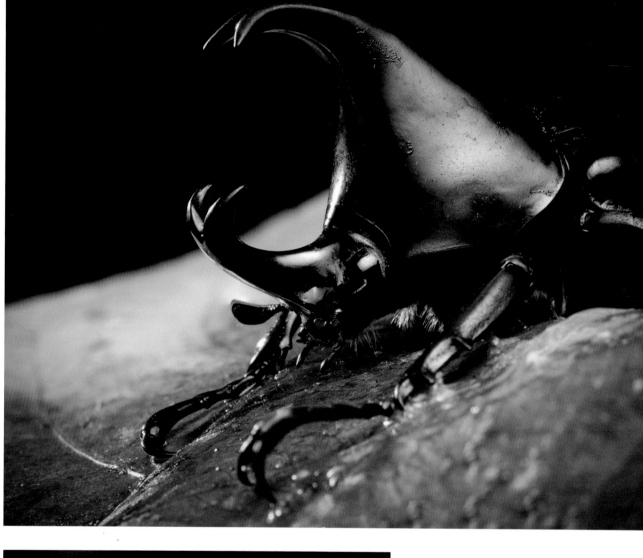

→
Protector of the masses
2.5 X LIFE-SIZE

The massive curled mandibles of this soldier Army Ant (*Eciton burchellii*) command respect. These huge-headed ants patrol the surging columns of raiding workers. Their mandibles can easily pierce human flesh, and they have a sting on their abdomen to back them up.

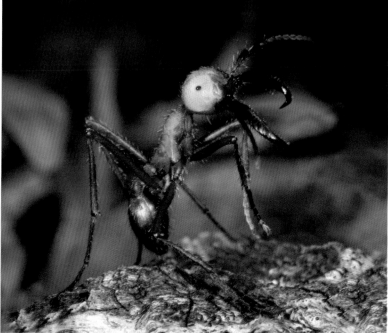

MINIBEASTS

→ Deadly injection
3.5 X LIFE-SIZE

Assassin Bugs (Reduviidae) are stealthy predators that move with a slow, calculated motion. They detect prey using their long antennae and big eyes, then move in slowly to avoid detection. Once close enough they strike with their needle-like mouthpart, which injects a paralyzing venom. After the victim has died the Assassin Bug sucks out its bodily fluids.

↓ Precision cutters
5 X LIFE-SIZE

Ants have particular body shapes and tools to suit the lifestyles they lead. Worker Leaf-cutter Ants (*Atta cephalotes*) have sharp, powerful mandibles for neatly cutting out sections of leaves they use to farm fungi within their nests. They also have very long legs, which gives them good clearance in order to carry such large items.

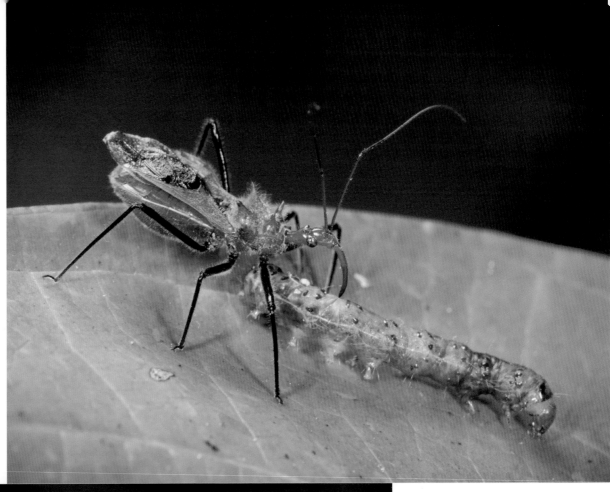

→ Spectacular vision
36 X LIFE-SIZE

Dragonflies (Anisoptera) have huge compound eyes — eyes with many lenses. These eyes wrap around their heads, which are perfectly adapted to their airborne predatory lifestyle. Having such eyes allows them to spot and track prey accurately while on the wing, and also be aware of incoming predators. This particular dragonfly has some rain drops on its eyes, creating some interesting magnifying effects.

TOOLS OF THE TRADE

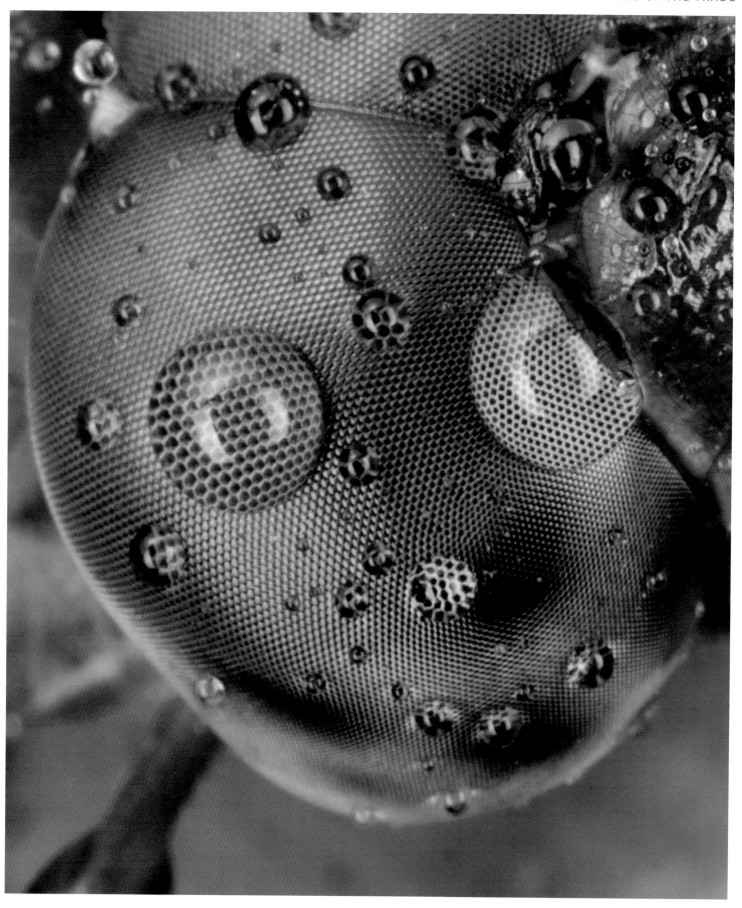

MINIBEASTS

→
Retractable eyes
5 X LIFE-SIZE
Snails are soft, flexible-bodied minibeasts belonging to the group Gastropoda. They have a single muscular 'foot' that they move about on, which is lubricated by sticky mucus. Most snails have their eyes on the end of the longest of their two pairs of stalks (known as tentacles). The tentacles can be retracted by rolling in on themselves, just like the fingers of a glove.

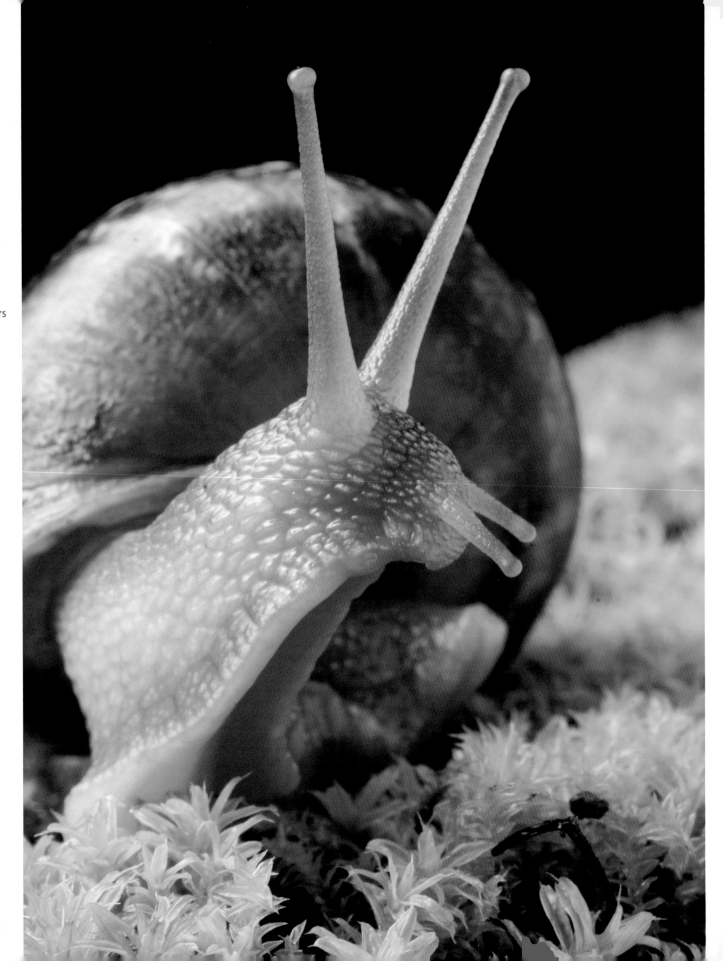

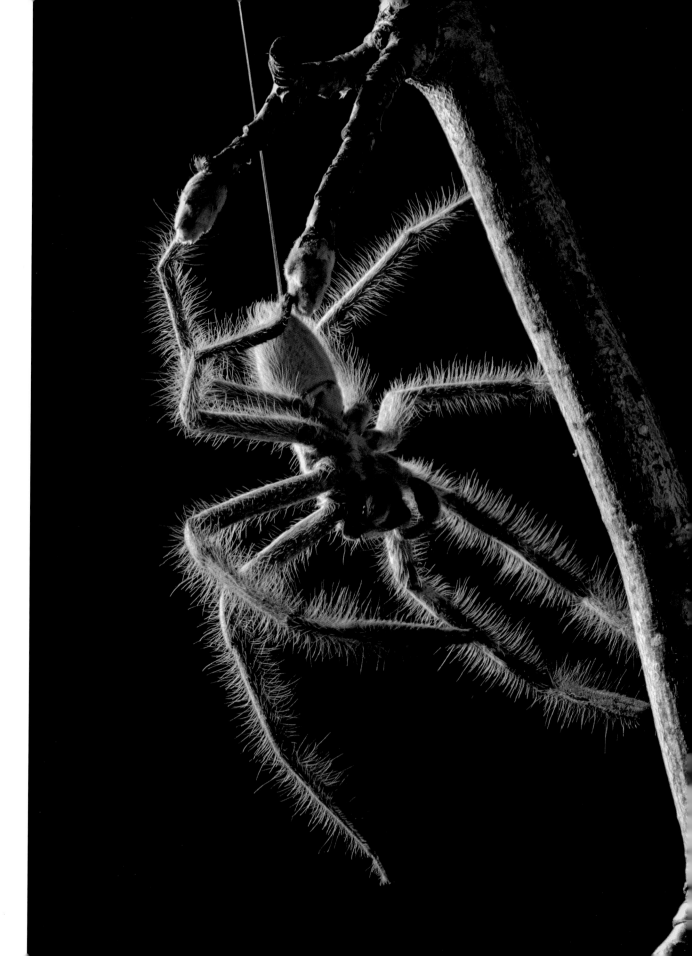

→

Sensory overload

1.4 X LIFE-SIZE

Bristling with sensory hairs, this Banded Huntsman (*Holconia murrayensis*) is on full alert and waiting for airborne prey. Spiders have a variety of hair types, including trichobothria. These are incredibly sensitive to air movement, and allow the spider to 'hear' the vibrations caused by the beating of an insect's wings and accurately pinpoint its location. Spiders like this huntsman are able to hunt in the dark without vision and still lunge with precision to capture prey in mid-flight.

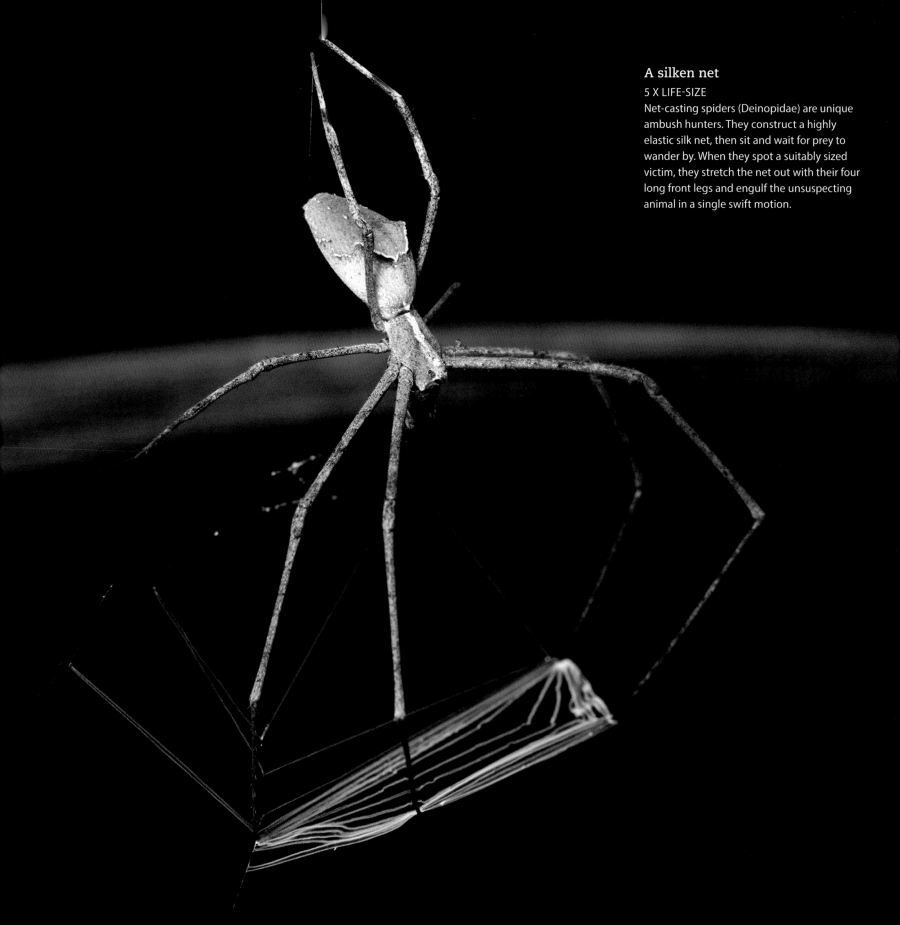

A silken net
5 X LIFE-SIZE
Net-casting spiders (Deinopidae) are unique ambush hunters. They construct a highly elastic silk net, then sit and wait for prey to wander by. When they spot a suitably sized victim, they stretch the net out with their four long front legs and engulf the unsuspecting animal in a single swift motion.

TOOLS OF THE TRADE

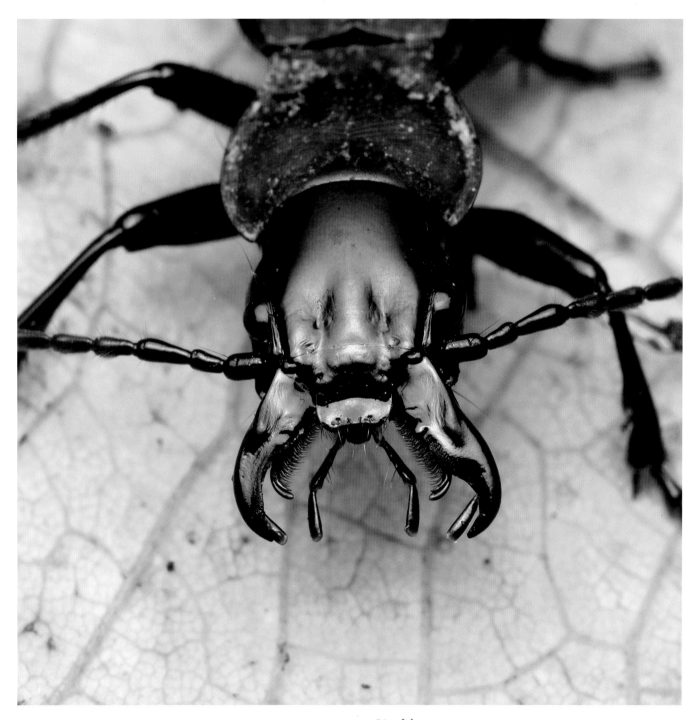

Crushing power
10 X LIFE-SIZE
The powerful mandibles (jaws) of a predatory ground beetle (Carabidae). These beetles hunt and scavenge for food as they roam through the leaf litter. Their jaws are used to crush and cut through the hard exoskeletons of the invertebrates they feed on.

2

STRIKING COLOUR

In the minibeast world, colour is everywhere. It may be subtle, it may be bold. It may help hide the animal or be an advertisement so stunning that it is impossible to miss.

Like the rest of nature, minibeasts have evolved colours to suit their particular survival needs. One obvious use is in creating camouflage. Many minibeasts exhibit the colours that occur in the habitats in which they live, rendering them near-invisible and protecting them from being picked off by visual predators.

Colour, however, is useful for much more than simply blending in. Many species flaunt themselves using brilliant vibrant colours to avoid being eaten. Colours such as reds, oranges and yellows are nature's warning colours and are used by minibeasts to tell predators at a glance that they are distasteful, poisonous or can sting or bite. While it is well known that visual vertebrate predators such as birds take notice of such colours and tend to avoid eating these brightly coloured minibeasts, even minibeasts themselves can read these signs. Studies have shown that jumping spiders can recognize colours and favour prey not exhibiting reds and yellows.

Exhibiting bright colour is clearly a successful way of avoiding being lunch for another animal, and like any favourable strategy, success in the minibeast world is often emulated. While the process of evolution doesn't consciously copy a successful strategy, harmless species that have evolved to exhibit such colours enjoy the same benefits as poisonous ones. As such, the use of warning colours is not restricted to those minibeasts that have the goods to back up the hype — there are plenty of pretenders using warning colours, piggybacking on the success of the real inedible species.

These pretenders are known as mimics, and it often takes a very good eye to tell them apart.

Not all minibeasts using warning colours choose to display them all the time. Some keep their cards close to their chests until they need to play them. Many stick insects that normally use colour as a form of camouflage have brightly coloured wings, which they can flash to startle predators if they are discovered.

Colour is also used as an element of confusion, another strategy to avoid predators. The iridescent colours on the upper surface of some butterfly wings are created by the refraction and reflection of light upon microscopic physical structures on the wing surface. When in flight, the wing surface reacts with the light in such a way as to make the butterfly appear and disappear in flashes of brilliant colour. This type of visual movement and colour bombardment makes it very difficult for an airborne predator to accurately follow.

For minibeasts with good eyesight, colour is also an effective way to communicate. This can be especially useful when choosing a good mate during courtship. Male Peacock Spiders (*Maratus* spp.) have brightly coloured abdomens, some with extendable flaps that are held up and shown off to females during elaborate courtship dances. These intricate displays of colour and pattern not only assure the female she is interacting with a male of her own species, but can indicate his fitness and abilities.

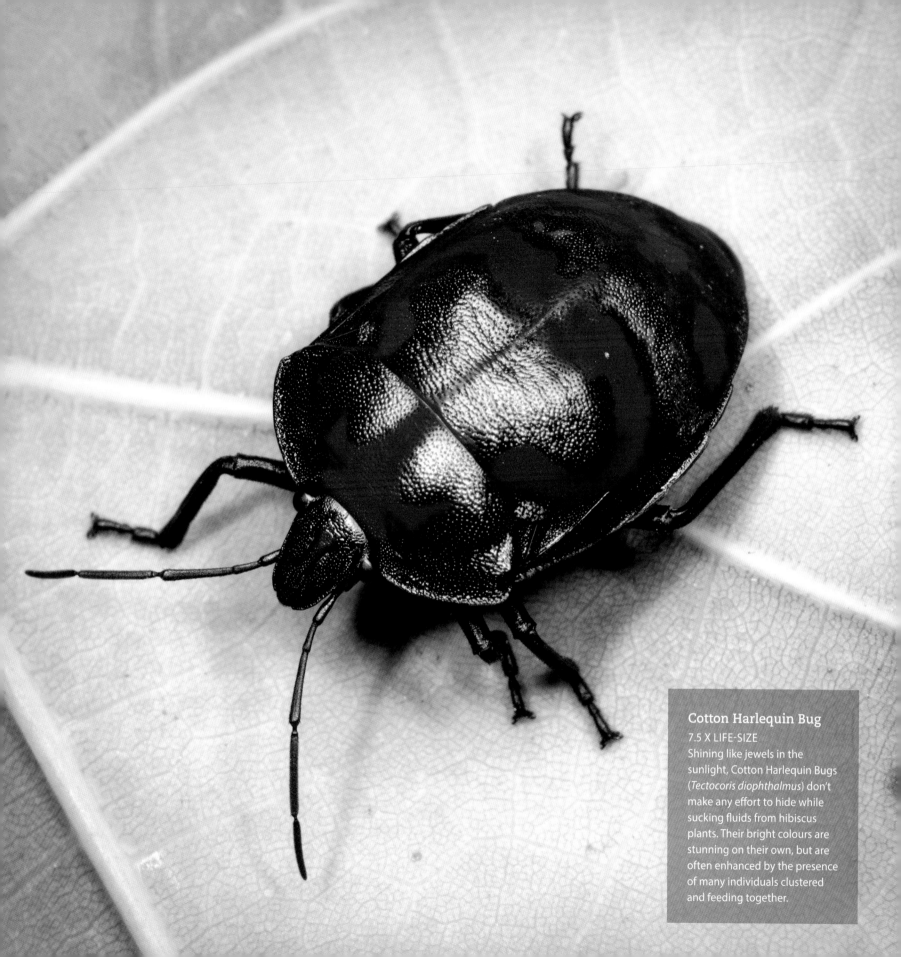

Cotton Harlequin Bug
7.5 X LIFE-SIZE
Shining like jewels in the sunlight, Cotton Harlequin Bugs (*Tectocoris diophthalmus*) don't make any effort to hide while sucking fluids from hibiscus plants. Their bright colours are stunning on their own, but are often enhanced by the presence of many individuals clustered and feeding together.

MINIBEASTS

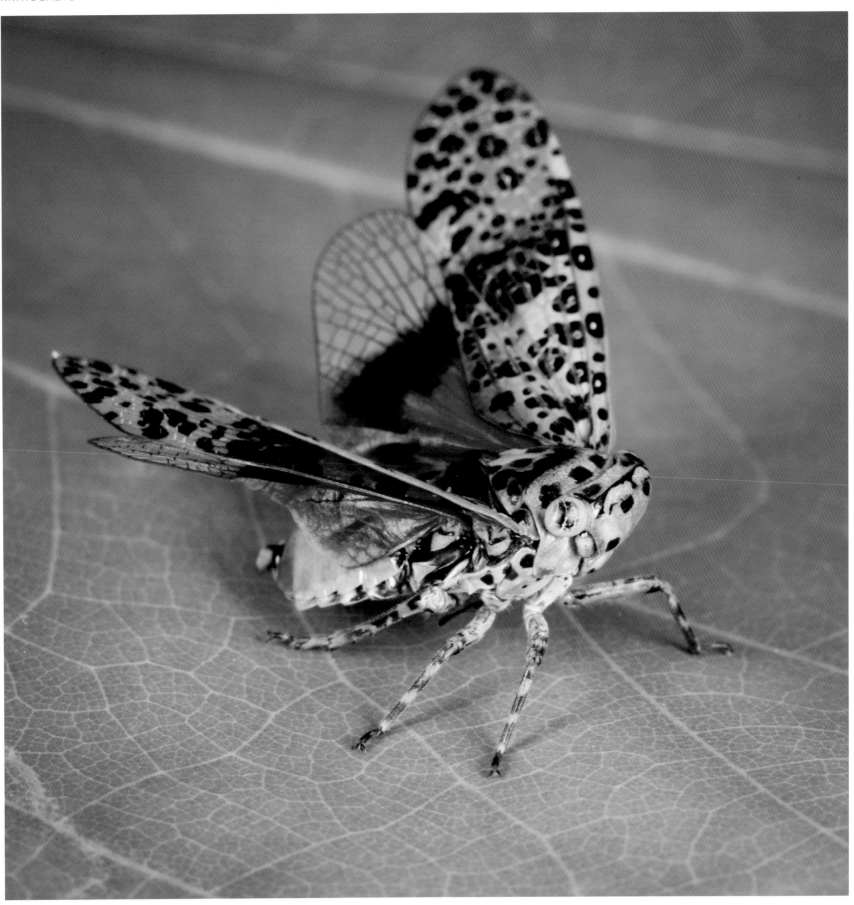

Leafhopper
6 X LIFE-SIZE
Suddenly flashing warning colours is an effective strategy used by minibeasts to startle predators if they are being threatened. This leafhopper (Cicadellidae) is flaring its wings, exposing bright red and orange — enough to make most visual predators think twice and, with luck, give the leafhopper time to escape.

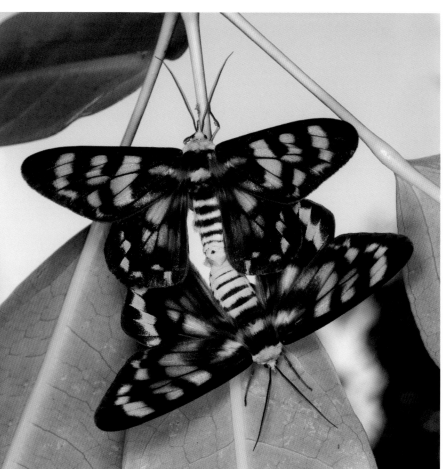

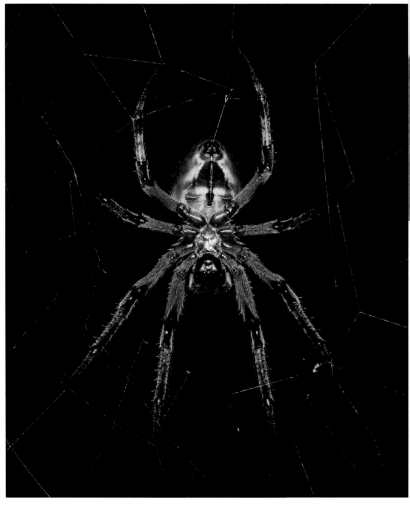

What time is it?
0.9 X LIFE-SIZE
These Four O'clock Moths (*Dysphania numana*) are active during the day, particularly late in the afternoon — hence the name. While most moths avoid daylight and the scrutiny of hungry birds, these moths are quite safe and usually left alone by birds due to their bright colours. That's just as well, as these two have important business to attend to.

Revealing your colours
1.5 X LIFE-SIZE
From above, this Flame-bellied Orb-weaving Spider *(Eriophora fuliginea)* is dark grey–brown, allowing it to camouflage itself against branches and tree trunks while resting. When visible in its web, the spider reveals its crimson underbelly.

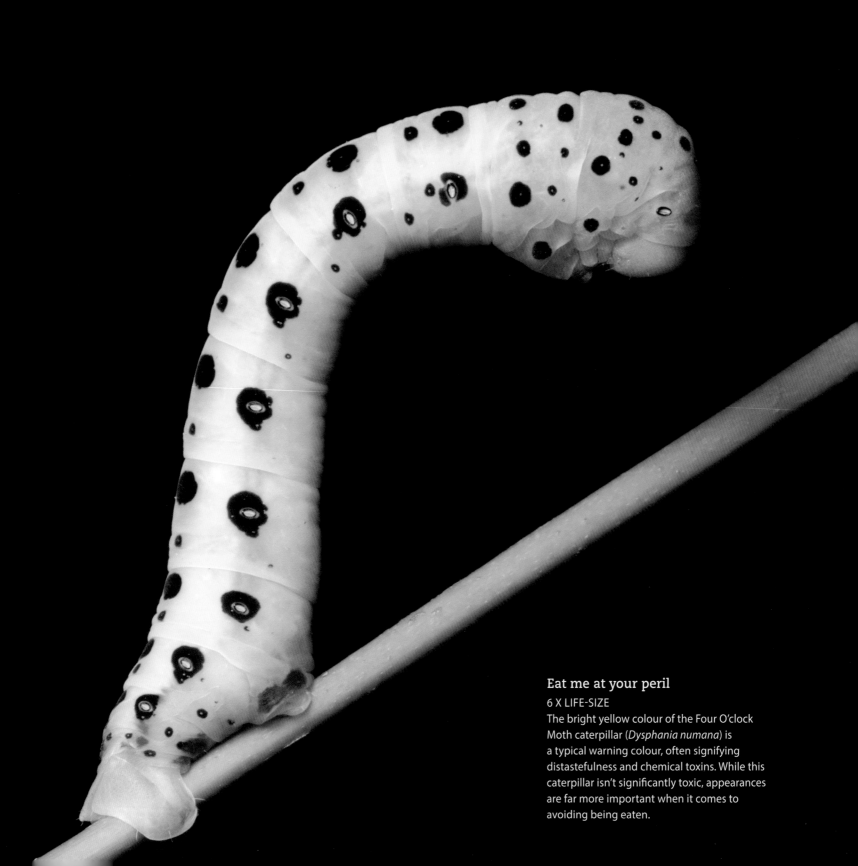

Eat me at your peril
6 X LIFE-SIZE
The bright yellow colour of the Four O'clock Moth caterpillar (*Dysphania numana*) is a typical warning colour, often signifying distastefulness and chemical toxins. While this caterpillar isn't significantly toxic, appearances are far more important when it comes to avoiding being eaten.

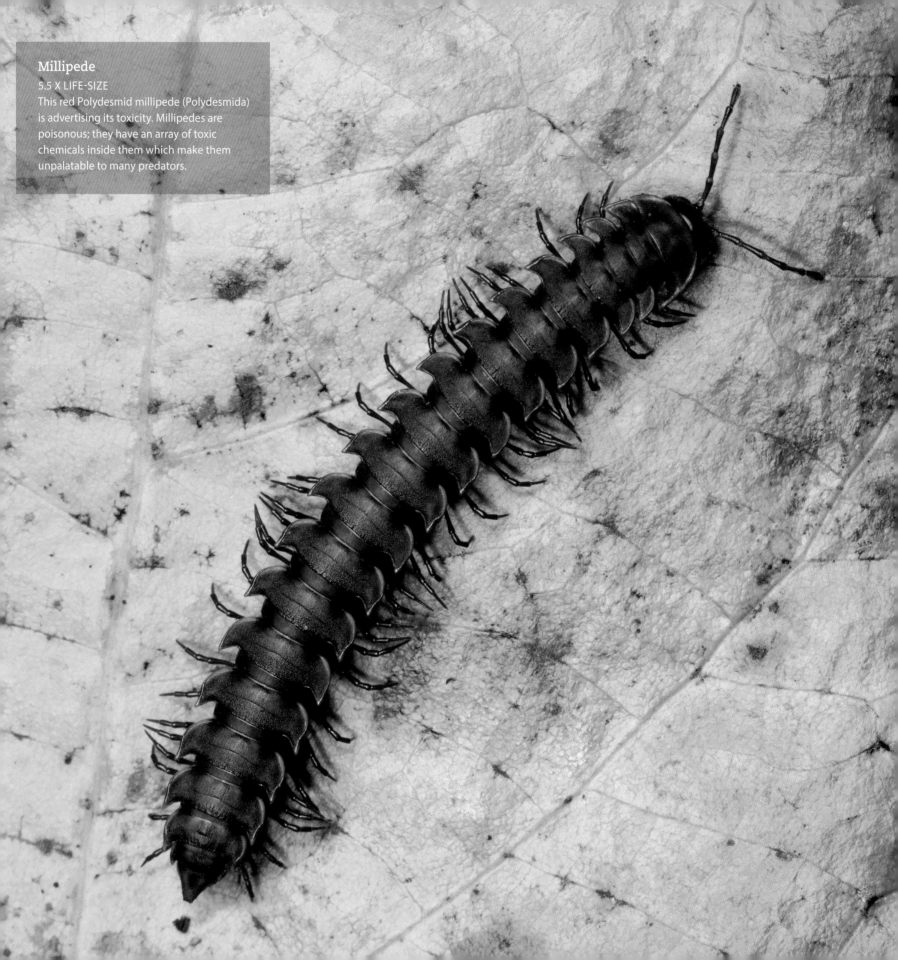

Millipede
5.5 X LIFE-SIZE
This red Polydesmid millipede (Polydesmida) is advertising its toxicity. Millipedes are poisonous; they have an array of toxic chemicals inside them which make them unpalatable to many predators.

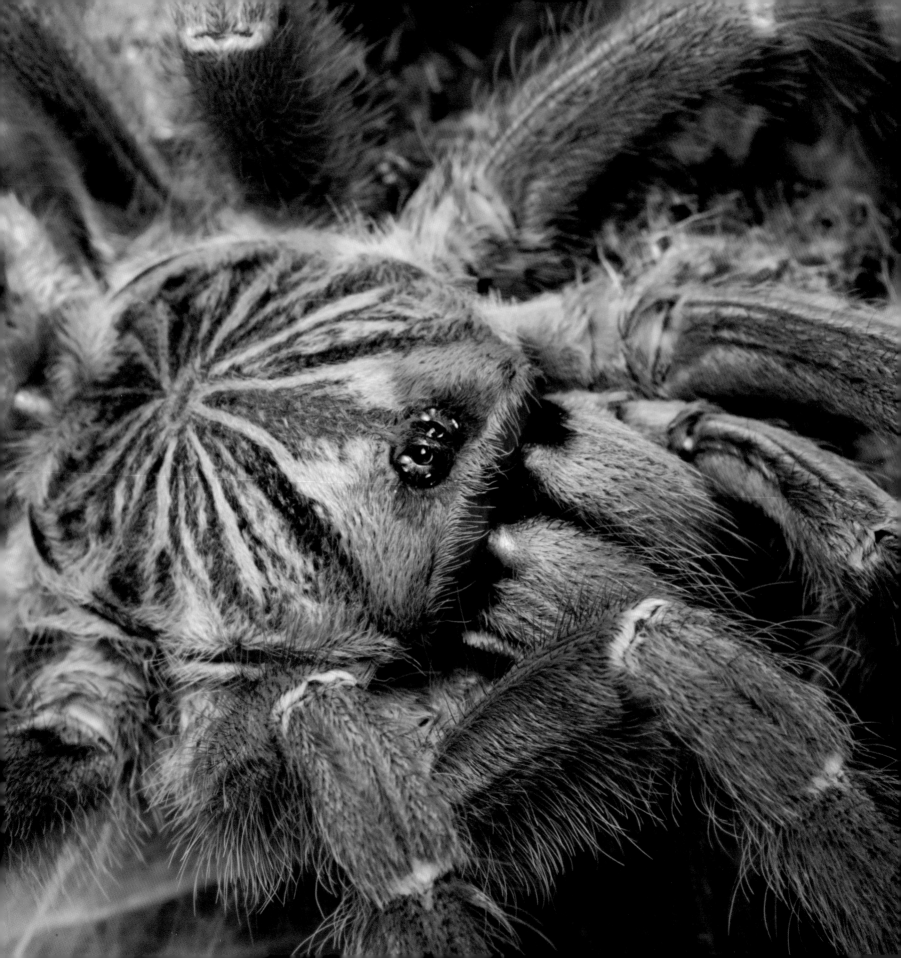

STRIKING COLOUR

Orange Baboon Tarantula
6 X LIFE-SIZE

The stunning colour of this Orange Baboon Tarantula (*Pterinochilus murinus*) may be a warning to its predators, but in this case it has the temperament to back up the signals. If harassed, this spider immediately bears its fangs and fiercely defends itself.

Not hiding
5.5 X LIFE-SIZE

A colourful cockroach! This rainforest gem (*Paratropes* sp.) has classic warning colours to warn off predators. While many cockroaches have drab colours enabling them to hide, this one has the complete opposite.

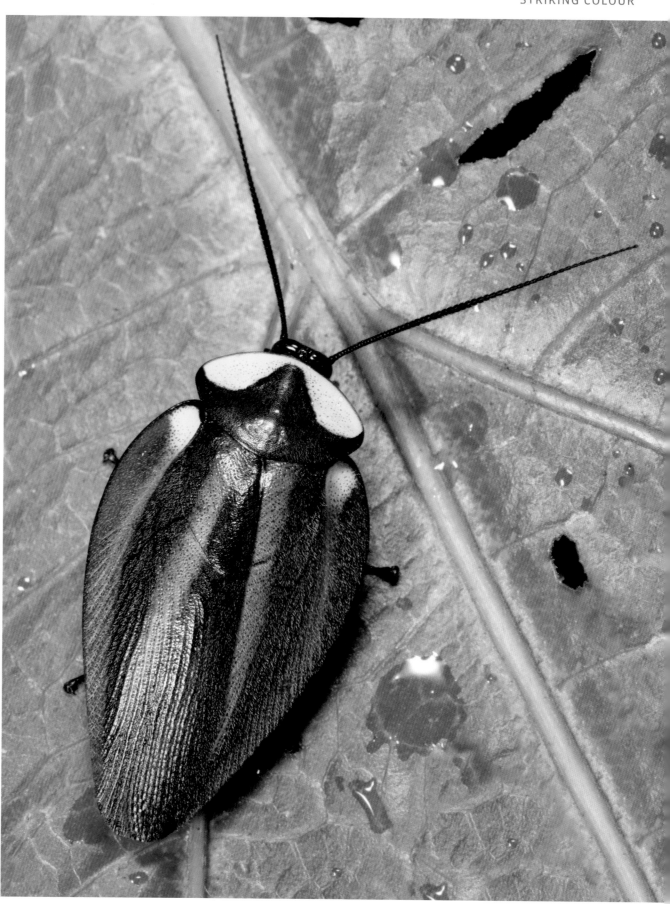

MINIBEASTS

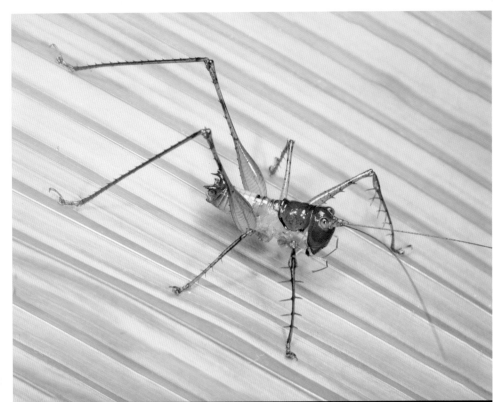

←

Candy Cane Katydid
1.5 X LIFE-SIZE

Most katydids in the jungles of Costa Rica are brown or green and rely on camouflage to hide from predators. The brightly coloured Candy Cane Katydid (*Arachnoscelis feroxnotha*) does the exact opposite and uses warning colours to deter predators.

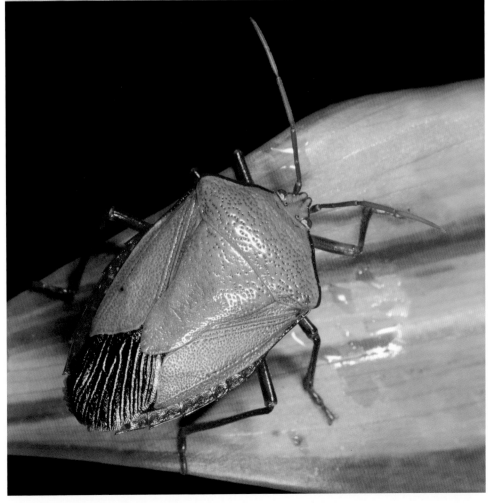

←

Colourful odours
4.5 X LIFE-SIZE

The pungent chemical defence of these Red-legged Stink Bugs (*Edessa rutomarginata*) would provide most predators with a very bad experience. While it might not help the individual Stink Bug if it is eaten, the predator may well never touch another, which benefits the species overall.

→

Flashing brilliance
2 X LIFE-SIZE

The flight of a Ulysses Butterfly (*Papilio ulysses*) is like seeing a brilliant blue beacon pulsing through the rainforest. This flashing of colour makes it difficult for visual predators to accurately pursue it. When it rests, it closes its wings and relies on camouflage to blend into its habitat.

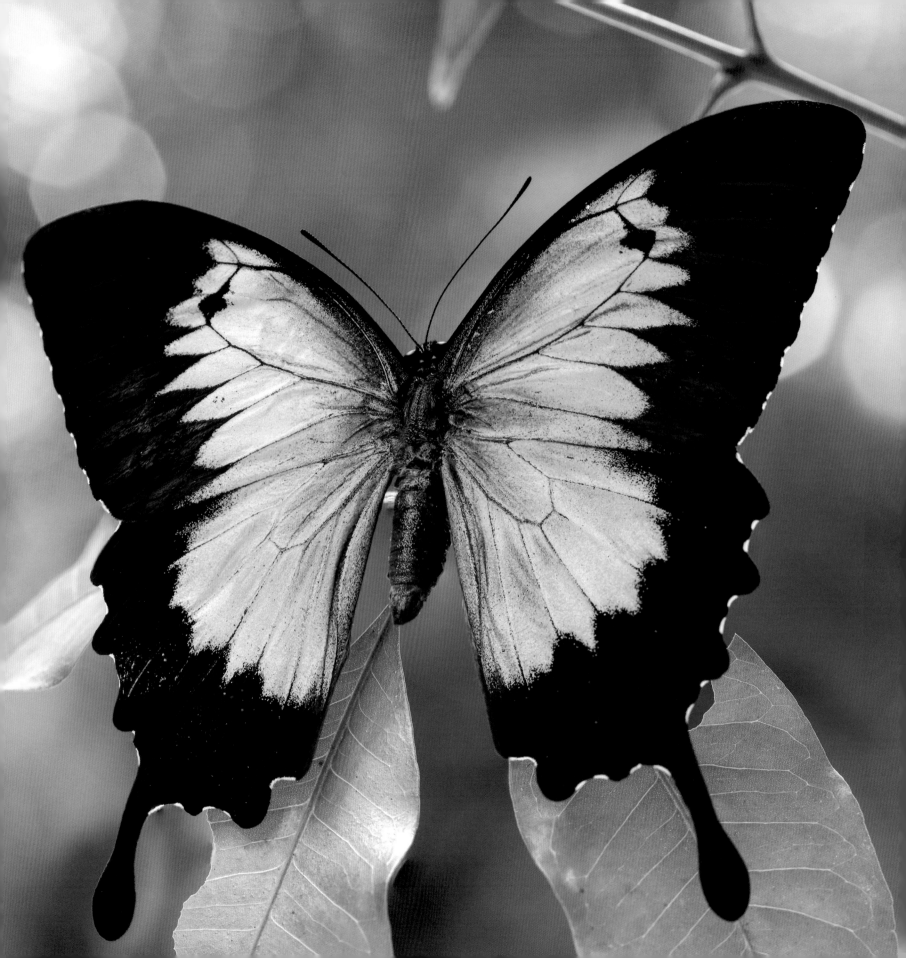

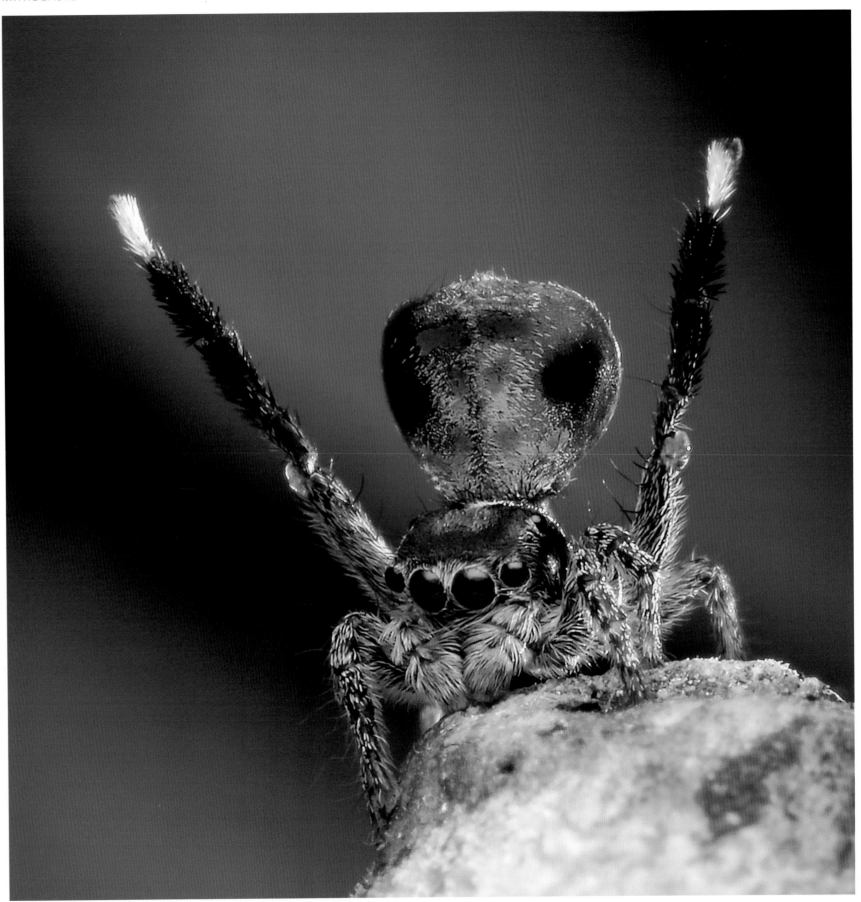

STRIKING COLOUR

← Big show on a small scale
26 X LIFE-SIZE
Male Peacock Jumping Spiders are tiny, about 5 millimetres long ($1/10$ inch). Yet what they lack in size they make up for with colour and show. This male (*Maratus amabilis*) is displaying to a female, holding his abdomen aloft and extending flaps of skin on the sides to expand his fantastic display. Males of each of the various species have a unique pattern and colour scheme which, when combined with distinct dance moves, aids the females to not only identify their mates but also to judge their fitness.

↑ Giant Velvet Mite
17 X LIFE-SIZE
After monsoonal rains in southwest United States and Mexico, these bizarre-looking Giant Velvet Mites (*Dinothrombium* sp.) suddenly appear and wander the ground in broad daylight. Their vivid red colour warns off predators, so they can seek out their food in relative safety. They prey on small invertebrates which include winged termites that also emerge en masse after the rains.

3

THE REAL TRANSFORMERS

The Transformers TV series and blockbuster movies have long transfixed adults and children alike with their depictions of giant fighting robots, able to transform from cars and trucks at will. While this seems a fantastical concept invented by science fiction writers, the reality is that minibeasts have been doing this for millions of years.

Beetles are able to transform themselves rapidly from robust robot-like walkers into aerobatic machines, zooming off into the sky with their once-hidden wings. This ability to change provides them with far more flexibility in what they do and where they live, and has enabled them to become one of the most successful and species-rich groups of insects on Earth. While many different groups of insects have wings, it is the beetles that have mastered the complete transformation. The secret to success has been the evolution of elytra, the outer wings that lost their flying ability and evolved into hard protective covers. Thanks to their elytra, dung beetles can dig headlong into piles of animal waste and water beetles can dive to the bottom of ponds, yet both can take to the air readily, as their delicate flight wings are completely protected from damage.

Beetles, however, are not the only transformers in the minibeast world. There are other transformers — perhaps slower, but certainly more dramatic. Insects develop in two major ways: hemimetabolous and holometabolous development.

During hemimetabolous development, insects moult their exoskeleton a number of times and gradually change with each moult until they reach adulthood. This is also known as incomplete metamorphosis. The final moult is the most dramatic change, when useable wings appear and the insect can suddenly look very different than it did prior to its last moult. Dragonflies and damselflies transform from underwater creatures with gills to aerobatic predators, capable of some of the most amazing aerial feats in the minibeast world. Cockroaches, crickets, grasshoppers, praying mantises and stick insects also undergo transformations over time.

The most high-profile transformers in the minibeast world are surely the butterflies. Yet ants, flies, beetles, bees and moths all undergo the same remarkable transformation process. This is holometabolous development — more commonly known as metamorphosis — and is where the real magic happens. In this form of development, the insect passes through a grub-like larval stage, with the sole purpose of feeding and achieving growth. It then enters pupation, where dramatic change occurs. The mature animal that exits the pupation case bears next to no resemblance to the grub it was before.

With both forms of development, there is no further growth once the insect reaches its adult form. With incomplete metamorphosis, the adult stage usually has wings, although there are some exceptions. With complete metamorphosis, there is no further growth after the insect emerges from the pupation case. A small ant is a small adult ant, a small beetle is a small adult beetle — they are not babies.

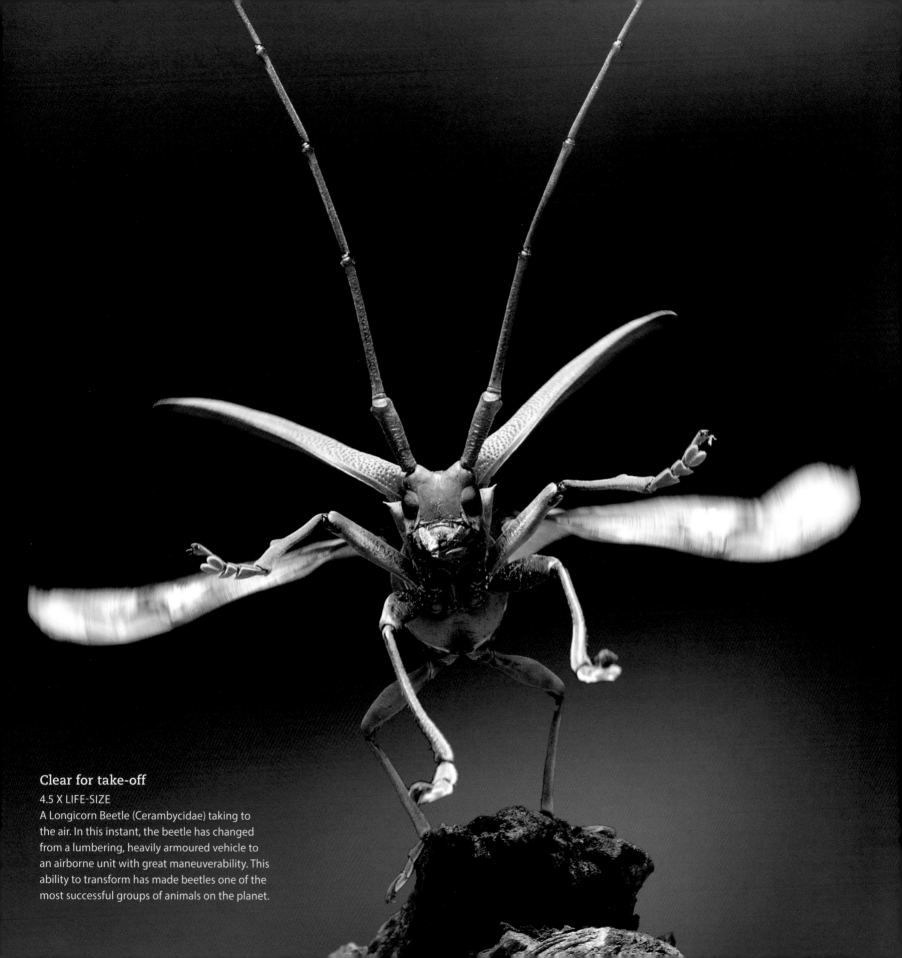

Clear for take-off
4.5 X LIFE-SIZE
A Longicorn Beetle (Cerambycidae) taking to the air. In this instant, the beetle has changed from a lumbering, heavily armoured vehicle to an airborne unit with great maneuverability. This ability to transform has made beetles one of the most successful groups of animals on the planet.

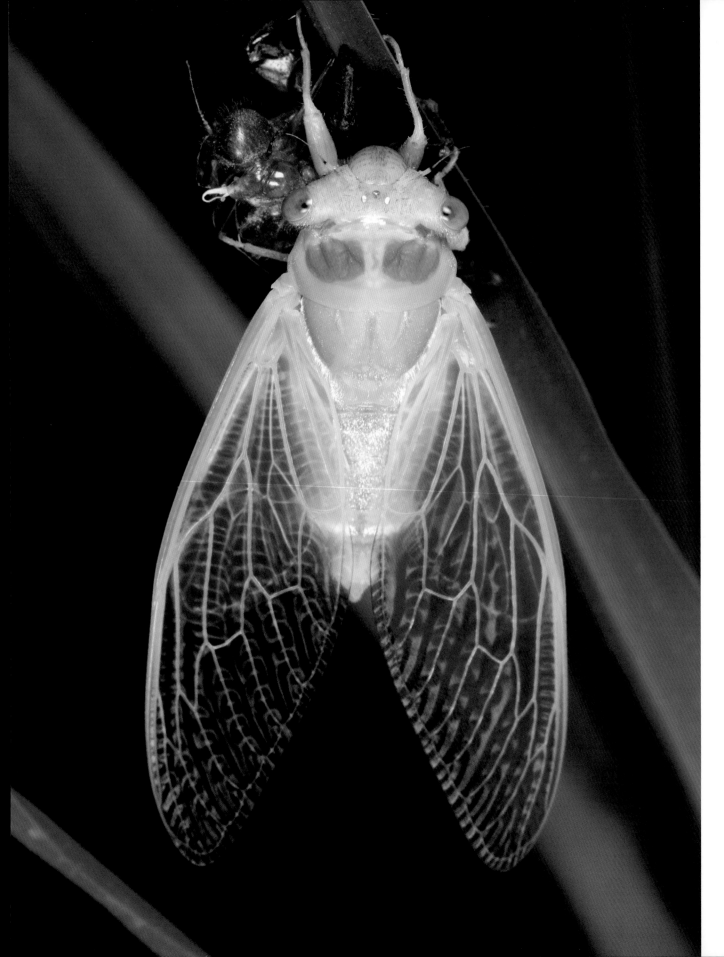

←
Coming of age
4 X LIFE-SIZE

After a long period living underground as a dull brown nymph, a dramatic transformation has taken place. In the space of about fifteen minutes, the colourful adult cicada (Cicadidae) has emerged from the nymph's exoskeleton through a process called ecdysis. The cicada will remain hanging until its wings harden sufficiently and will then head up into the trees to feed and seek a mate.

→
Caterpillar pupation
2.5 X LIFE-SIZE

This caterpillar has shed its exoskeleton four times during its growth, each time becoming larger but still similar in appearance. The first major transformation is the moult into the pupa stage. It wriggles out of the exoskeleton to reveal the pupal case. Around eight days later it will emerge as a butterfly.

THE REAL TRANSFORMERS

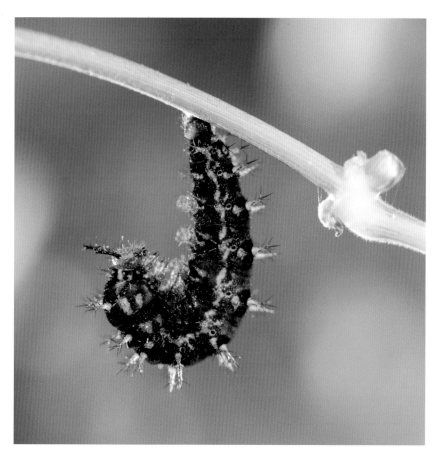
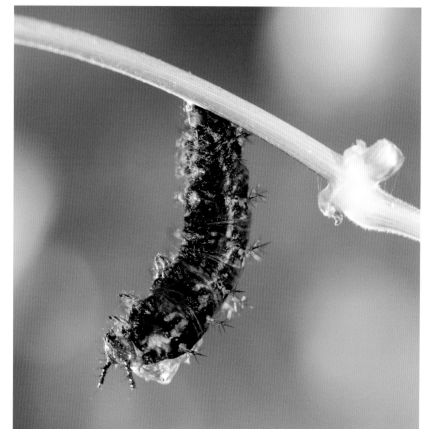
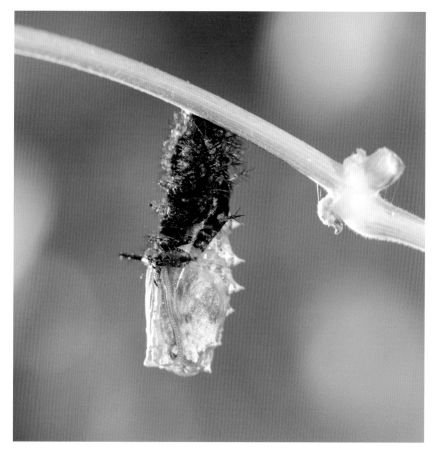
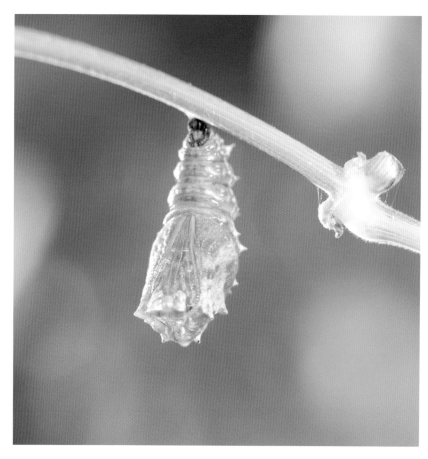

MINIBEASTS

↓
Now there are wings
2 X LIFE-SIZE
This Raspy Cricket (Gryllacrididae) is moulting to maturity. It is transforming from a wingless nymph to a sexually mature adult with wings. The moulting process is over in less than half an hour, but the cricket will hang for a while afterwards to dry its newly formed wings.

→
From water to the air
2 X LIFE-SIZE
The scene of a major transformation. This dragonfly nymph has crawled out of the water, up a nearby tree and then moulted into its adult form. After its wings are sufficiently dry the insect will take to the air, a stark contrast to its previous underwater existence.

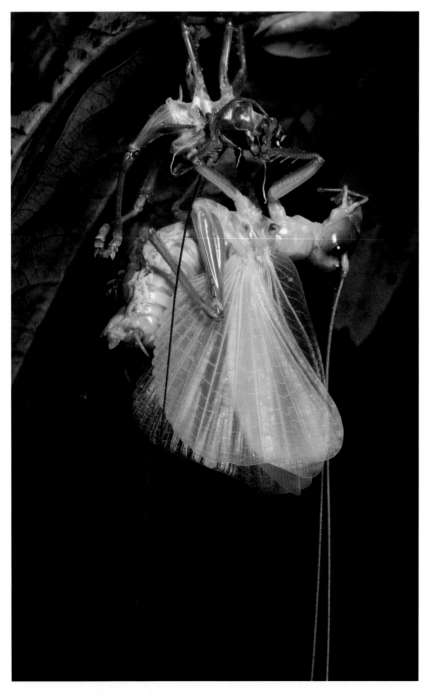

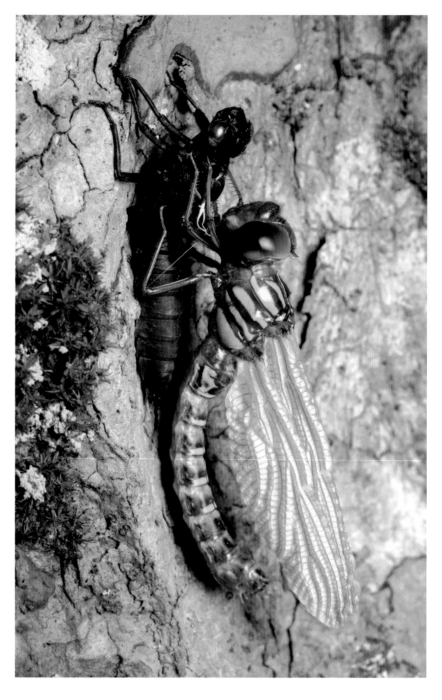

→
Big changes
2.7 X LIFE-SIZE
The difference between this desert Pie-dish Beetle adult (*Helea* sp.) and the juvenile larva is staggering. The larval stage lives beneath the ground and is adapted for tunnelling through roots, debris and decomposing timber. The adult beetle is extremely flattened and hides beneath logs and bark.

THE REAL TRANSFORMERS

4
SHAPE AND FORM

As a macrophotographer I'm continually amazed at the diversity within the world of minibeasts. There seems to be an endless degree of shape and form within this immense group of diminutive animals. The level of diversity and variation is almost beyond our wildest imagination. For me, it has become a case of expecting anything yet still being astounded whenever I see something new.

On an average night walking through the rainforest with my camera I'll encounter myriad invertebrates, with an incredible array of shapes and forms, all doing their bit, and all perfectly adapted to their way of life. Through evolution, their survival challenges have been continually met over a vast period of time. What we see are the survivors, still battling to overcome the odds but carrying with them the 'designs' enforced through natural selection that have got them this far.

Many of these 'designs' are mind-blowing. While many insect larvae are grub-like, the tiny larva of a lacewing (Osmylops sp.) is a flattened disc-shaped animal that roams the surfaces of leaves in search of prey. It has enormous sickle-shaped jaws that are held open at more than 180 degrees and snap shut upon small prey. The body is truly remarkable and is fringed with tiny branching structures covered in fine hairs. These make the creature appear as though it is surrounded by feathers, much like a living dreamcatcher. The function of these structures appears to be to reduce the shadow of the animal, allowing it to blend in better while at rest; but it might also play sensory and defensive roles in fending off predators.

While we have unlocked the secrets of many strange shapes and forms, there are many more we are yet to understand. Why this colour? Why this texture? Why this shape? How does that help them survive? What implications might this have for our own survival? These are the questions that scientists puzzle over and attempt to answer. Answering these questions can often assist us in solving our own problems, influencing designs in technological development and even within the field of medicine. A study at Kiel University in Germany is using the tiny flexible penis of a Thistle Tortoise Beetle (Cassida rubiginosa) to assist the design of new medical catheters that are flexible yet rigid and don't crimp. Unlike our designs, which often begin as untested ideas, basing them on minibeasts means that millions of years of successful testing has already taken place. The resource these animals provide is immeasurable and makes the loss of even one species utterly tragic. Meanwhile, these creatures go on with their lives, their shape and form interwoven with their ability to survive.

Their beauty is not here for our enjoyment. Similarly, those that horrify or disgust us do not exist to do so; it is simply how they are, and how we perceive what we see. When you think about it, we humans are pretty weird-looking creatures, too.

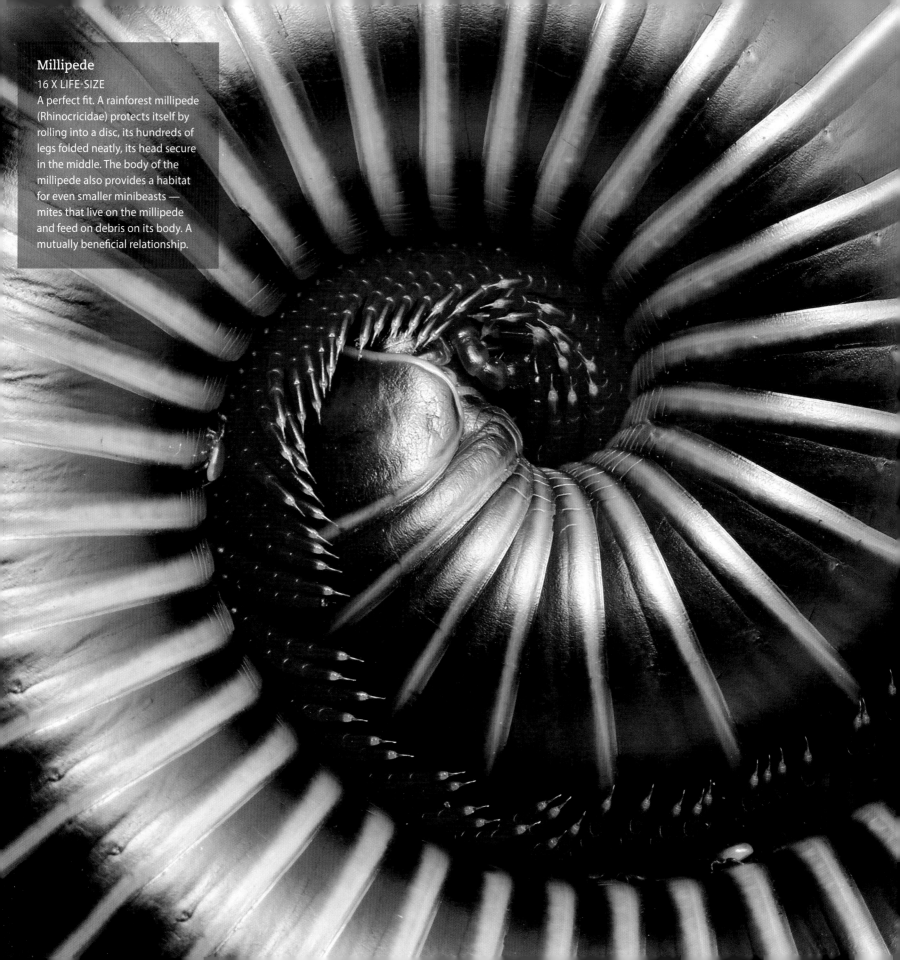

Millipede
16 X LIFE-SIZE
A perfect fit. A rainforest millipede (Rhinocricidae) protects itself by rolling into a disc, its hundreds of legs folded neatly, its head secure in the middle. The body of the millipede also provides a habitat for even smaller minibeasts — mites that live on the millipede and feed on debris on its body. A mutually beneficial relationship.

MINIBEASTS

→
Butterfly wing
13 X LIFE-SIZE
Up close, butterfly wings are more than just flat canvases of colour. The wings are covered in scales, which have multiple purposes. They have structures to refract and reflect light, which is used for communication and to deter predators. The scales can also be readily shed, making the butterfly hard to grip and allowing it to escape from predators.

↑
Playing hard to get
8 X LIFE-SIZE
Just like a reptilian tortoise, this Orange Tortoise Beetle (*Aspidimorpha westwoodi*) shelters within an armoured exterior. The beetle has broad, flattened elytra (wing cases) and a shield-like protection over its head, both of which clamp down onto a leaf if it is threated. It grips tight with its feet so that predators have great difficulty in dislodging it.

→
Bristling with spines
1.8 X LIFE-SIZE
Spines bristle from this Rainforest Tree Katydid (*Phricta spinosa*). The spines assist its camouflage by breaking up the solid outline of the cricket's shape against tree trunks. They also provide a physical defence; if threatened, the cricket kicks powerfully at its provocateur with its long hind legs.

SHAPE AND FORM

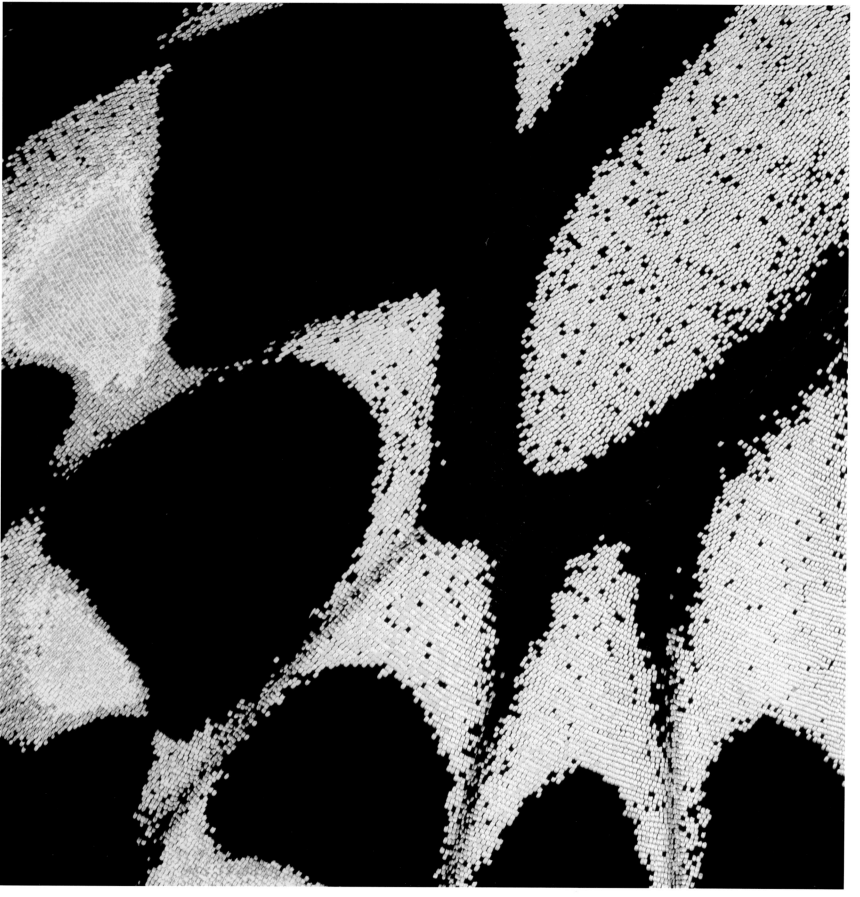

45

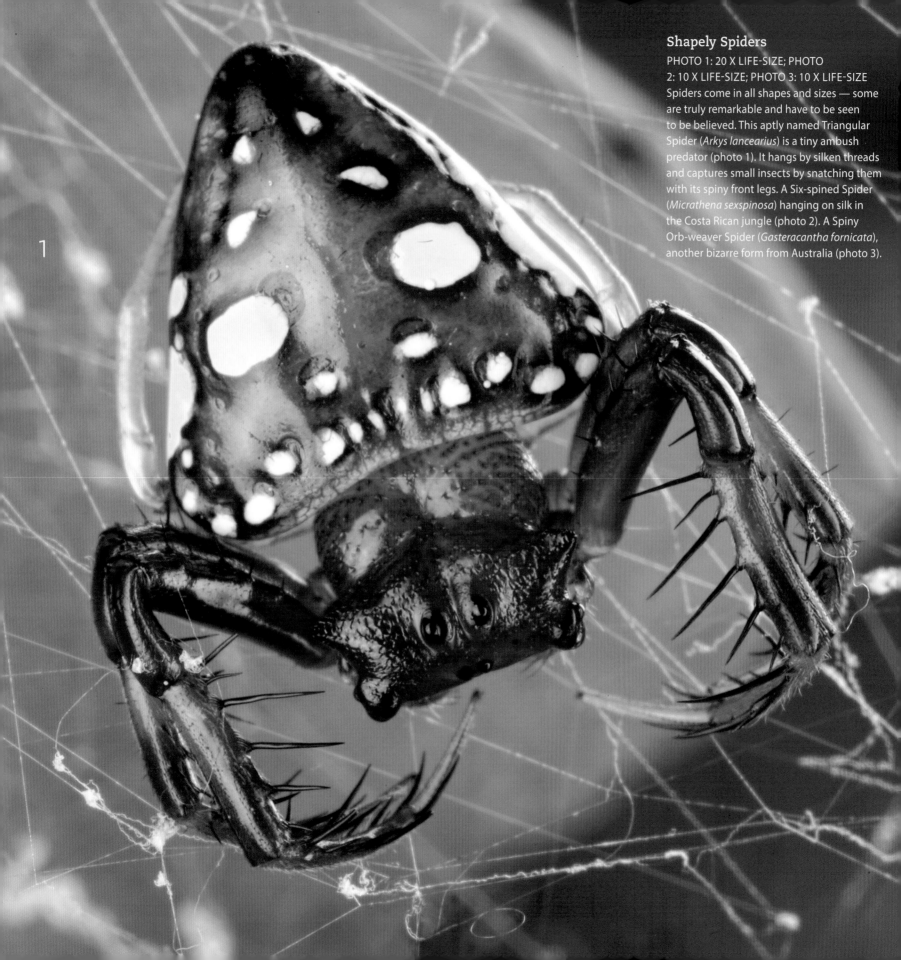

Shapely Spiders

PHOTO 1: 20 X LIFE-SIZE; PHOTO 2: 10 X LIFE-SIZE; PHOTO 3: 10 X LIFE-SIZE

Spiders come in all shapes and sizes — some are truly remarkable and have to be seen to be believed. This aptly named Triangular Spider (*Arkys lancearius*) is a tiny ambush predator (photo 1). It hangs by silken threads and captures small insects by snatching them with its spiny front legs. A Six-spined Spider (*Micrathena sexspinosa*) hanging on silk in the Costa Rican jungle (photo 2). A Spiny Orb-weaver Spider (*Gasteracantha fornicata*), another bizarre form from Australia (photo 3).

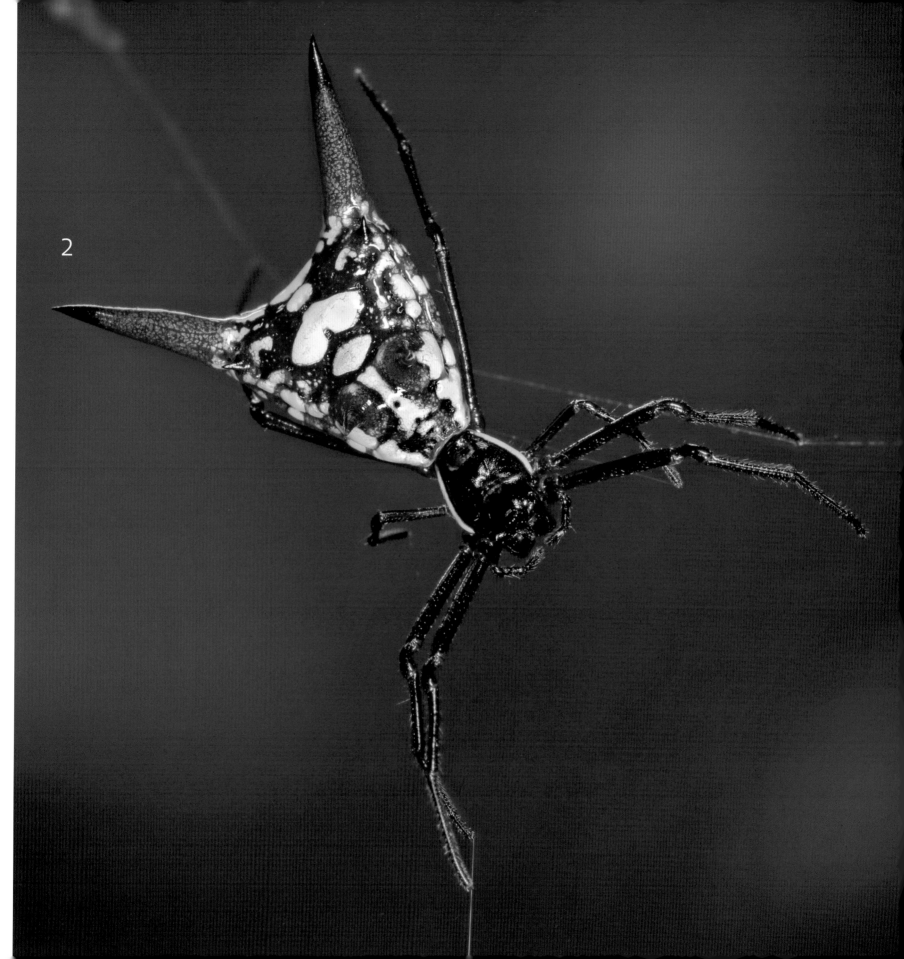

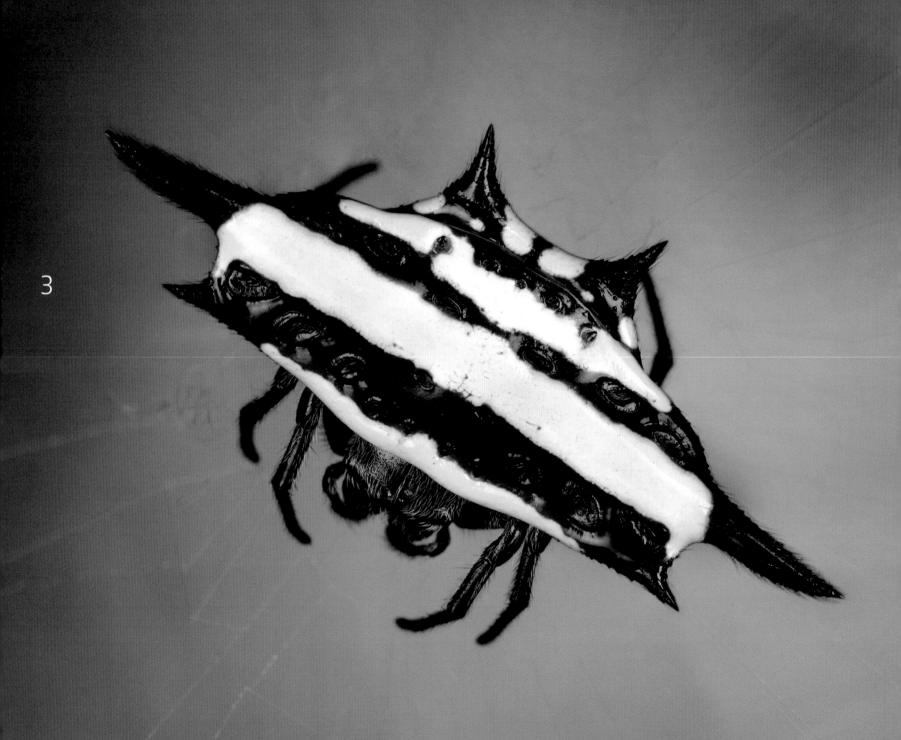

3

SHAPE AND FORM

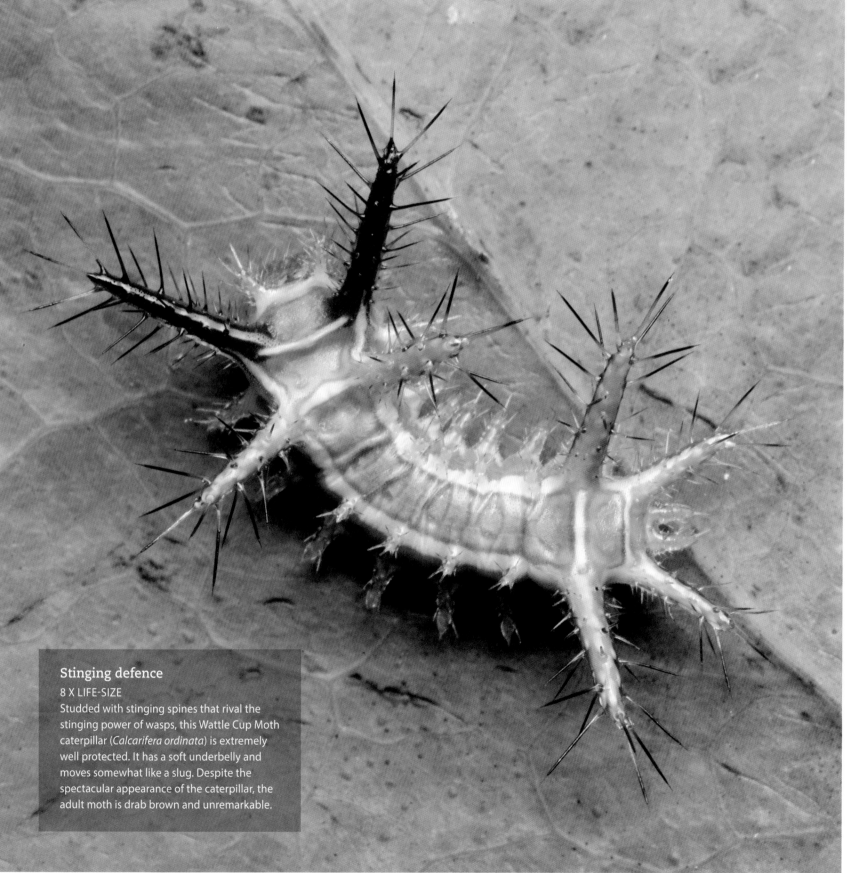

Stinging defence
8 X LIFE-SIZE
Studded with stinging spines that rival the stinging power of wasps, this Wattle Cup Moth caterpillar (*Calcarifera ordinata*) is extremely well protected. It has a soft underbelly and moves somewhat like a slug. Despite the spectacular appearance of the caterpillar, the adult moth is drab brown and unremarkable.

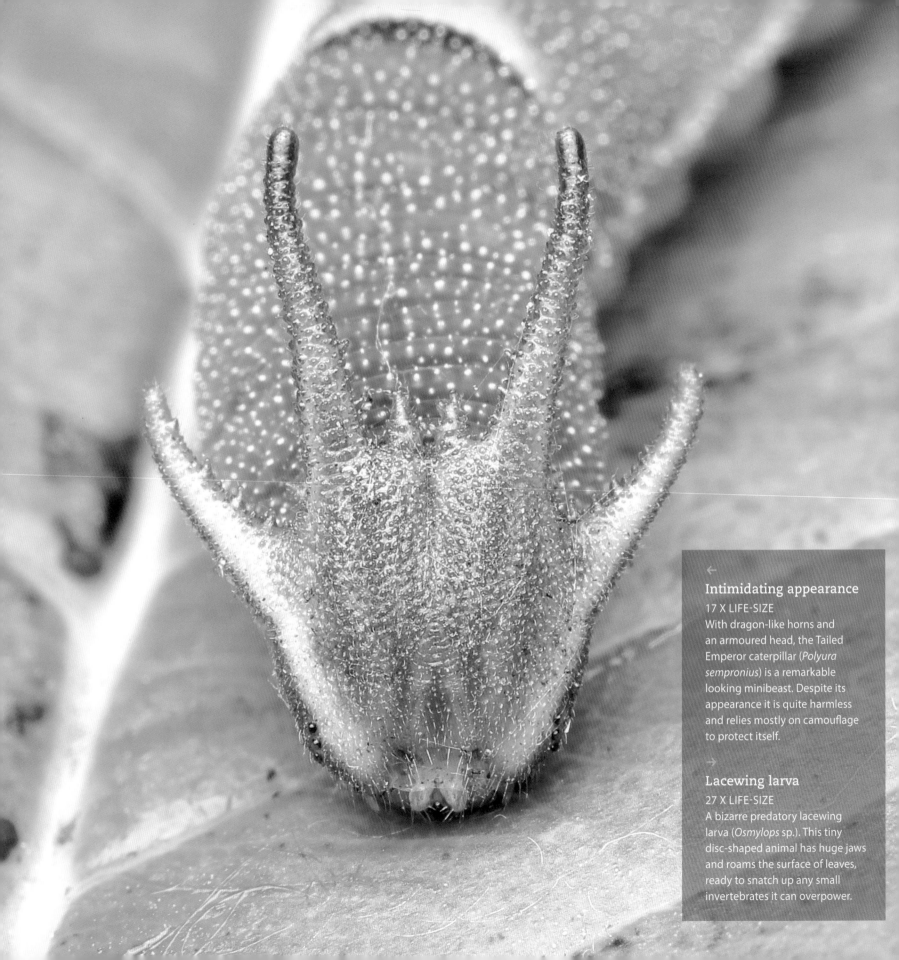

Intimidating appearance
17 X LIFE-SIZE
With dragon-like horns and an armoured head, the Tailed Emperor caterpillar (*Polyura sempronius*) is a remarkable looking minibeast. Despite its appearance it is quite harmless and relies mostly on camouflage to protect itself.

Lacewing larva
27 X LIFE-SIZE
A bizarre predatory lacewing larva (*Osmylops* sp.). This tiny disc-shaped animal has huge jaws and roams the surface of leaves, ready to snatch up any small invertebrates it can overpower.

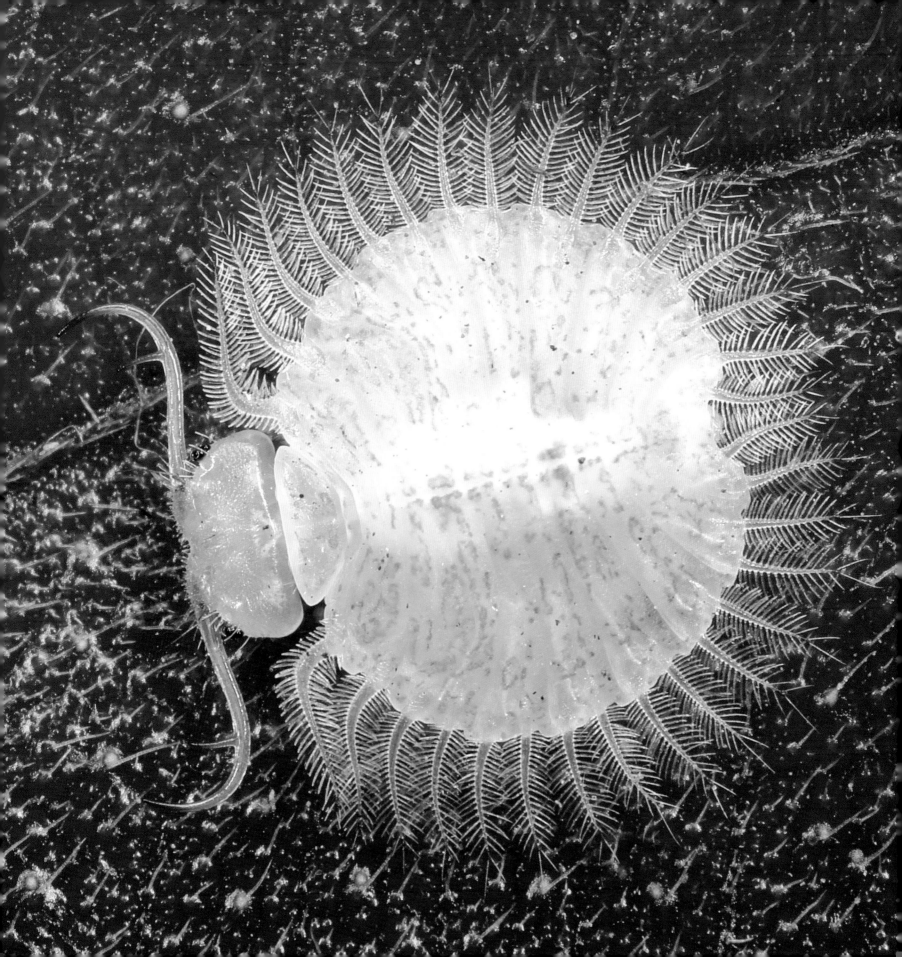

MINIBEASTS

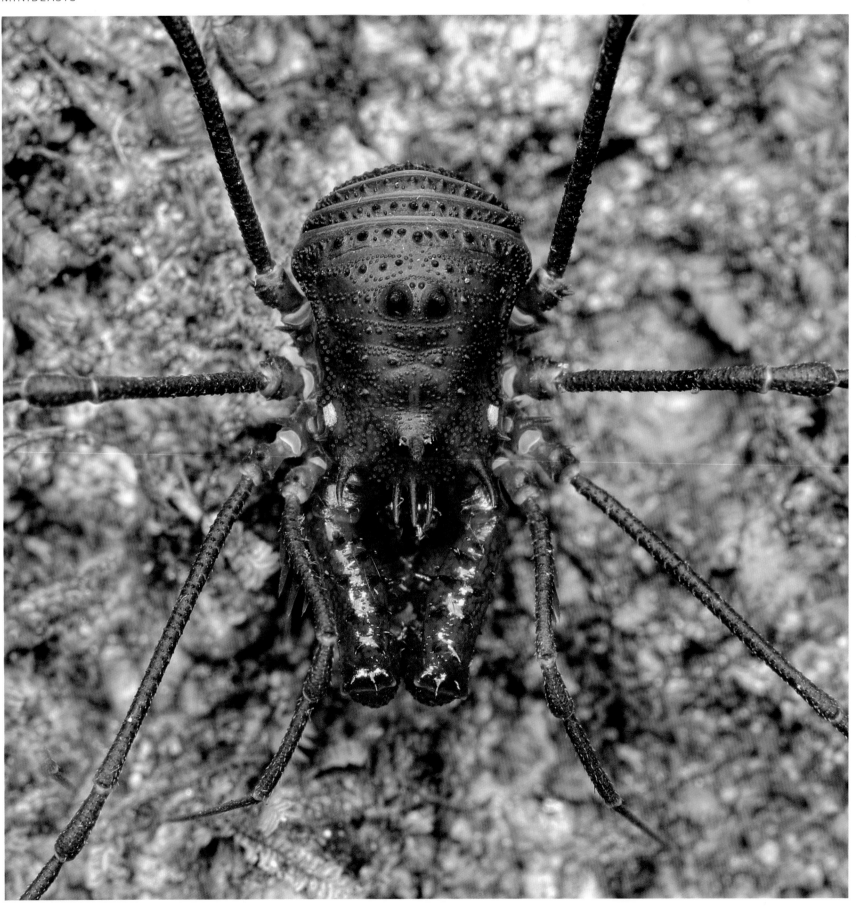

SHAPE AND FORM

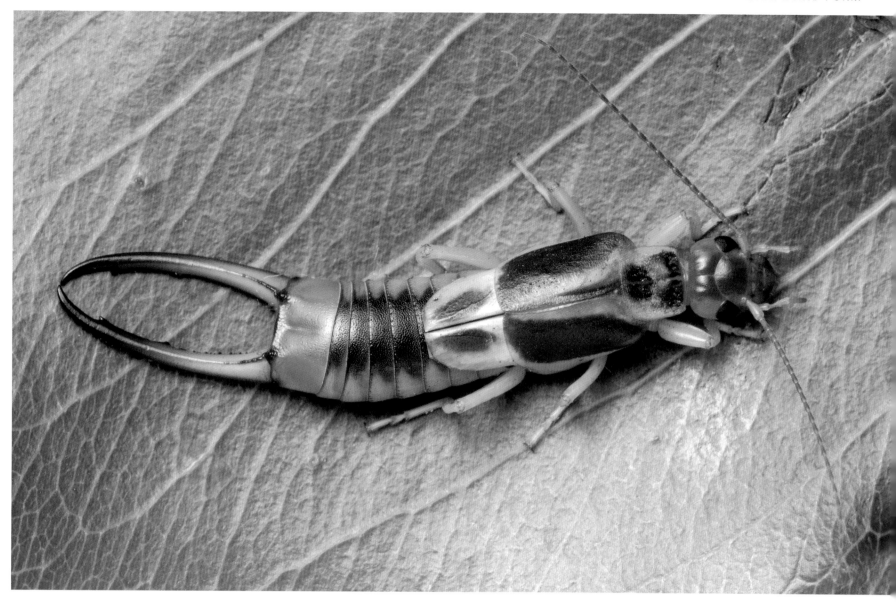

↑
Earwig
8 X LIFE-SIZE
Contrary to popular belief, earwigs (Dermaptera) don't get into our ears. Many species are scavengers, some feed on pollen (and pollinate plants in the process), while others are predators feeding on other small invertebrates. The pincers are called the cerci and may be used to defend the earwig against predators. Male earwigs usually have larger pincers than females.

←
Harvestman
23 X LIFE-SIZE
A creature ready-made for a sci-fi movie. This is a Harvestman (*Opiliones*), a non-venomous arachnid and a cousin to spiders and scorpions. It roams the forest at night on its long legs, hunting and scavenging for food. It has pincer-like mouthparts and a hard-armoured body studded with spines.

5
LIFE ON THE WING

The earliest fossil record of insect wings belongs to a mayfly-like creature and dates back around 310 million years. The evolution of wings and flight was a monumental step in the ability of insects to disperse and make use of new habitats, slotting themselves into new environmental niches. Insects are the only group of minibeasts that have acquired the ability to fly. Flight opened up a whole new world of opportunities for insects, and since then they have blossomed into myriad shapes and forms. No longer were they limited to crawling on the ground, but could now travel long distances, gather more resources in less time and reach areas previously inaccessible. The sky was the limit.

Most insects have two pairs of wings: the forewings and the hindwings. Flies are an exception to this, having only one pair of flying wings; their hindwings have been reduced to small balancing organs called halteres, which aid stability in flight. Other groups of insects have lost the use of the forewings, which have become coverings that protect the delicate hind wings from damage when not in use. Grasshoppers, crickets and some cockroaches have such wing cases. The ultimate development in wing protection, however, belongs to the beetles; their forewings have become thick armoured plates called elytra, allowing beetles to become the most versatile winged insects on Earth.

Not all insect wings work in the same way. Dragonflies, damselflies and mayflies — the earliest insects to evolve wings — have flight muscles that connect directly to their wings. Their wings flap once for every muscle contraction. All other winged insects have muscles that connect to the thorax, distorting it and causing the wings to beat as a result. Some have evolved further, to the point where each single nerve pulse causes multiple muscle contractions. These insects can beat their wings much faster than their more primitive cousins.

Regardless of the type of wings they have and the way in which they work, each species of winged insect has perfect wings for the role they perform, many of which, either directly or indirectly, are of benefit to us.

Many flowering plants, including our agricultural crops, depend almost entirely on myriad winged insect pollinators for their survival. While the role of bees is well known, there are many other flying insects that pollinate these plants, some of which have very specific relationships with certain types of plant. Flies, butterflies, moths, beetles, crickets and even flying cockroaches moving from flower to flower cause the transfer of pollen. Without these insects, we simply could not produce enough food to meet our ever-growing demands.

The feats insects achieve through flight is incredible. Flies and butterflies have been recorded at heights of around 6000 metres (3.7 miles). While controversy rages over who holds the speed record, a Horsefly (*Hybomitra hinei*) apparently can travel at speeds up to 145 kilometres per hour (90 miles per hour). Dragonflies receive an honourable mention, clocking in at close to 100 kilometres per hour (62 miles per hour).

Insect wings can have other functions, too. Some use their wings as banners to communicate via colour and pattern, whether to warn off predators or attract a mate. Some use them as camouflaged 'cloaks' which hide them from predators while at rest. And some, most remarkably, use them to generate sound. Crickets and katydids rub together serrations on their wings for the purpose of communication. Males 'call' to females using their wings as instruments, each species having a particular frequency and style. This enables willing females to identify and locate mates among a cacophony of other insect sounds.

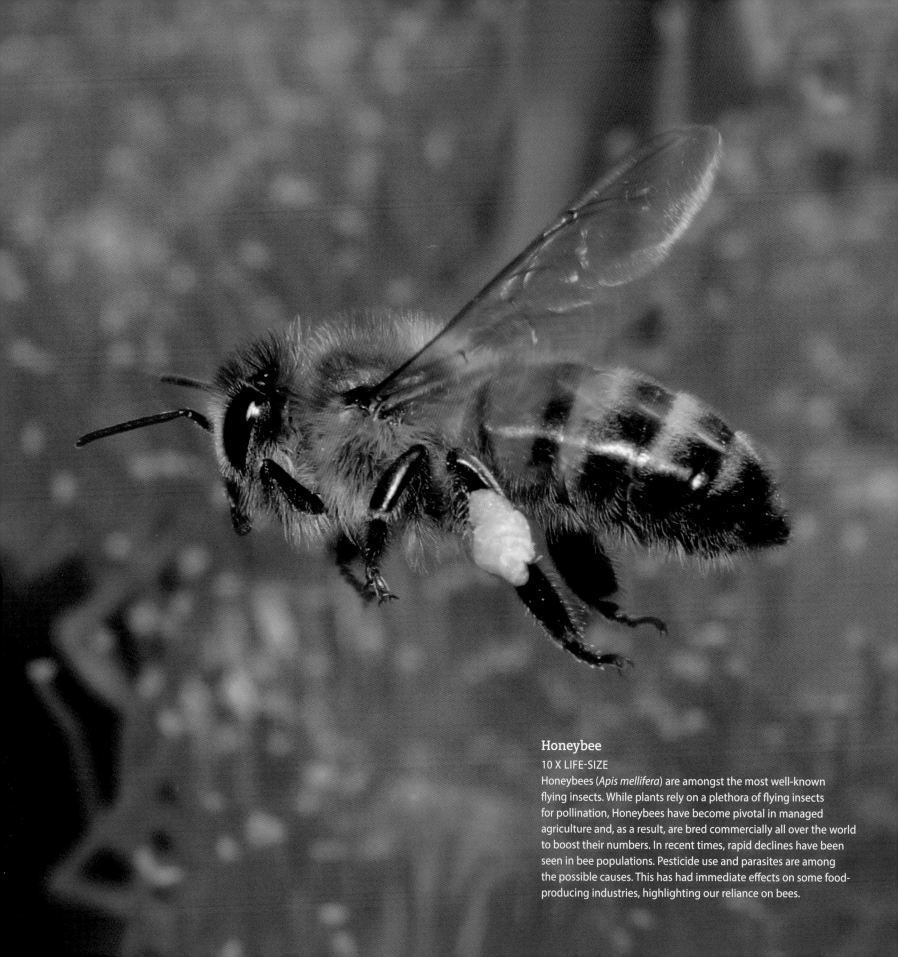

Honeybee

10 X LIFE-SIZE

Honeybees (*Apis mellifera*) are amongst the most well-known flying insects. While plants rely on a plethora of flying insects for pollination, Honeybees have become pivotal in managed agriculture and, as a result, are bred commercially all over the world to boost their numbers. In recent times, rapid declines have been seen in bee populations. Pesticide use and parasites are among the possible causes. This has had immediate effects on some food-producing industries, highlighting our reliance on bees.

Precision fliers
3 X LIFE-SIZE
Damselflies (Zygoptera) are dainty cousins to dragonflies. They have two pairs of large wings that are held folded above the body while not in use. These insects are able to pursue and catch smaller insects in flight and have great precision and maneuverability. Their wings are the subject of significant aerodynamic study, inspiring designs in robotic flight craft and wind turbine blades.

Well protected wings
3.6 X LIFE-SIZE
Beetles have two pairs of wings. The forewings have evolved into hard, protective covers called elytra that protect the hindwings while not in flight. This Christmas Beetle (*Anoplognathus boisduvali*) is in the act of take-off.

LIFE ON THE WING

Assassin in the sky
4.5 X LIFE-SIZE
Assassin Flies (Asilidae) are airborne hunters that pluck their victims out of the air or off leaves. They sit, wait and watch for passing prey with their massive eyes on full alert. Once their prey is spotted, the Assassin Fly takes to the air in pursuit. With superior speed and precision, it captures the insect and kills it with a lethal injection. This one has captured a blowfly.

Flies

PHOTO 1: 5 X LIFE-SIZE;
PHOTO 2: 13 X LIFE-SIZE

Flies (Diptera) have a single pair of wings. Their hindwings have evolved into small oscillating organs called halteres, which provide stability during flight. These organs are very obvious on the Crane Fly (Tipulidae) (photo 1), but are hidden in species such as this blue rainforest fly (photo 2).

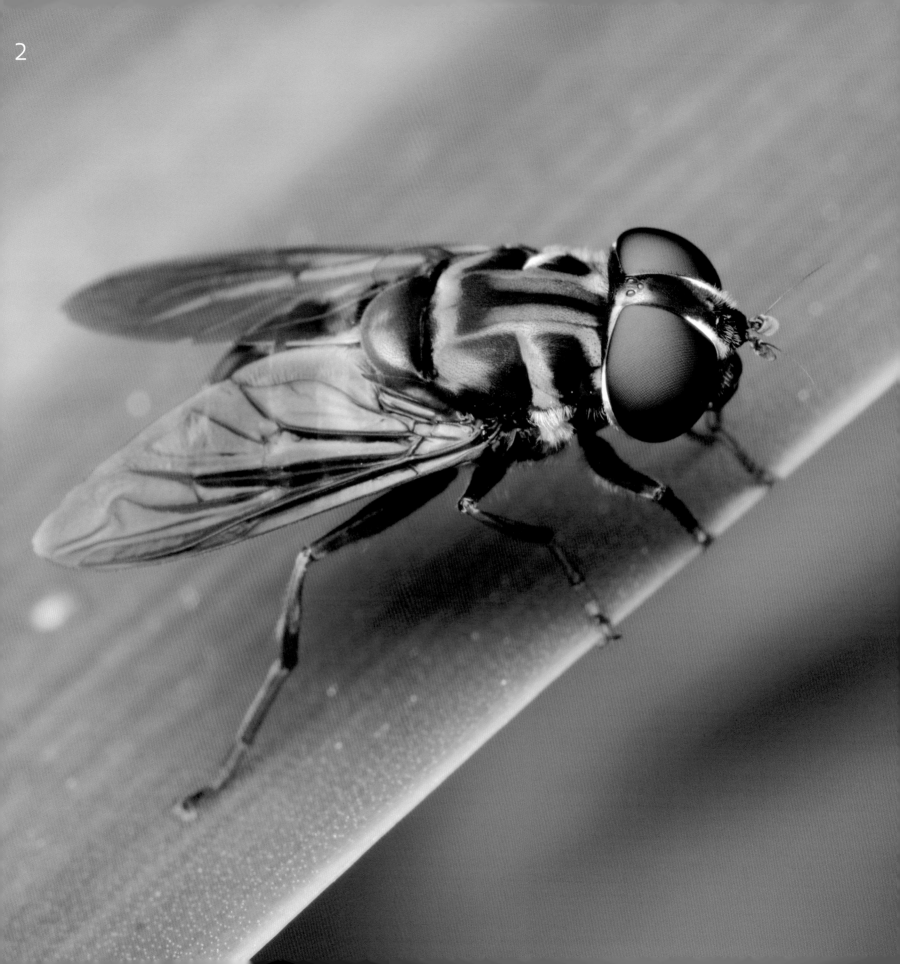

Dragonfly wing

4.5 X LIFE-SIZE

Insect wings are incredibly varied in their structure, size and appearance. They have a number of veins running through them, which initially function to expand the soft wings when the insect matures. After setting hard, the veins provide the structural integrity the wings require to fly. Many insects with clear wings have microscopic structures within them that refract light, causing iridescent colours to be seen when viewed against dark backgrounds. Research suggests that these patterns are unique to each species and may be part of their visual communication.

Dragonfly
1.5 X LIFE-SIZE
Dragonflies (Anisoptera) are aerial masters and were among some of the earliest flying insects to evolve, around 300 million years ago. They have two pairs of large wings, giving them excellent speed and maneuverability in order to catch their prey.

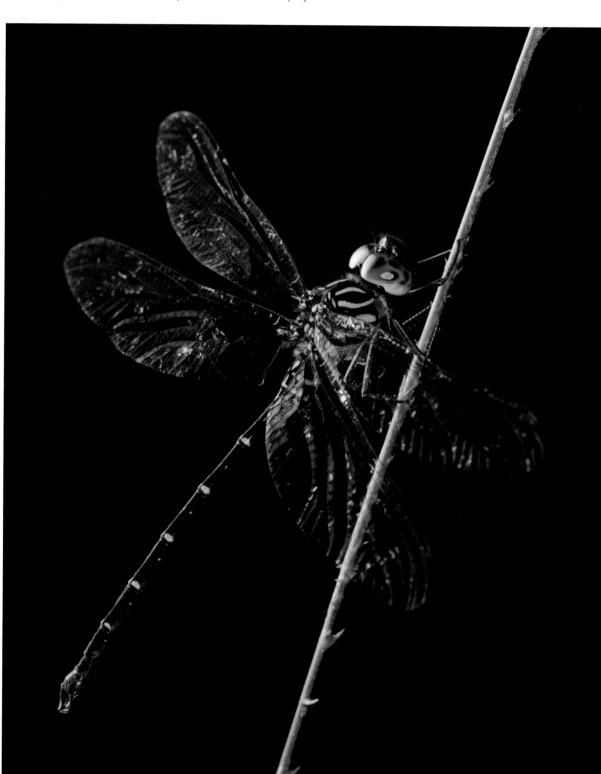

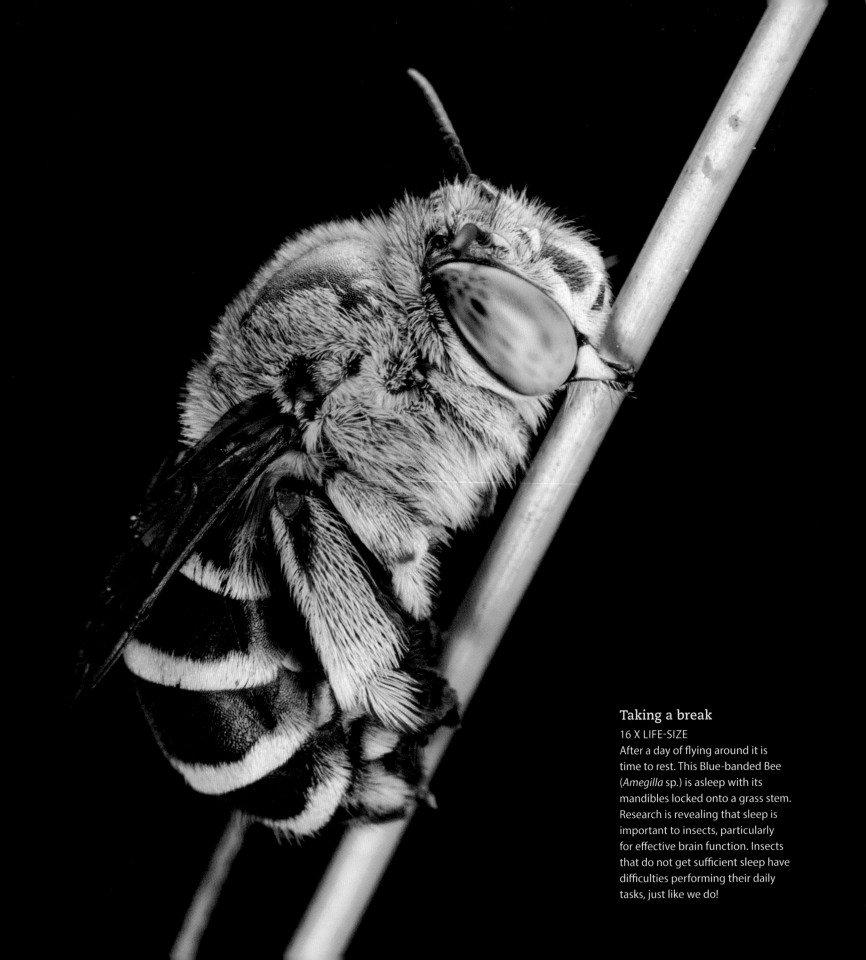

Taking a break

16 X LIFE-SIZE

After a day of flying around it is time to rest. This Blue-banded Bee (*Amegilla* sp.) is asleep with its mandibles locked onto a grass stem. Research is revealing that sleep is important to insects, particularly for effective brain function. Insects that do not get sufficient sleep have difficulties performing their daily tasks, just like we do!

Winged communicators
4 X LIFE-SIZE

Wings are not just for flying. This male Balloon-winged Katydid (*Hexacentrus mundurra*) uses his wings to call to females. He rubs structures on the top of his left forewing over the other to create a loud 'zeek zeek' sound, a process called stridulation. The shape and air space within the forewings assist to amplify the call, making the sound travel a significant distance.

Cairns Birdwing Butterfly
0.8 X LIFE-SIZE

This stunning set of wings belongs to a Cairns Birdwing Butterfly (*Ornithoptera euphorion*). Butterflies and their close relatives, the moths, have thousands of minute scales covering their wings. The scales have several functions: most notably, they enable colour and patterns to be displayed on the wings. The tiny scales can also be shed easily, making it easier to escape from sticky spider webs.

6

FACE TO FACE

Minibeasts have extraordinary faces. Some we can easily see, others are so different to what we are used to that it can be hard to even tell where their faces are! They are often described as alien-like, which is an interesting way of putting it since our most famous 'aliens' are often based on minibeasts themselves. Many Hollywood blockbusters have drawn directly from our very own earthly invertebrates to create their monsters from deep space. Classic films such as *Predator* and *Starship Troopers* feature alien creatures with facial anatomy based on living minibeasts. Multiple eyes, jagged mandibles, and piercing and sucking mouthparts all serve to make the Hollywood creations more chilling.

We humans are very visual creatures, particularly in the way we communicate. It is natural for us to make eye contact with other people and we carry this visual habit through when we engage with other animals. When it comes to looking at minibeasts, though, we might find it hard to meet their eyes, which might not be prominent, might sit in odd positions or be more numerous than we are expecting (or not there at all). That can mess with our heads a little!

We often subconsciously anthropomorphize minibeasts, too. Many people find minibeasts with well-defined faces and eyes more appealing, and perhaps as a result are more accepting of those animals. Praying mantises are one of the best examples. Their two large, engaging eyes give us the sense that they are curious, charismatic and full of personality. They are some of the best-loved minibeasts, probably for this reason — but this kind of interpretation is often far removed from reality. In fact, praying mantises are brutal predators, taking their prey by force and devouring it live. Conversely, many far more benign invertebrates have strange, inhuman faces and are generally perceived as far more horrifying than the brutal praying mantis.

So what is the face of a minibeast? Some have mouths and eyes on different sides of their heads. Some lack eyes, and some even lack mouthparts. Those with mouthparts don't always have an obvious opening or mouth as we know it. Some have a rostrum, a needle-like mouthpart that may be used to inject venom or digestive juices and to suck fluids out of their food. While their faces serve many of the same purposes that ours do, some of the key things we have on our faces are lacking on minibeasts. A nose, for instance, is something you will not find on the face of a minibeast. While antennae do sense airborne particles like our nose does, they do not breathe through any such opening on their face. Minibeasts such as insects and spiders have small openings on their bodies that enable air to be taken in, so they cannot drown with just their head underwater. The faces of these animals, like all their other assets, are merely aspects of their anatomy required to survive. Like their other body parts, their faces are perfectly evolved features that enable them to survive within their environment.

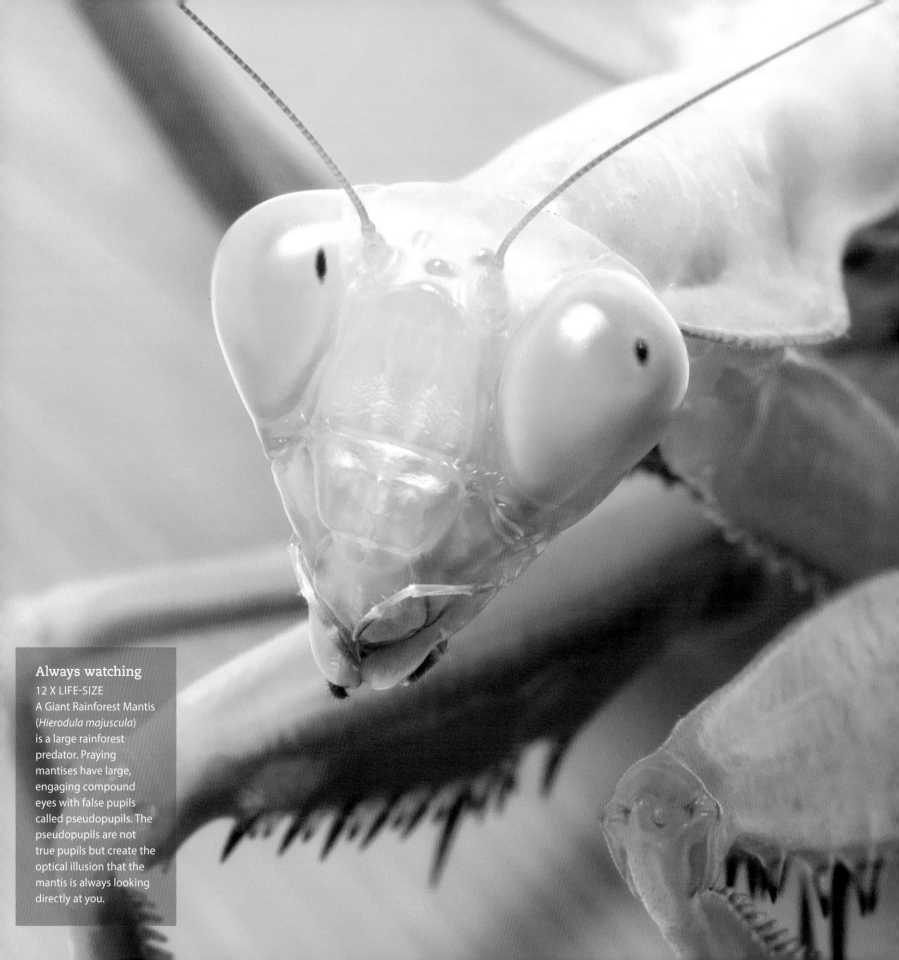

Always watching

12 X LIFE-SIZE
A Giant Rainforest Mantis (*Hierodula majuscula*) is a large rainforest predator. Praying mantises have large, engaging compound eyes with false pupils called pseudopupils. The pseudopupils are not true pupils but create the optical illusion that the mantis is always looking directly at you.

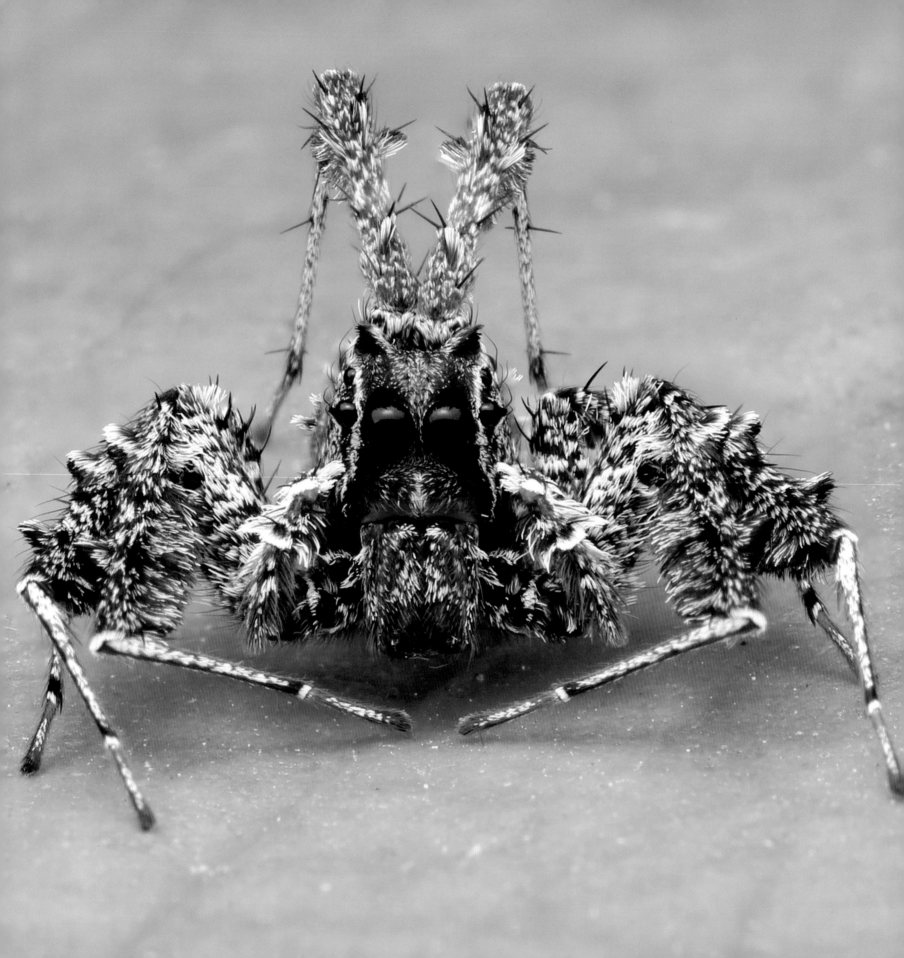

FACE TO FACE

←
The smart spider
25 X LIFE-SIZE
The face of the most intelligent spider on Earth. Portia (*Portia fimbriata*) is a jumping spider. It is a specialist spider assassin and can solve an array of problems it may encounter while stalking its prey. It can modify its tactics if they are not working, and uses different techniques to attack different species of spiders.

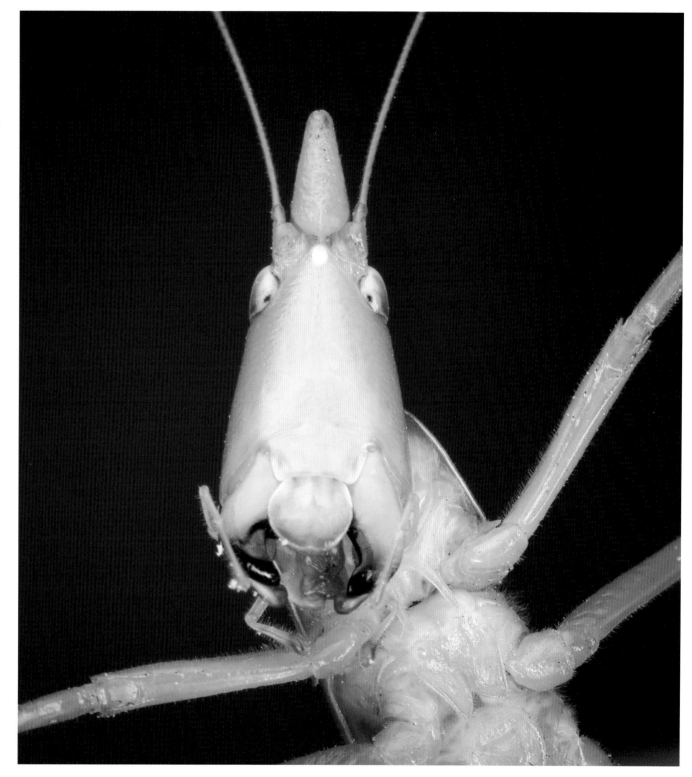

→
Why the long face?
8.5 X LIFE-SIZE
This seed-eating katydid (*Pseudorhynchus lessonii*) has an elongated head and body, allowing it to lay flat along grass stems to hide. It has powerful mandibles for crushing hard seeds — mandibles also quite useful as a defensive measure against predators.

MINIBEASTS

↓
Fuzzy features
4.5 X LIFE-SIZE
While many moths don't have very engaging faces, this Northern Emperor Moth (*Syntherata escarlata*) could steal the show. The fuzzy hair, large compound eyes and somewhat stylish antennae all complete an appealing look. The one thing missing here is a mouth. This moth belongs to a family of moths that don't feed as adults. All the feeding and growth takes place during the caterpillar stage; the adults live short lives with the sole objective of breeding.

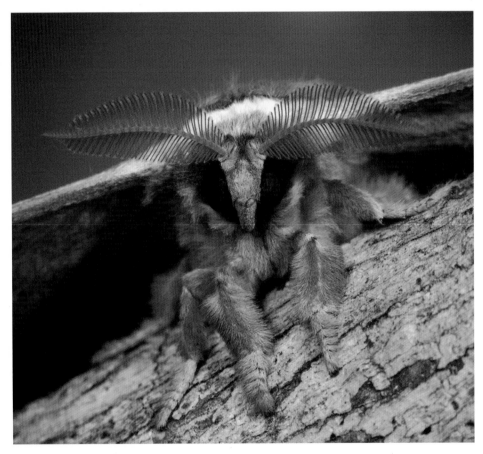

→
Spectacular weapons
11 X LIFE-SIZE
A face like a true sci-fi monster. This is an Amblypygid, commonly known as a Whip Spider. These non-venomous arachnids use their serious weaponry to snatch and grab other invertebrates. While at rest they hold their lethal equipment in front of their face. They sense their world primarily through a pair of extremely long legs which act as antennae. Their tiny eyes provide them with only basic vision.

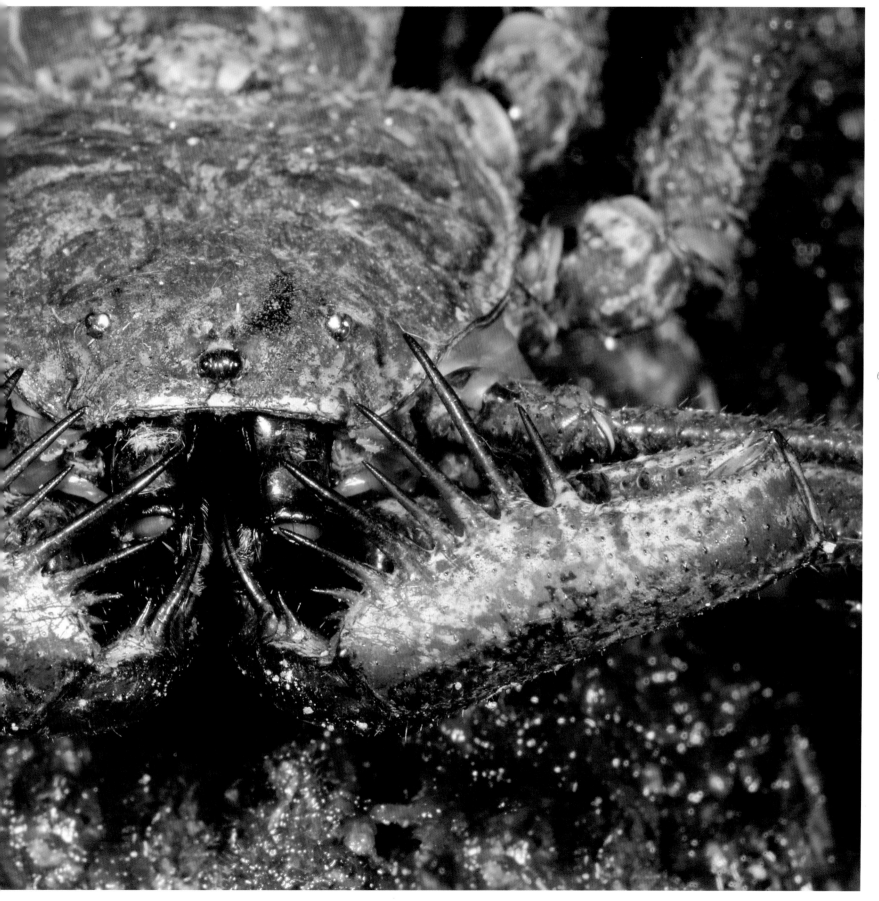

MINIBEASTS

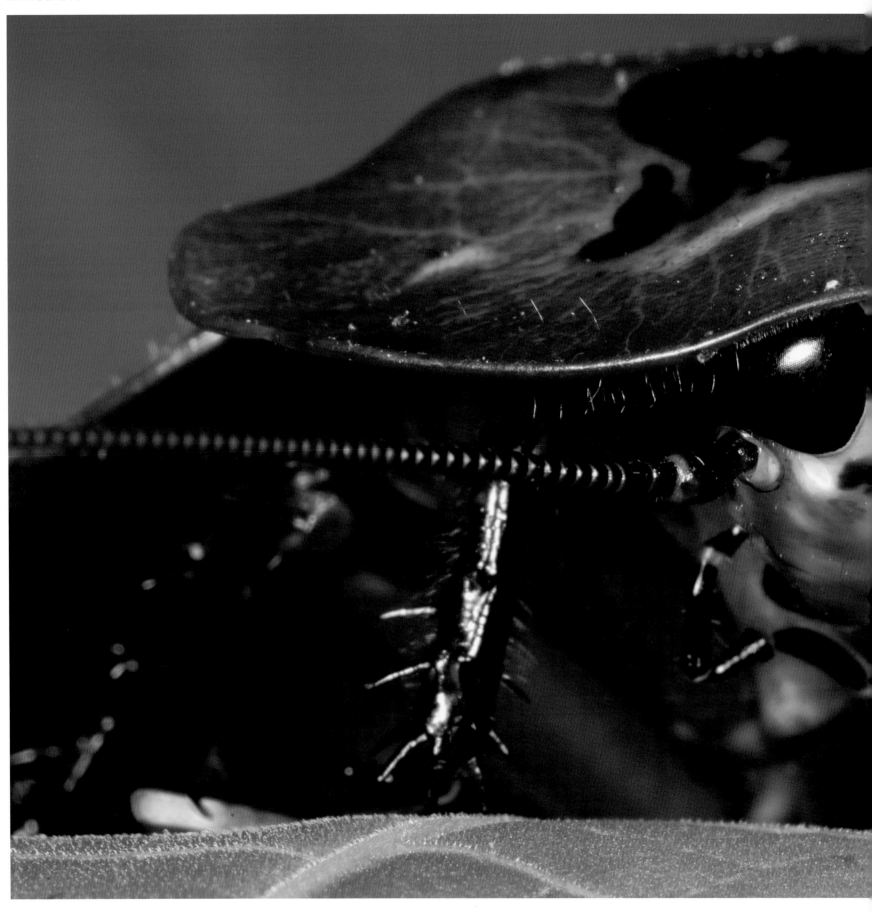

FACE TO FACE

Well-armoured
10 X LIFE-SIZE
Peeking out from beneath its protective armour, this Giant Cockroach (*Blaberus* sp.) checks out the world. The large black compound eyes are situated on the top of the head so they can see forwards while still maintaining a low profile.

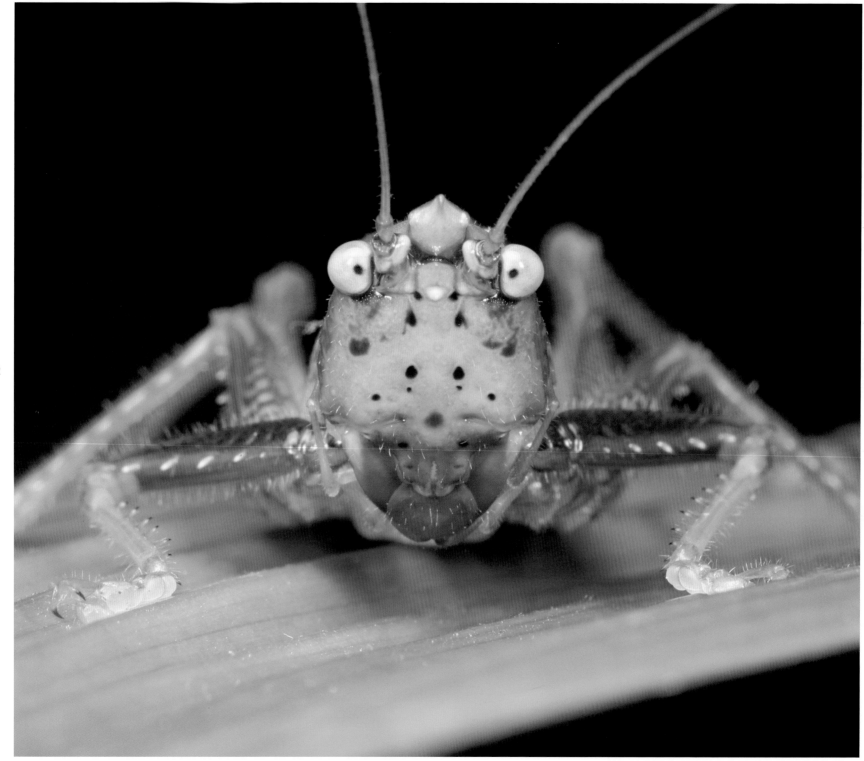

Conehead Katydid
6 X LIFE-SIZE
The inquisitive face of a Conehead Katydid (Copiphorini). They have large mandibles which are well suited to a diet of seed eating. Some are opportunistic predators, tackling prey such as caterpillars with their spiny front legs.

FACE TO FACE

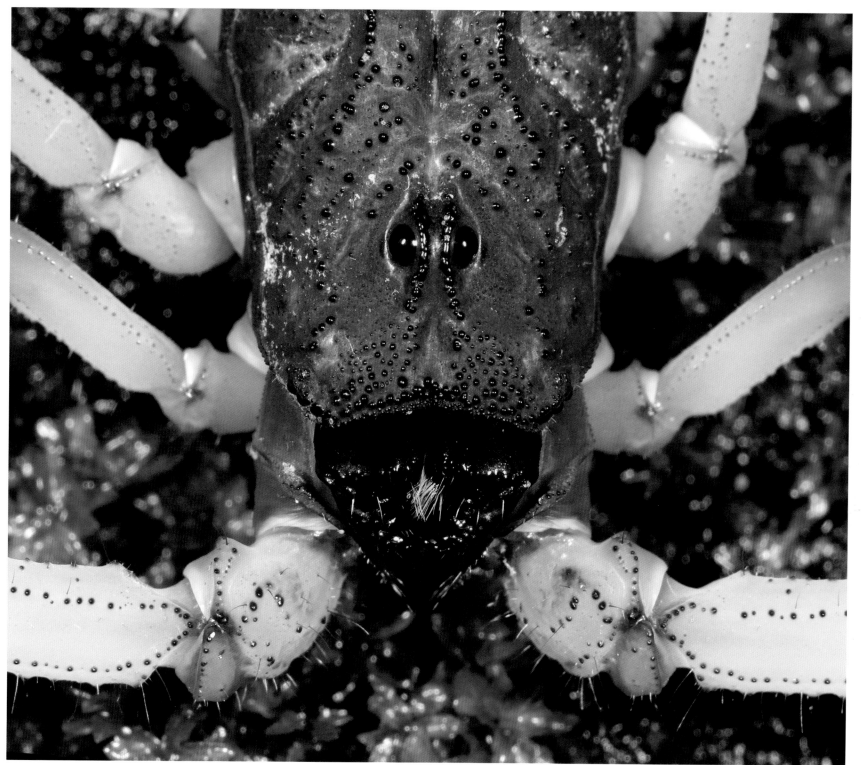

Black-tailed scorpion
9 X LIFE-SIZE
The face of a scorpion is best viewed from above. They have relatively small eyes and as a result their vision is quite limited. This species (*Centruroides bicolor*) has two larger eyes in the centre of the head and three small eyes on the angled margins towards the front. The mouthparts are like mini-claws that crush and tear up their prey prior to ingestion.

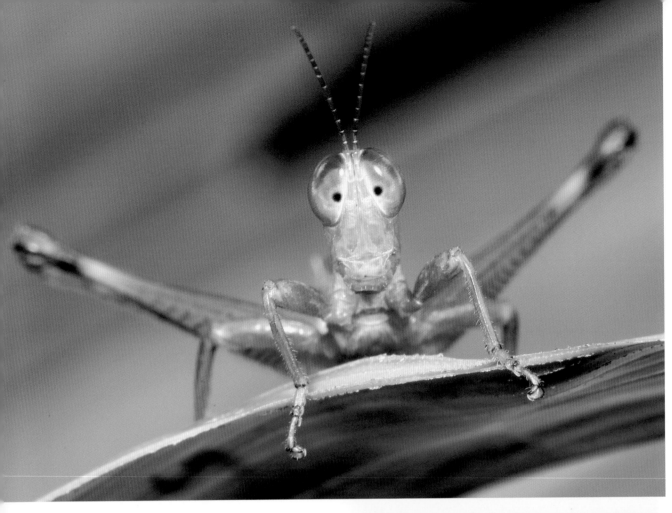

→

Sharp features
10 X LIFE-SIZE
Longicorn Beetles (Cerambycidae) are wood-boring beetles. Their powerful mandibles dominate their face, along with a pair of large compound eyes. They are the bolt-cutters of the minibeast world, with the ability to make short work of hard timber.

↑

All eyes
8.5 X LIFE-SIZE
A tiny Monkey Grasshopper (*Biroella* sp.) only 15 millimetres (1/2 inch) long, peeps over a leaf. Its huge eyes provide it with a great field of view, enabling it to see predators coming and take evasive action if required. This group of grasshoppers is found in jungles throughout the world.

→

Feed me
3.3 X LIFE-SIZE
A Northern Emperor Moth caterpillar (*Syntherata escarlata*) has the face of an eating machine. Caterpillars usually have quite small heads in comparison to their large expandable bodies. Their purpose is to eat and grow as quickly as possible to prepare for pupation into the mature stage.

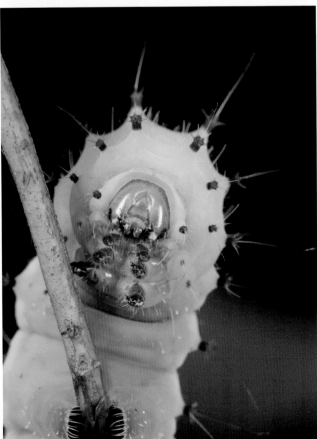

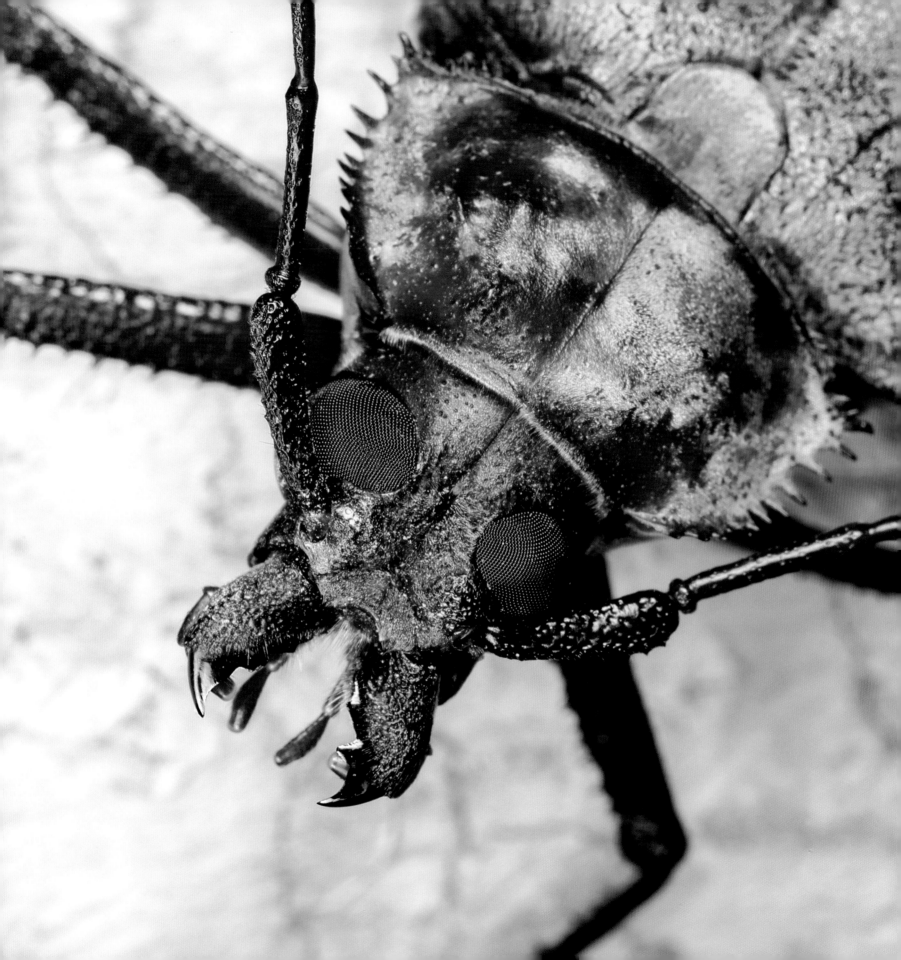

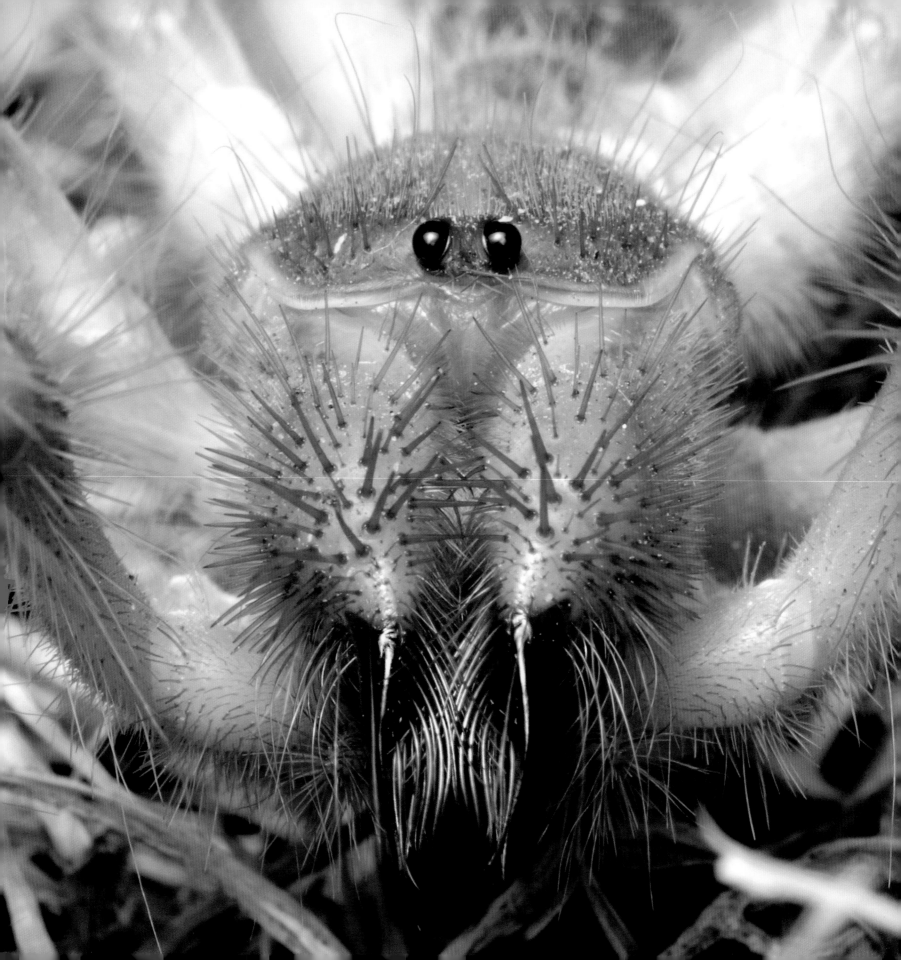

A hairy stare
13.5 X LIFE-SIZE
A Solifugid (Solifugae) is an energetic predatory arachnid — a non-venomous relative to scorpions and spiders. These animals have large pincer-like jaws (chelicerae) which are very powerful tools for cutting through their food.

Precision jumper
30 X LIFE-SIZE
Very few spiders have faces as engaging as the Green Jumping Spider (*Mopsus mormon*). Jumping spiders have eight eyes, forming a ring around their head that provides them with an almost 360-degree view. The two largest eyes face forward and provide the spider with great visual detail. The smaller forward-facing eyes assist the spider to judge distance.

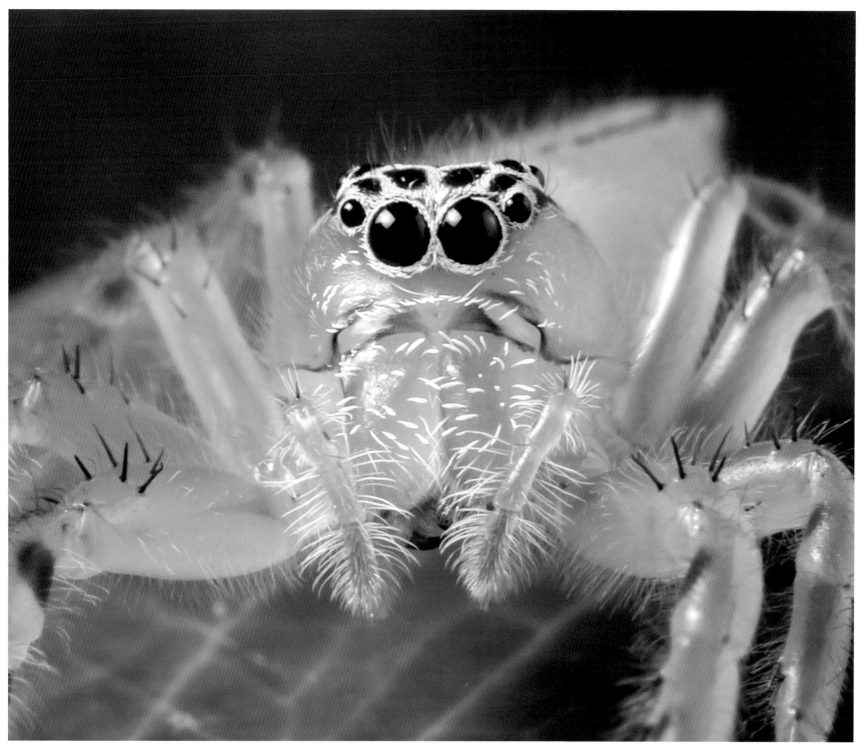

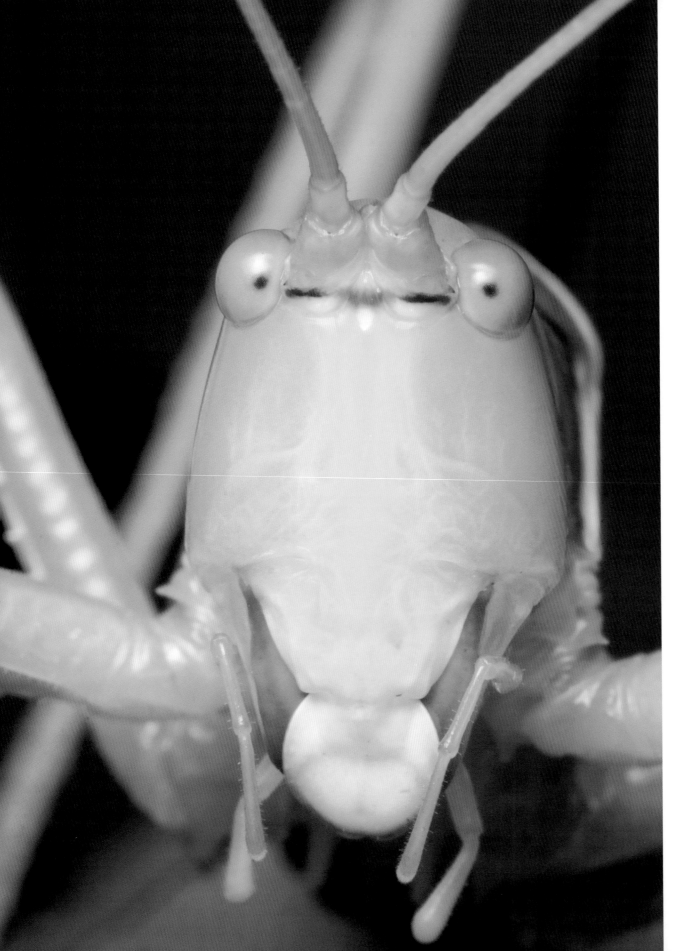

Mischievous intentions
10 X LIFE-SIZE
This happy-looking katydid is actually a smiling assassin. The Gum-leaf Katydid (*Terpandrus woodgeri*) is a fearsome predator able to catch and dismember insects as large as itself. It uses a combination of vision and chemical sensing via its antennae to detect its prey.

Eyes of the wolf
16 X LIFE-SIZE
Wolf Spiders (Lycosidae) are fast-moving hunters that run down their prey. They have excellent eyesight with six forward facing eyes and another two large eyes on the back of the head, giving them extensive visual coverage.

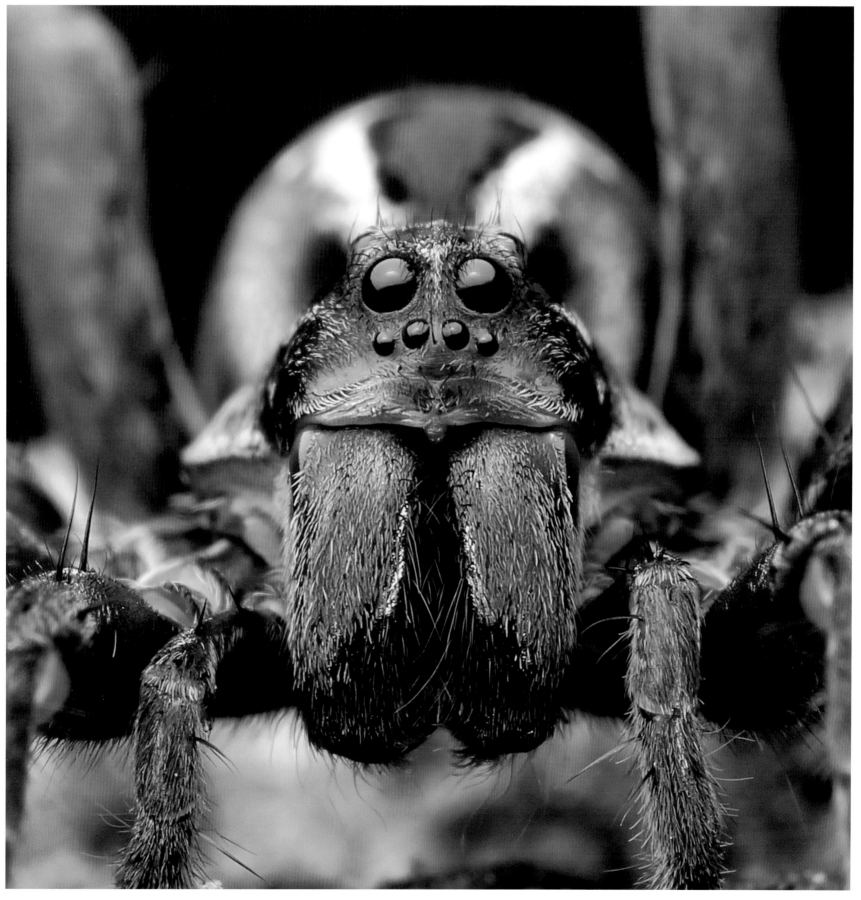

NOW YOU SEE ME

The ability to hide in plain view is something that has always amazed me, and there are some incredible examples in the minibeast world. While touring people through the rainforest, I often play a little game and wander right up to a cryptic minibeast. One of my favourites is the Lichen Huntsman (*Pandercetes gracilis*), a spider that blends in superbly with lichen-covered tree trunks. Without drawing too much attention to it I'll wait and see if anyone can spot it. Usually most can't without some assistance, which often makes for a fantastic 'reveal' experience for all on the tour.

Camouflage is a term we are all relatively familiar with. It enables an animal to hide. The purpose of hiding is quite simple: to avoid being eaten. For minibeasts that are predators themselves, there is an additional layer of utility to staying hidden — it can be both a form of protection and a way to ambush your own prey. Camouflage, however, is more than just stripes and spots. Colour and pattern are important ingredients when 'disappearing' into the background, but variations in shape and form bring another dimension to camouflage entirely.

Blending with the surroundings often relies just as much on the ability to break up the outline and shape as it does on matching the habitat colour. The Lichen Huntsman, like many minibeasts, has evolved a method to do this which uses clusters of protruding hairs. The thick clusters of hairs distort the visual outline of the spider and also soften the shadow created by the animal on the background upon which it sits, thus allowing almost seamless blending.

Some minibeasts have evolved to physically mimic objects in their environment. Leaf mimics are extremely common, and we often don't spot them unless they are out of their habitat and much more obvious. Many katydids, grasshoppers, mantises and phasmids have wings that match the shape, colour and texture of the leaves and grasses they live amongst. Some Leaf Insects (*Phyllium* sp.) have truly amazing camouflage that almost perfectly resembles live green leaves — some even have what appears to be insect 'chew marks' on them to complete the façade.

There are myriad species of stick insects that look just like twigs and small branches complete with knots, bumps and apparent broken parts. Some even look like seed pods and curled bark.

Just when you think you have seen it all, a select group of minibeasts has taken things even further in order to be overlooked. Bird poo is an item most predators certainly don't want a mouthful of — so looking like a piece of excrement is in fact not a bad way to survive. The aptly named Bird-dropping Spiders, along with a variety of caterpillars and moths, look exactly like bird droppings — and it allows them to hide in full view.

The best disguise in the world, though, can be ruined the moment the animal moves. For this reason, camouflage doesn't just rely on appearance; it also involves behaviour. Most minibeasts using camouflage move in a way that enhances their ruse rather than blowing their cover. Many species sway back and forth when they walk, just like leaves or debris blowing in the wind. This certainly helps prevent the keen eyes of a hungry bird spotting them.

Like many other aspects of these amazing animals, the ability of minibeasts to conceal themselves in plain sight is something that is being studied for human benefit. One such insect is being touted as the source of inspiration for designing an invisibility cloak. Scientists from Pennsylvania State University are focusing upon a small leaf hopper which has microparticles in its wings that have an incredible capacity to absorb light and render the insect practically invisible to many predators. While an actual invisibility cloak may be a far-fetched idea, the scientists have developed synthetic versions of the particles and see many other more practical applications for them; capturing more light on solar panels to assist with our ever-growing energy demands is one such possibility.

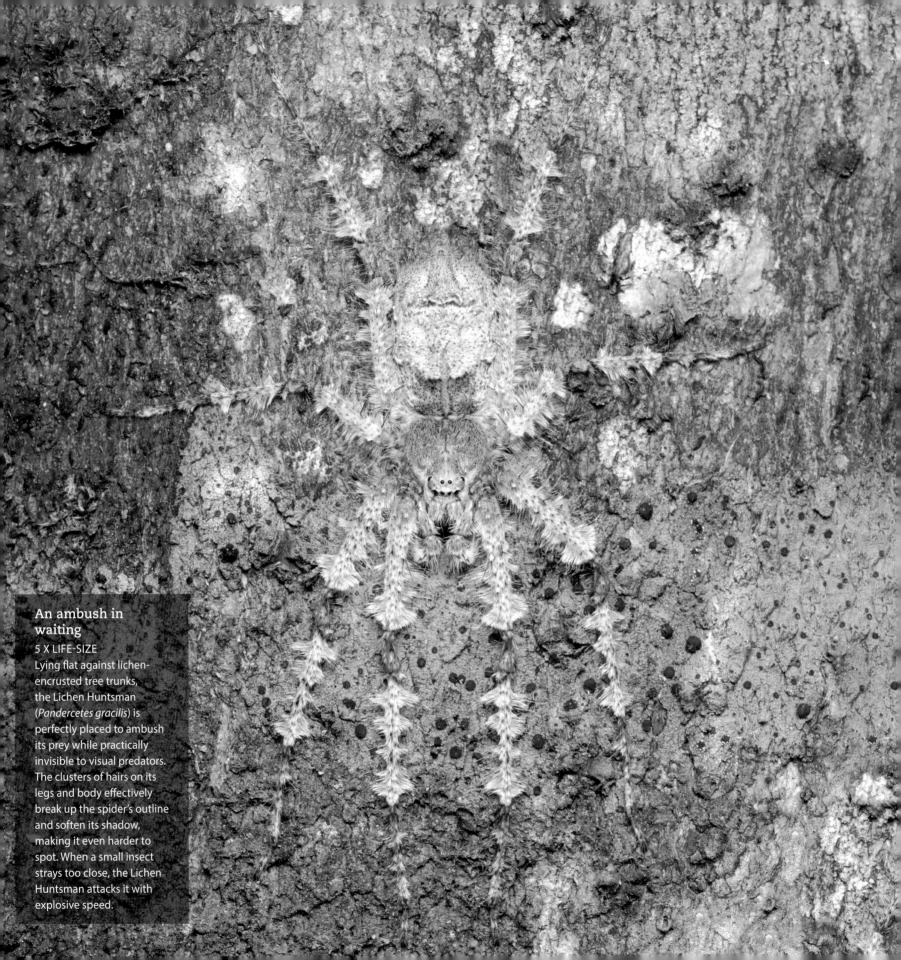

An ambush in waiting

5 X LIFE-SIZE

Lying flat against lichen-encrusted tree trunks, the Lichen Huntsman (*Pandercetes gracilis*) is perfectly placed to ambush its prey while practically invisible to visual predators. The clusters of hairs on its legs and body effectively break up the spider's outline and soften its shadow, making it even harder to spot. When a small insect strays too close, the Lichen Huntsman attacks it with explosive speed.

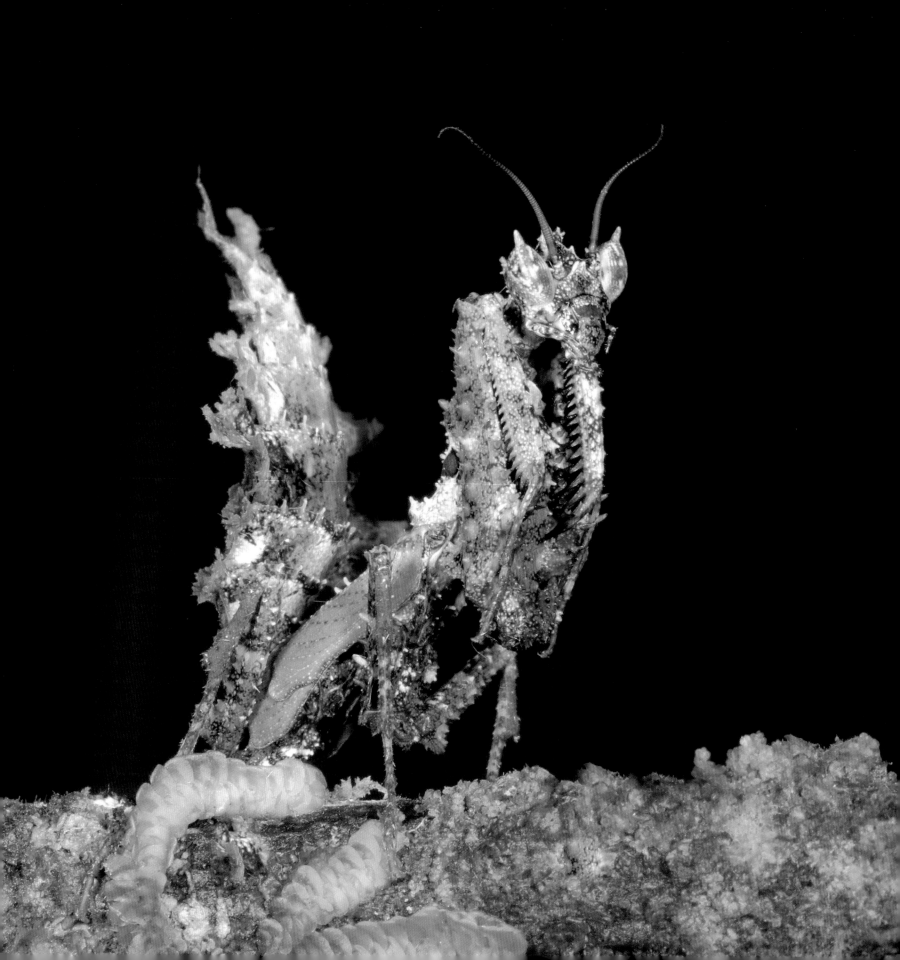

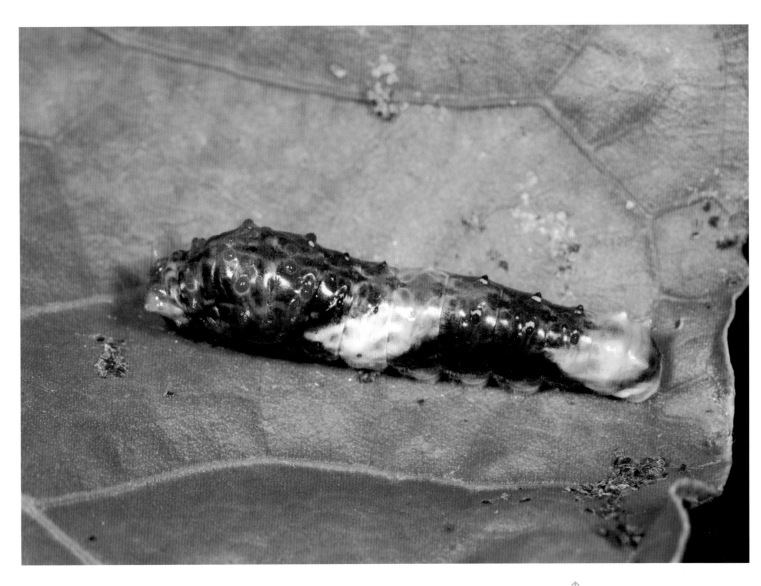

↑
Don't eat that!
4.5 X LIFE-SIZE
A novel way to avoid being eaten by birds is to look like something they've already eaten! This Giant Swallowtail caterpillar (*Papilio cresphontes*) looks enough like a fresh bird dropping to provide a good level of safety in which to sit on leaves in full view.

←
Moss with an appetite
5.5 X LIFE-SIZE
What could easily be mistaken for a twig covered in moss is actually a superbly camouflaged predator. This Moss Mantis (*Pseudocanthops* sp.) from the jungles of Costa Rica hides upon moss-covered branches, perfectly hidden from predators and prey alike.

MINIBEASTS

1

Leaves with legs

PHOTO 1: 3 X LIFE-SIZE;
PHOTO 2: 3 X LIFE-SIZE

Many katydids have evolved to look very much like the leaves on which they live. To avoid too much scrutiny, they usually spend the daylight hours very still, moving and feeding after dark. This Leaf-winged Katydid (*Mastigaphoides* sp.) from Australia looks like a healthy green leaf (photo 1), while the Costa Rican Leaf-mimic Katydid (*Mimetica* sp.) looks more like a fallen damaged leaf (photo 2).

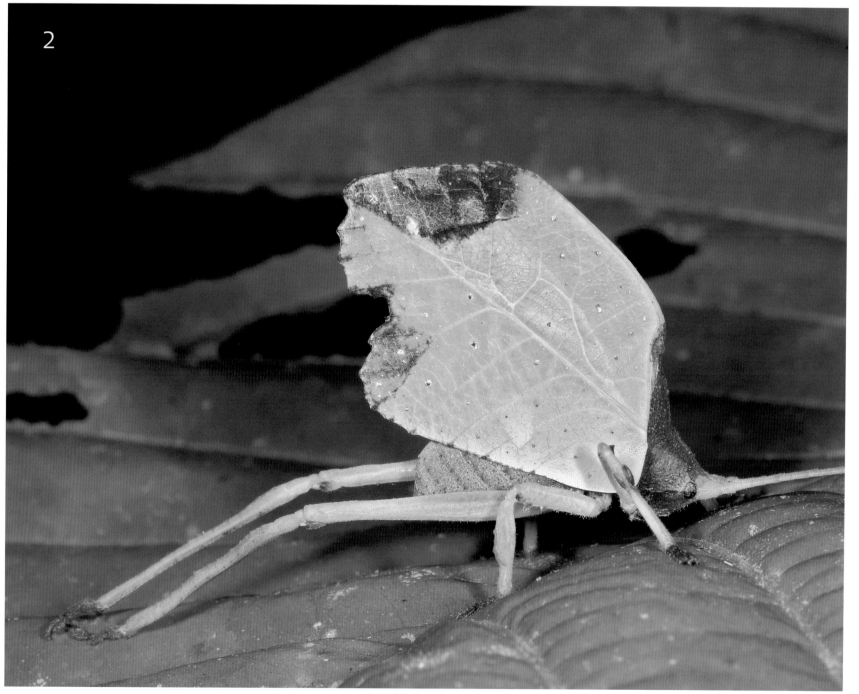

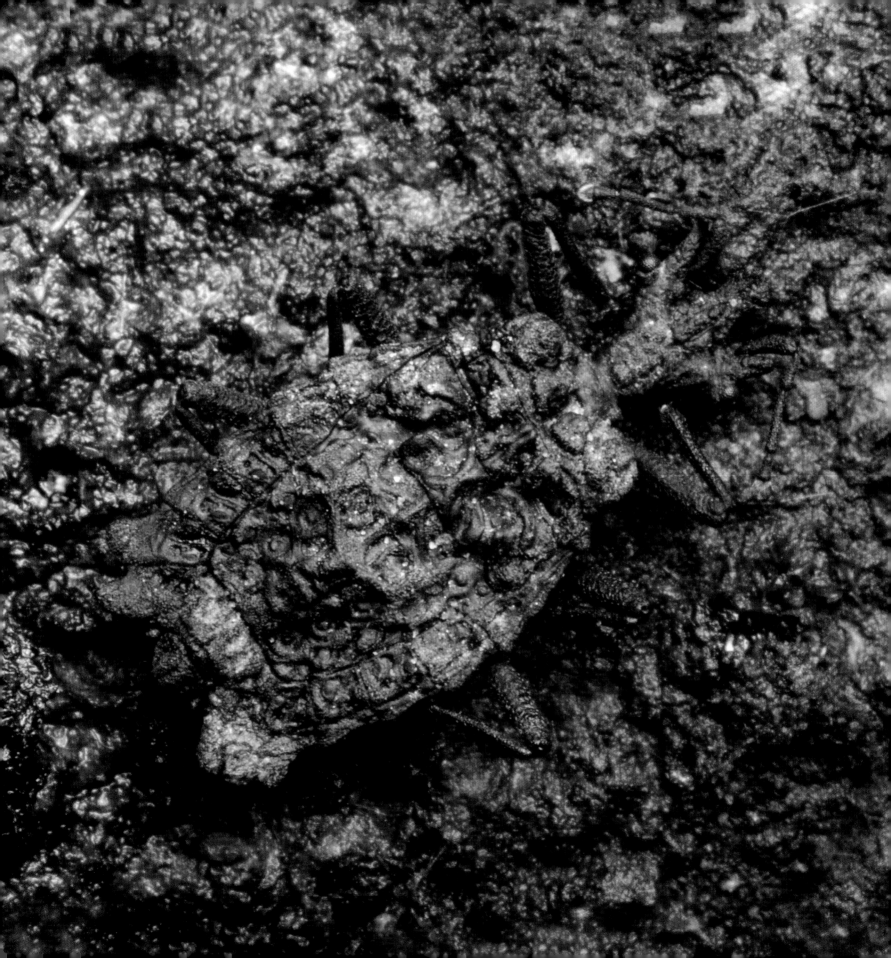

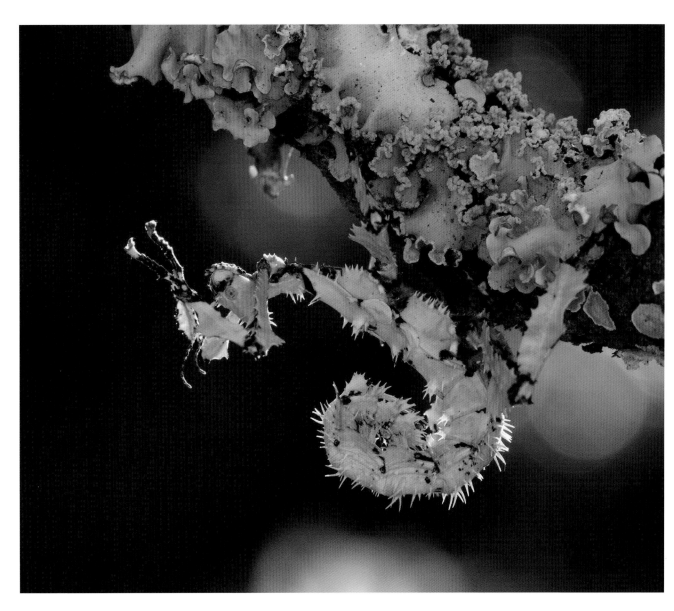

Lichen that camouflage
2 X LIFE-SIZE
Spiny Leaf Insects (*Extatosoma tiaratum*) appear in a wide variety of colour forms. They seem to adapt their camouflage in response to the plants they eat and the environment around them. This particular individual has stunning lichen-like camouflage, making it very hard for predators to spot.

Flat bug
20 X LIFE-SIZE
At ground level, an array of minibeasts cling to rocks and logs with their shape, colour and texture all assisting them to blend in with the background. This tiny Flat Bug (Aradidae) even has debris building up on its back which aids the disguise.

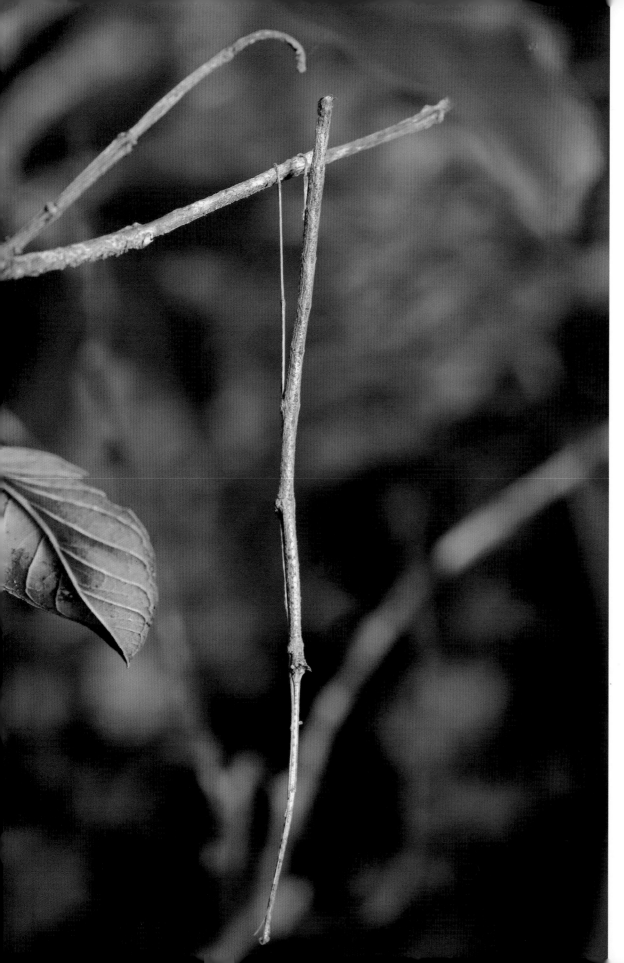

←

Living Twig
1.5 X LIFE-SIZE

A stick insect cannot get more stick-like than this! The Living Twig (*Austrocarausius mercurius*) dangles by the claws on its hind legs while at rest. The rest of its limbs are tucked up neatly against its body.

→

A leaf among leaves
5 X LIFE-SIZE

Leaf insects (*Phyllium* spp.) are truly masters of camouflage. This nymph is very difficult to spot amongst the leaves in which it lives. Its abdomen is flattened and shaped just as the leaves are. When moving, this insect rocks back and forth like leaves in the wind to maintain its concealment, as sudden movements can attract the attention of watchful predators.

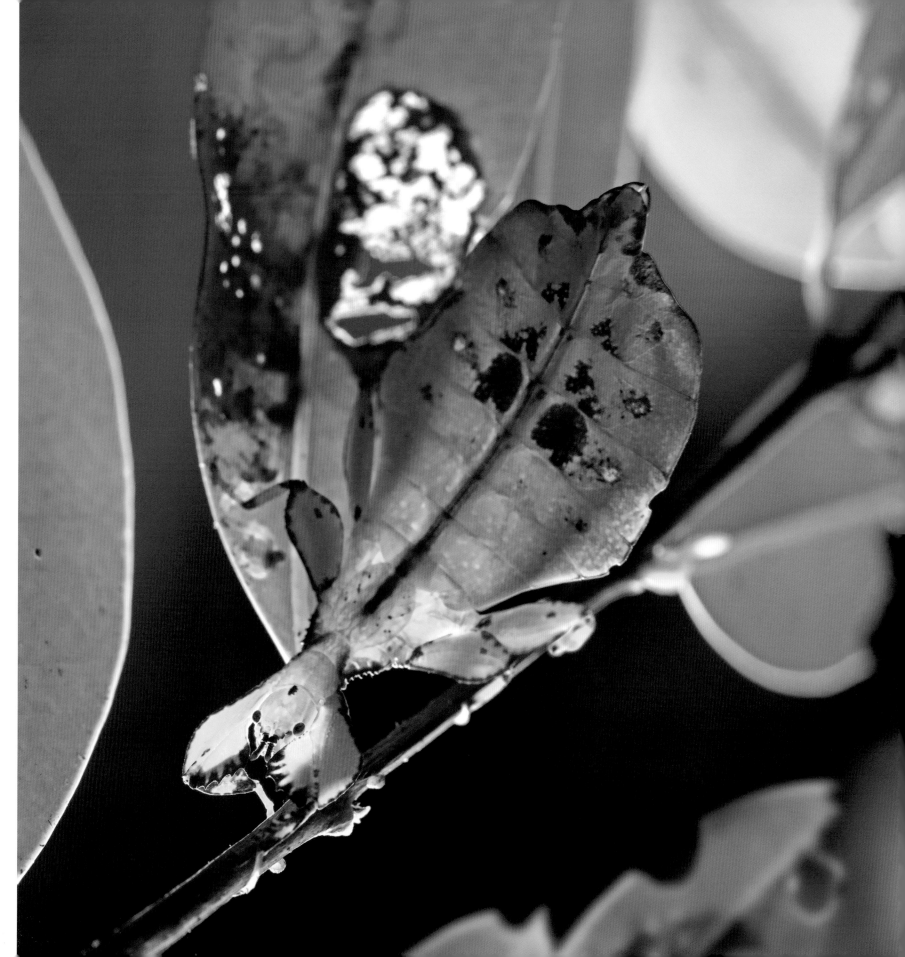

MINIBEASTS

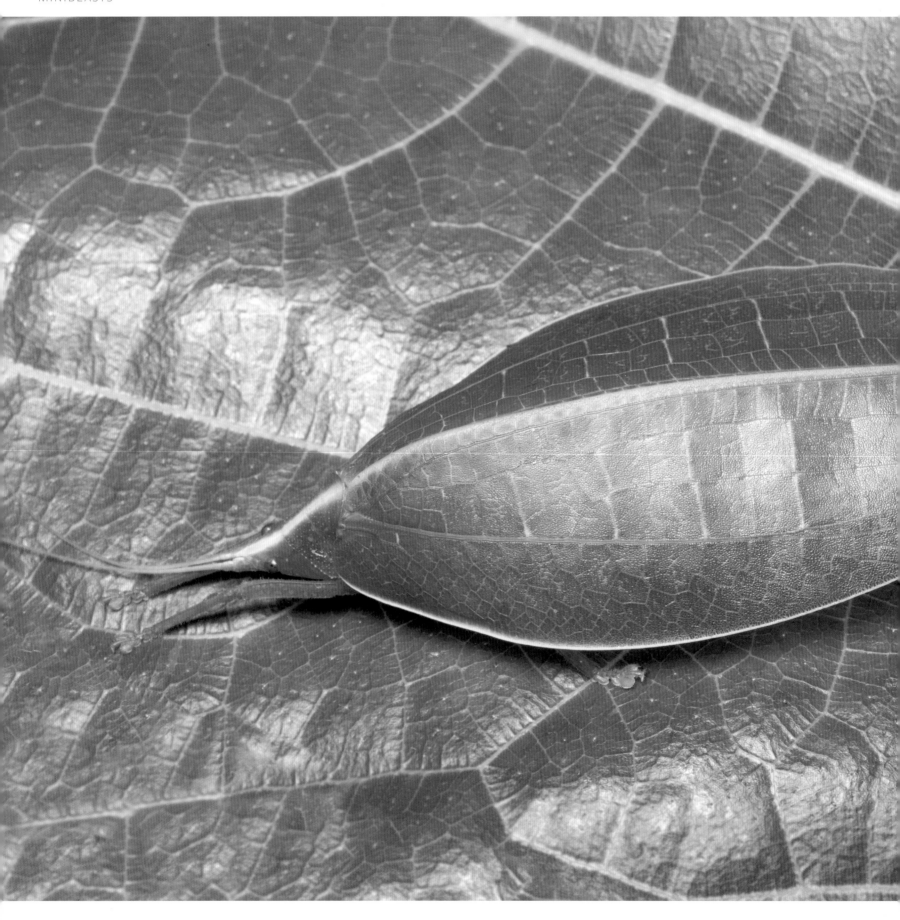

← **Hidden features**
4 X LIFE-SIZE
Another amazing leaf mimic. This Umbrella Katydid (*Acauloplacella* sp.) flattens out its wings to conceal its entire body. When aligned with the centre of a leaf, the similarity of the wings renders it almost invisible.

↑ **Nothing to see here**
10 X LIFE-SIZE
This tiny Nursery Web Spider (Pisauridae) sits in full view, however the patterns on its body, the bands on its legs and its colour break up its shape. At a glance it is not recognizable as a spider — or an animal for that matter — which protects it from visual predators such as birds.

8

LIFE AQUATIC

Minibeasts have evolved to live underwater just as many other animal groups have. Some species have gone about living under the surface in familiar ways, such as developing gill structures. Others have evolved truly unique methods of dealing with the challenges of living in and around water.

Like the amphibians, there are many species of invertebrates that spend their juvenile (nymph) stage of life in water and leave when they reach maturity. Dragonflies, damselflies, mayflies, mosquitos, stoneflies and many others spend their larval stages in water. During this phase, they are perfectly adapted for life underwater and bear little resemblance to the adult insects they will ultimately metamorphose into. Dragonfly nymphs are commonly known as mud-eyes and are fierce underwater predators. They have internal gills over which they pass water by sucking it in and out of their anus. They also can 'jet' propel themselves by forcing water rapidly out of their rear end!

Some species are equipped to spend their entire lives beneath the water but can leave if the need arises. Many can fly, but are far more at home under the surface. Insects such as backswimmers, water boatmen and water beetles breathe air and trap it upon their bodies so they can use it underwater in much the same way as a scuba diver uses an oxygen tank. The air is taken into their bodies via spiracles, the openings to tiny tubes which disperse the oxygen within them. These insects must return to the surface regularly to replenish their air supply.

Water scorpions and needlebugs have long, thin breathing tubes called siphons extending from the abdomen like a snorkel, which the insect pokes through the surface to periodically take in air. Giant Water Bugs (*Lethocerus* sp.) are among the largest of these underwater minibeasts and also the most ferocious. They have needle-like mouthparts which are used to inject venom and then suck the juices from their victims. These minibeasts regularly capture small fish, tadpoles and frogs.

Minibeasts have also mastered the surface of the water. Pond skaters skim rapidly over the surface, with their long thin legs splayed wide, kept aloft by the surface tension of the water. Whirligig beetles spin and whirl in dizzying circles upon the surface, scavenging as they go. These beetles have specialized eyes that allow them to see both below and above the surface at the same time.

Spiders have also taken to the water and there are many species that live on, and at times beneath, the surface. Diving Bell Spiders (*Argyroneta aquatica*) progressively take bubbles of air down to fill a bell-like chamber until it creates an air pocket in which it can reside. Other water spiders hunt upon the surface, able to run across the water rapidly and with ease due to specialized hairs on their feet. They can also dive beneath the surface to capture small fish or to escape predators by surrounding themselves in a spectacular silver coating of air.

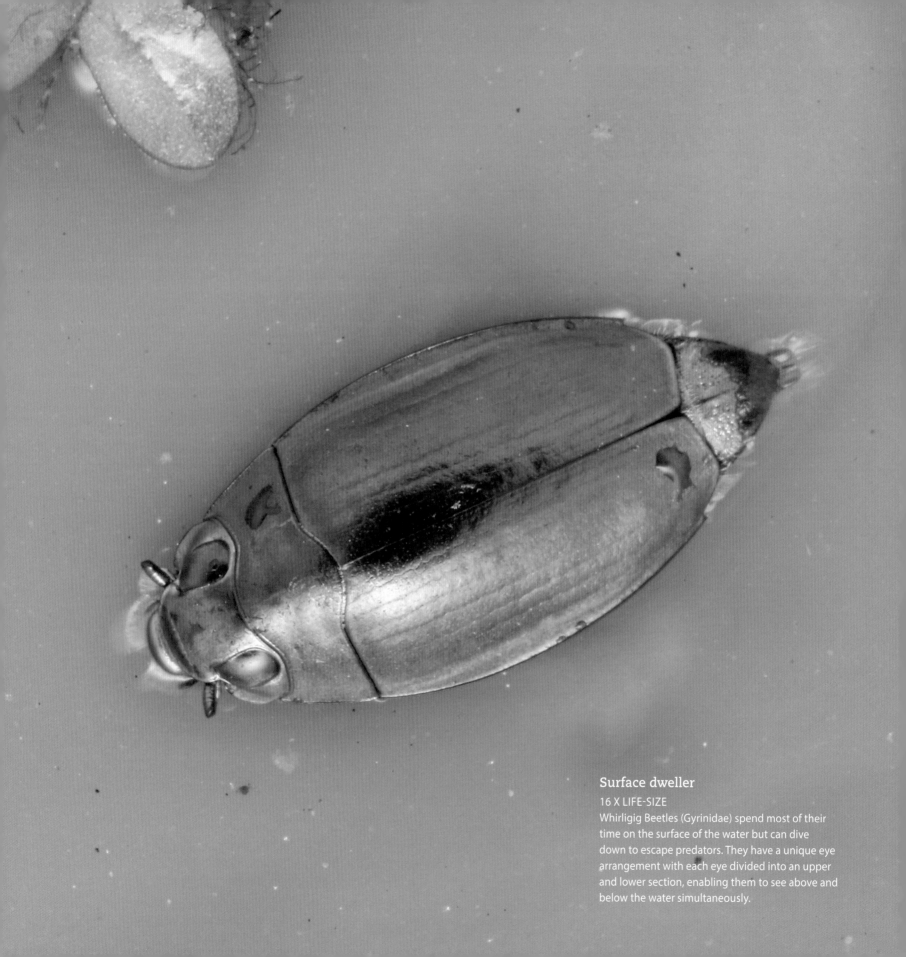

Surface dweller
16 X LIFE-SIZE
Whirligig Beetles (Gyrinidae) spend most of their time on the surface of the water but can dive down to escape predators. They have a unique eye arrangement with each eye divided into an upper and lower section, enabling them to see above and below the water simultaneously.

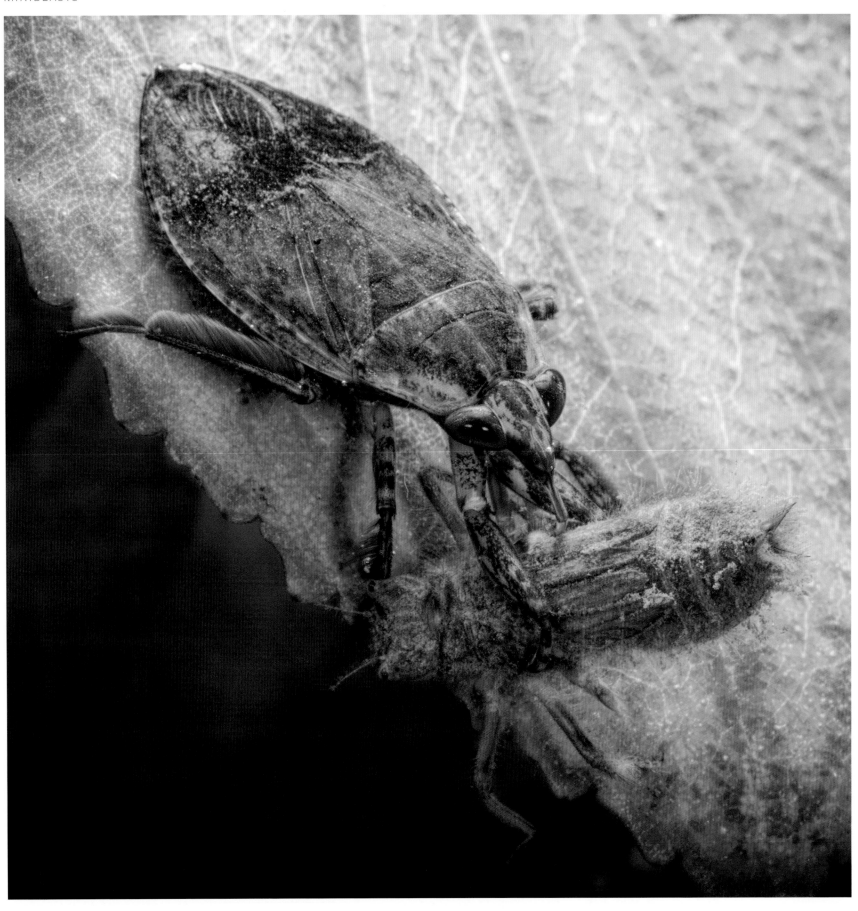

Deadly embrace
5 X LIFE-SIZE

Just as above water, it is a bug-eat-bug world below the surface. This predatory dragonfly nymph has met its match in a venomous Giant Water Bug (*Belostoma* sp.). The Water Bug extracts the bodily fluids of its prey through a needle-like mouth called a rostrum.

Diving beetle
4 X LIFE-SIZE

Diving Beetles (Dytiscidae) are perfectly adapted for life under water. The spiracles (small openings through which the beetle breathes) are on the beetle's back under the elytra (wing covers). They obtain air by swimming up to the surface and drawing air into the space beneath the elytra. The trapped air can then be used underwater, just as a scuba diver uses an oxygen tank.

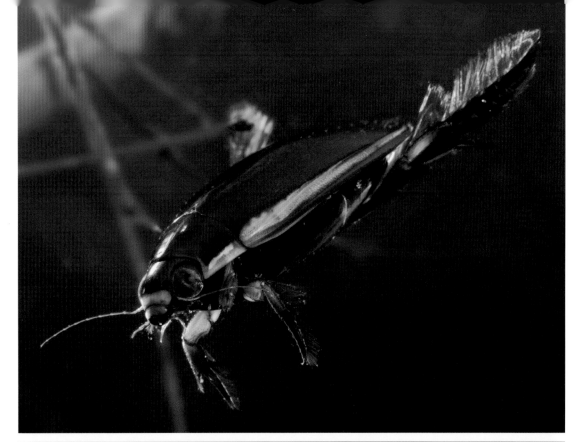

Hairy flippers
16 X LIFE-SIZE

The feet of underwater minibeasts have very different functions than those of their land-based cousins. This is the foot of a Diving Beetle (Dytiscidae). It has brushes of stiff hairs on its hind feet, which act as flippers to propel it through the water.

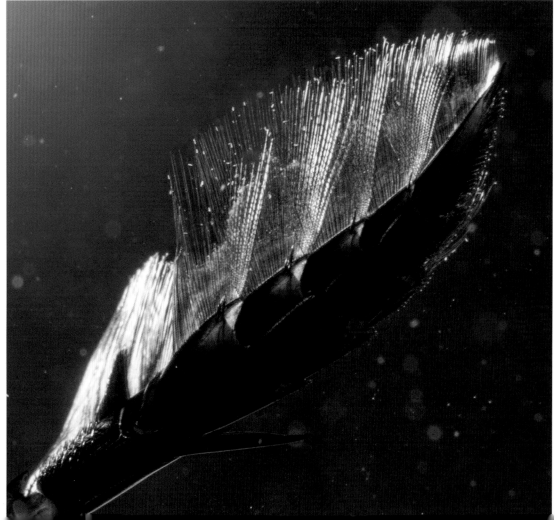

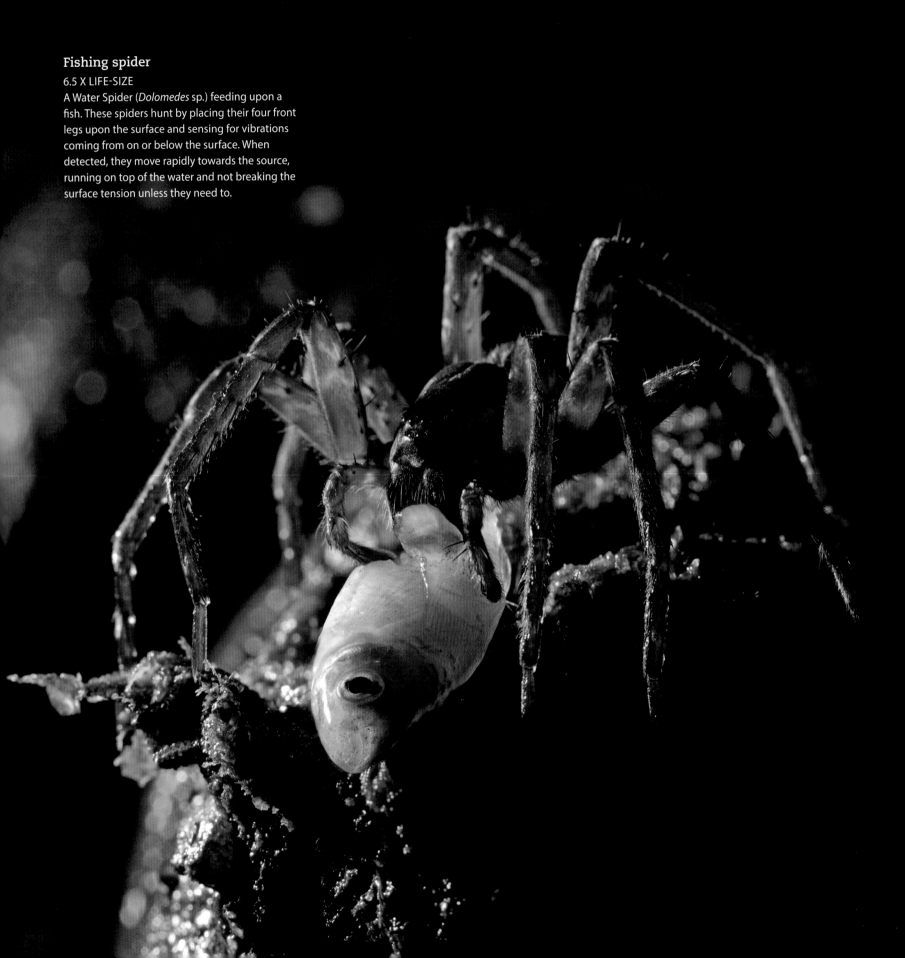

Fishing spider

6.5 X LIFE-SIZE
A Water Spider (*Dolomedes* sp.) feeding upon a fish. These spiders hunt by placing their four front legs upon the surface and sensing for vibrations coming from on or below the surface. When detected, they move rapidly towards the source, running on top of the water and not breaking the surface tension unless they need to.

LIFE AQUATIC

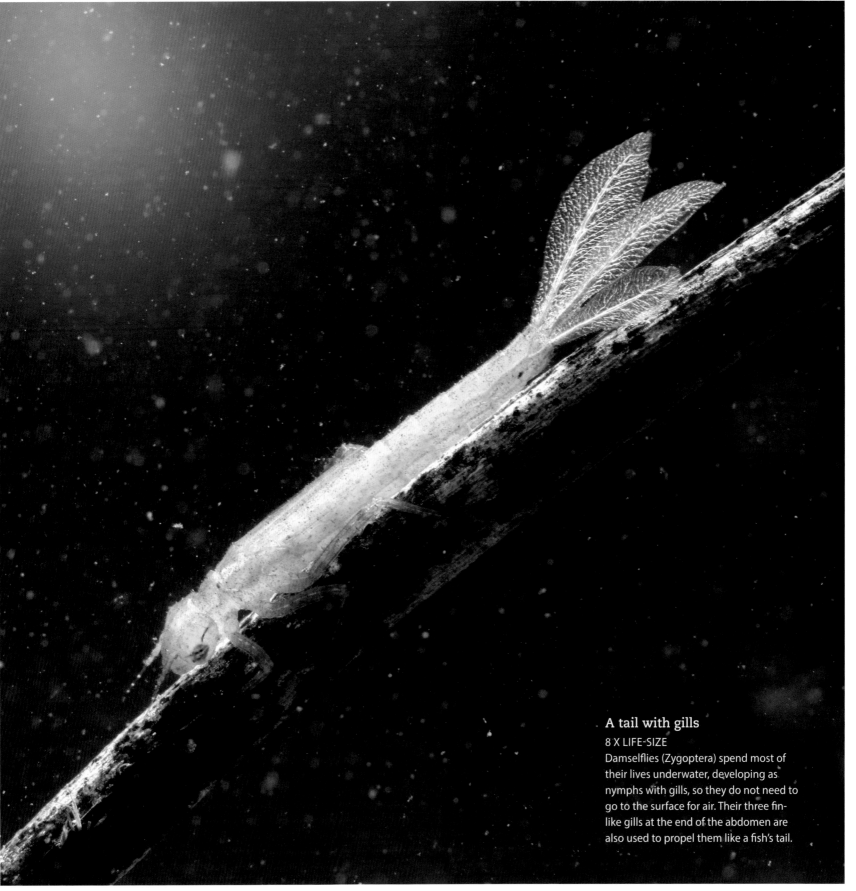

A tail with gills
8 X LIFE-SIZE
Damselflies (Zygoptera) spend most of their lives underwater, developing as nymphs with gills, so they do not need to go to the surface for air. Their three fin-like gills at the end of the abdomen are also used to propel them like a fish's tail.

MINIBEASTS

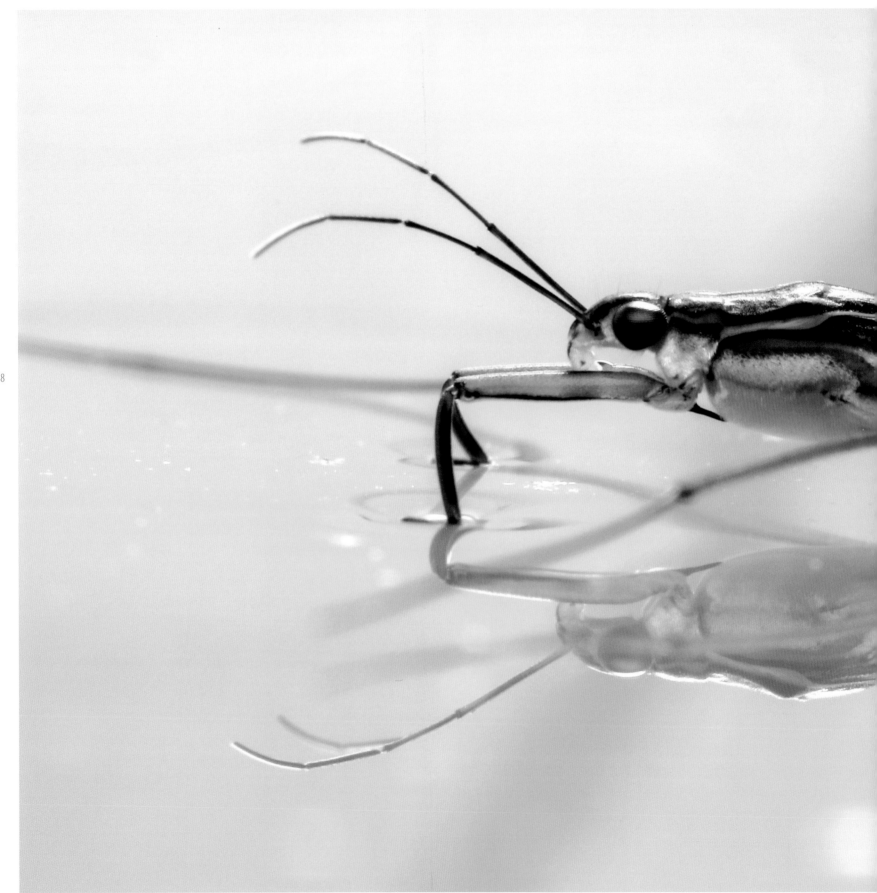

LIFE AQUATIC

Walking on water
26.5 X LIFE-SIZE
Water Striders (Gerridae), also known as Pond Skaters, are predatory insects that live upon the surface of the water. Their legs are covered in thousands of microscopic hairs which trap air and give them buoyancy. Quick flicks of their legs send them skating across the surface, but if threatened they can make quick leaping bounds, capable of moving at speeds of over 100 body lengths per second.

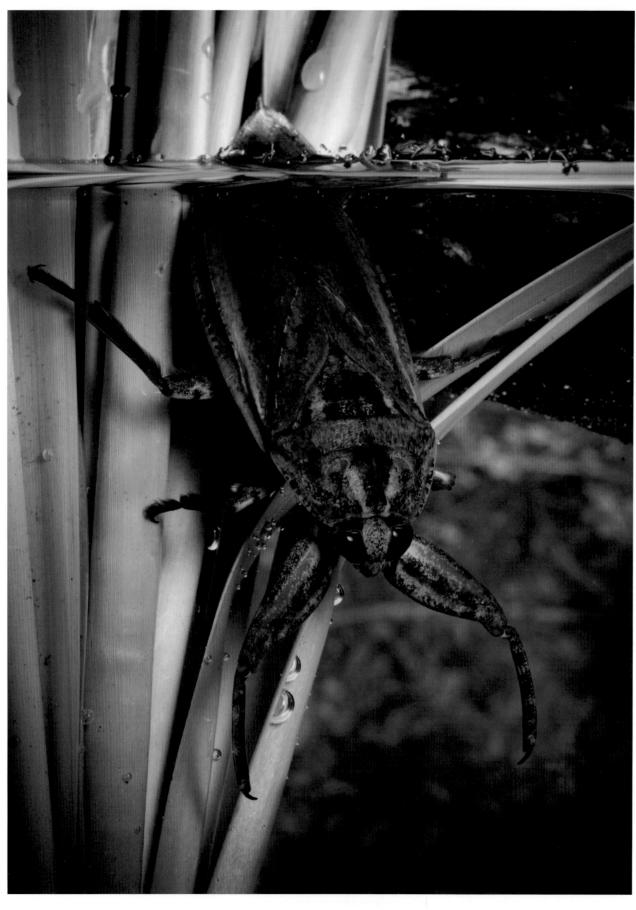

←
Underwater ambush
2 X LIFE-SIZE
Giant Water Bugs (*Lethocerus* spp.) are savage underwater predators that position themselves near the surface and breathe through a snorkel-like structure on their abdomen. They have excellent eyesight and launch themselves at passing prey, seizing it with their powerful front legs. Various aquatic insects, crayfish and even fish are captured and killed with venom injected via the bug's needle-like mouthparts.

→
Diving spider-style
4 X LIFE-SIZE
To evade predators, water spiders can dive below the surface and stay down for long periods of time. A film of air is trapped around the spider's body, covering the opening to their breathing tubes and giving the spider a silver appearance while it is underwater.

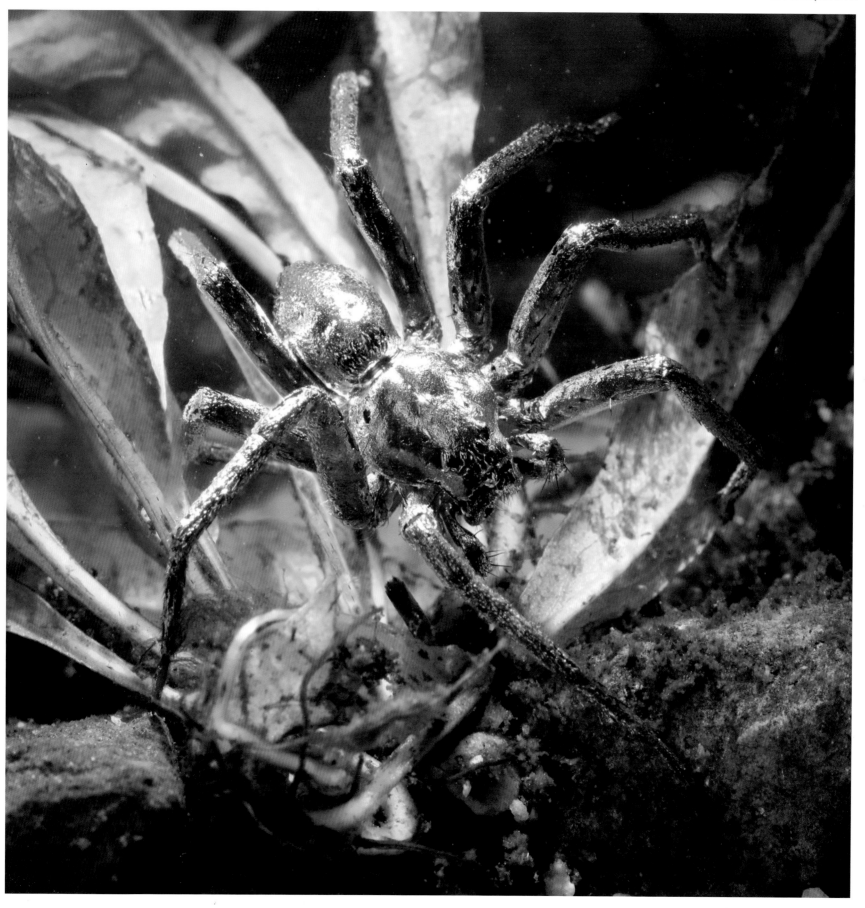

9

THE PRETENDERS

Infiltration, code-cracking and identity theft all sound like plot elements of a spy novel, however they are also very much part of the minibeast world. Many species imitate other species, sometimes for their own protection, but often for more devious outcomes that can involve the death of an unsuspecting party.

Mimicry is the term used in the biological field that describes when one species copies another in some way. The imitator is known as the mimic, and the copied species is the model. Mimicry isn't a conscious form of imitation but a gradual alignment that has evolved over millions of years because it has brought the mimic some kind of benefit.

Mimicry can take many forms, the most commonly encountered being Batesian mimicry, named after the research of Henry Walter Bates in the 1850s. This is where a harmless species has evolved to resemble a harmful or distasteful species, mimicking its warning colours, body shape or even its smell. This provides the mimic with an elevated level of protection from predators, who assume it is toxic and avoid it. Batesian mimicry was first discovered in Brazilian butterflies, when it became apparent that many similar brightly coloured butterflies were not closely related at all. Many were in fact mimicking the colour and patterns of toxic butterflies, while not being toxic themselves. Batesian mimicry is widespread throughout the invertebrate world. Many species of moths mimic wasps, and harmless flies such as the commonly seen Hoverflies (Syrphidae) mimic bees. Some insects such as the Spiny Leaf Insects (*Extatosoma tiaratum*) have a stage of their life-cycle where they exhibit mimicry. When they hatch, these insects visually mimic (and behave like) ants of the genus Leptomyrmex. This affords them protection from many species of birds that avoid eating ants.

In contrast to Batesian mimicry, aggressive mimicry occurs when a mimic, often a predator or parasite, imitates a harmless species. In the case of a predator, this enables it to avoid being detected by its prey, and often allows it to approach more closely or even attract its prey to it. While this form of mimicry can be visual, it is quite often achieved by copying the smell (pheromones) of the other species. This is particularly common where aggressive mimics target ants. Ants have a complex social network which relies on chemical codes to identify friend from foe. Ant-eating spiders use chemical 'cloaking' to enable them to approach ants without detection. Some parasitic caterpillars and wasp larvae are able to emulate ant chemical identifiers to such a degree that, once inside the ant nest, the ants preferentially feed the parasite at the expense of their own larvae. Some caterpillars have taken this ruse a step further, managing to remain inside ant nests with their chemical disguise to actually eat the ant larvae — all the while, the ants are blissfully unaware.

These complex and deceptive relationships have evolved over millions of years within the minibeast world, and just like our techniques of encryption and code-breaking, they continue to evolve today.

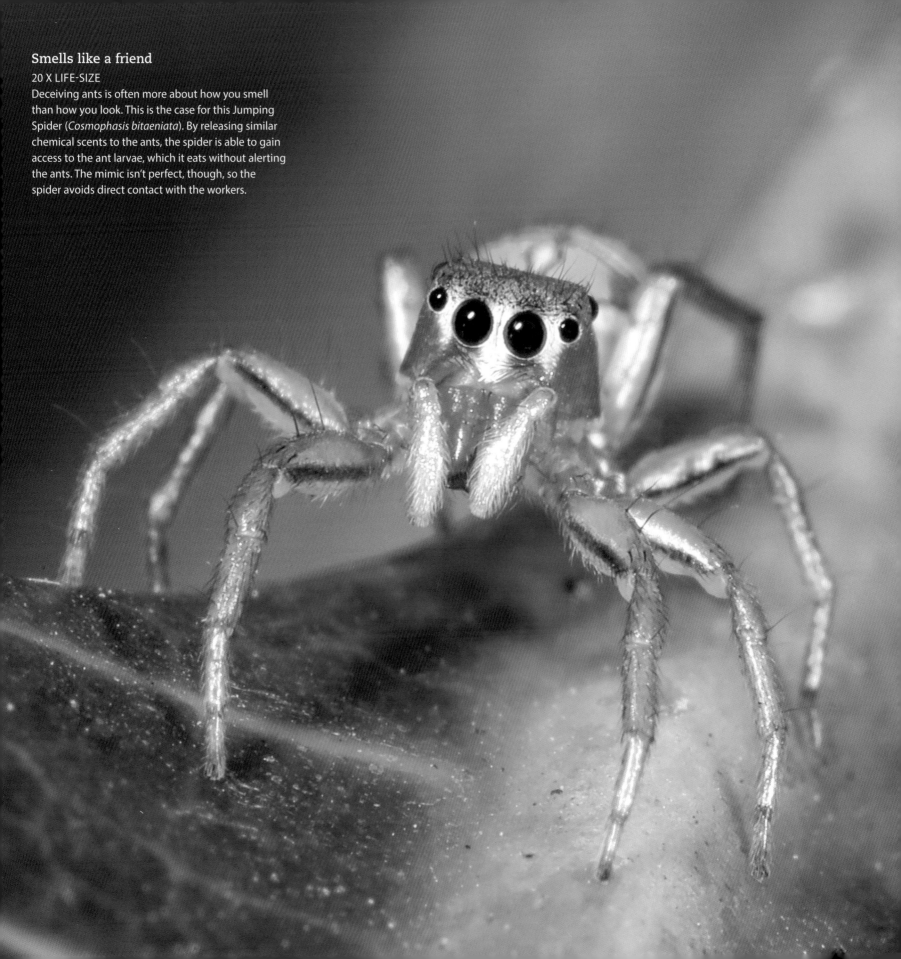

Smells like a friend
20 X LIFE-SIZE
Deceiving ants is often more about how you smell than how you look. This is the case for this Jumping Spider (*Cosmophasis bitaeniata*). By releasing similar chemical scents to the ants, the spider is able to gain access to the ant larvae, which it eats without alerting the ants. The mimic isn't perfect, though, so the spider avoids direct contact with the workers.

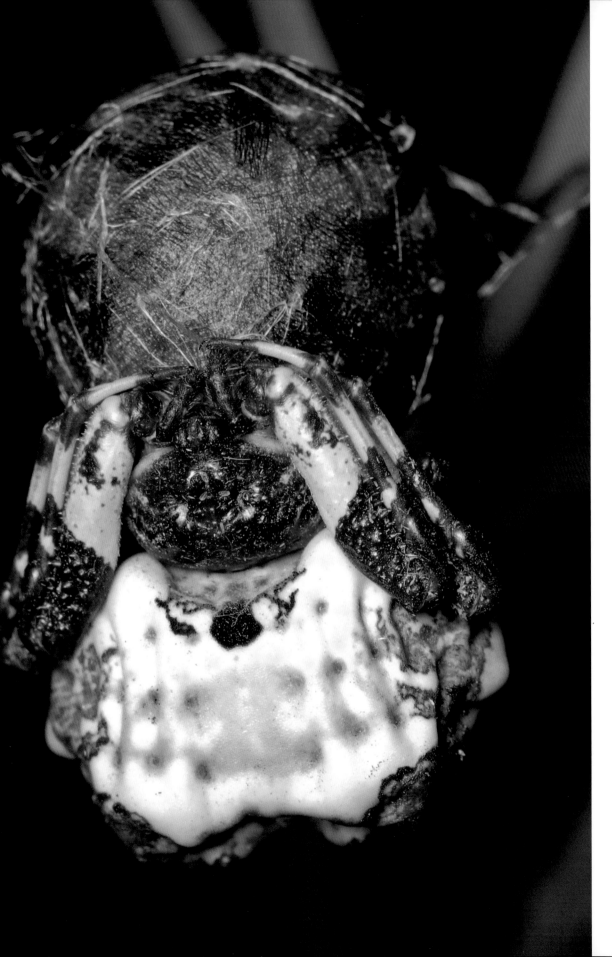

←
A double deception
10 X LIFE-SIZE
This is a Bird-dropping Spider (*Celaenia excavata*) that looks like bird poo to avoid predators during the day. The real mimicry, however, happens after dark. This spider releases a chemical that mimics the pheromones released by female moths to attract their mates. In this case, the males arrive expecting sex but find the awaiting fangs of a hungry spider.

→
Bee or not too bee?
13 X LIFE-SIZE
Hoverflies (Syrphidae) are harmless flies that often visit flowers to feed on nectar and pollen. They look very much like bees and as a result of this mimicry would be ignored by predators that associate them with their stinging lookalikes.

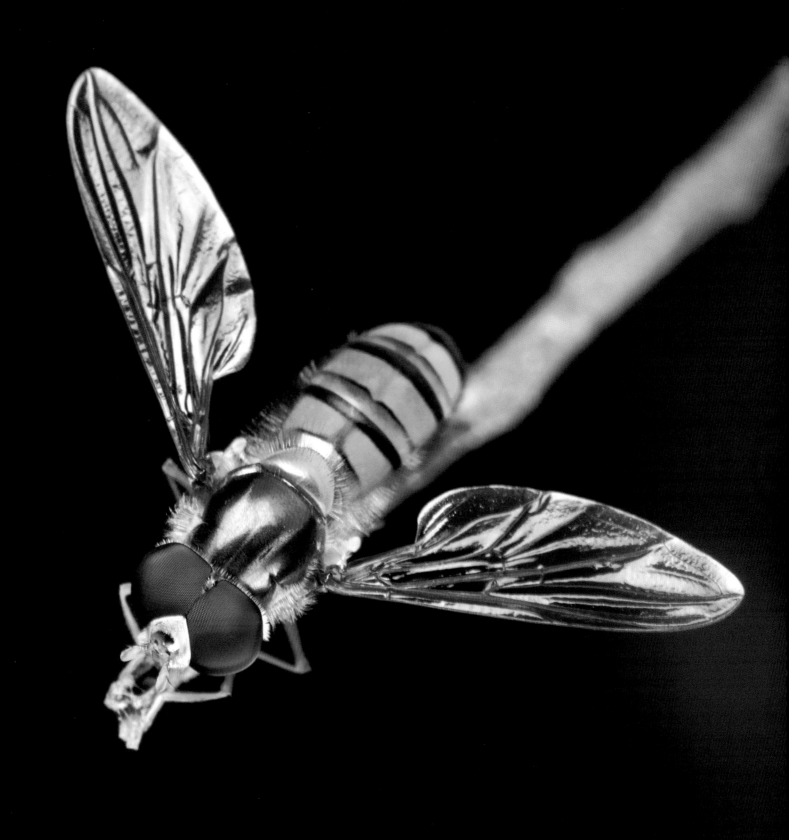

Rattle ant
20 X LIFE-SIZE
Black Rattle Ants (*Polyrhachis australis*) are common in the rainforests of northern Australia. They are distasteful and bite, and are avoided by many predators. Several species mimic these ants and gain protection by doing so.

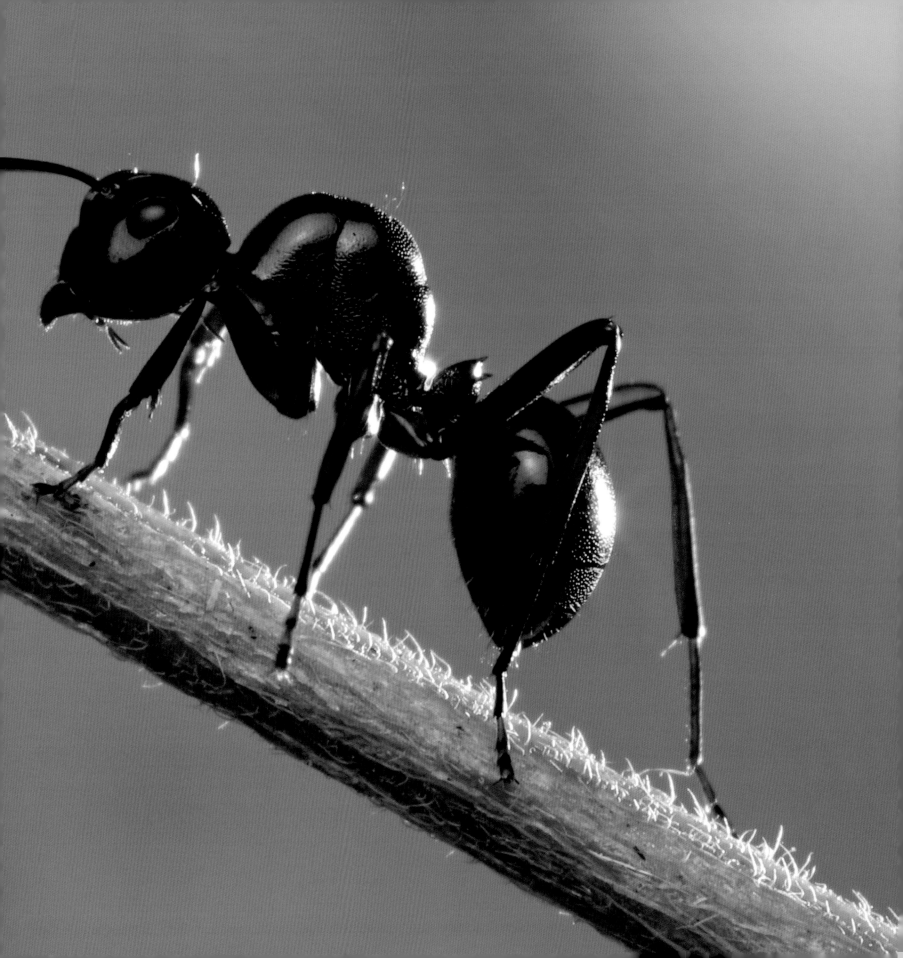

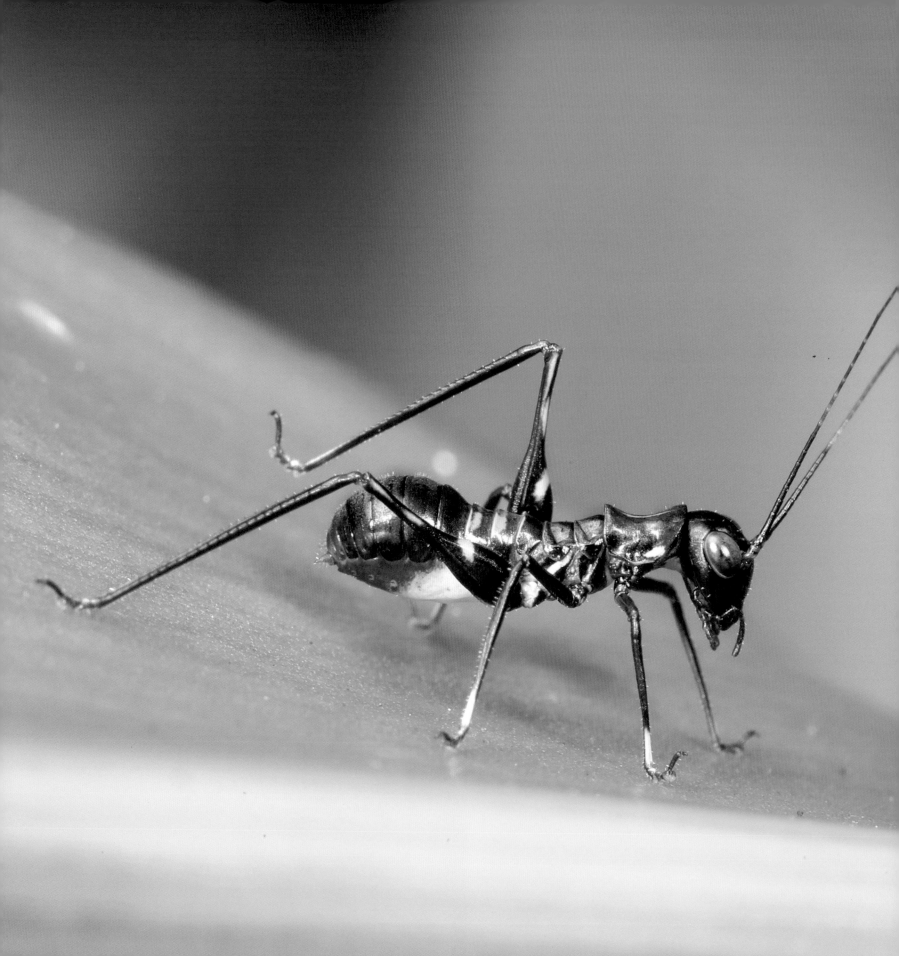

THE PRETENDERS

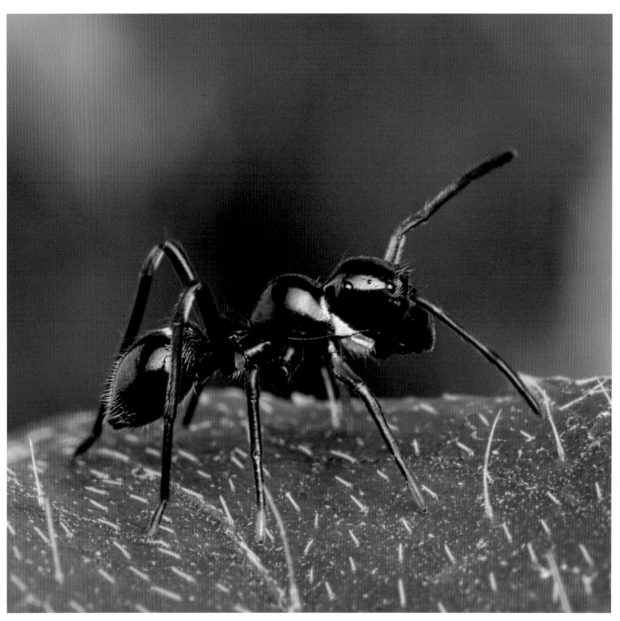

←
Ant-mimicking katydid
13 X LIFE-SIZE
This baby katydid (*Kurandoptera purpura*) mimics Black Rattle Ants. As well as looking like an ant at a glance, it acts the part and moves around like one.

↑
Ant-mimicking spider
13 X LIFE-SIZE
This jumping spider (*Myrmarachne* sp.) also mimics the Black Rattle Ant. Having eight legs instead of six isn't a problem; the spider holds its front two legs outstretched so they look like the ant's antennae.

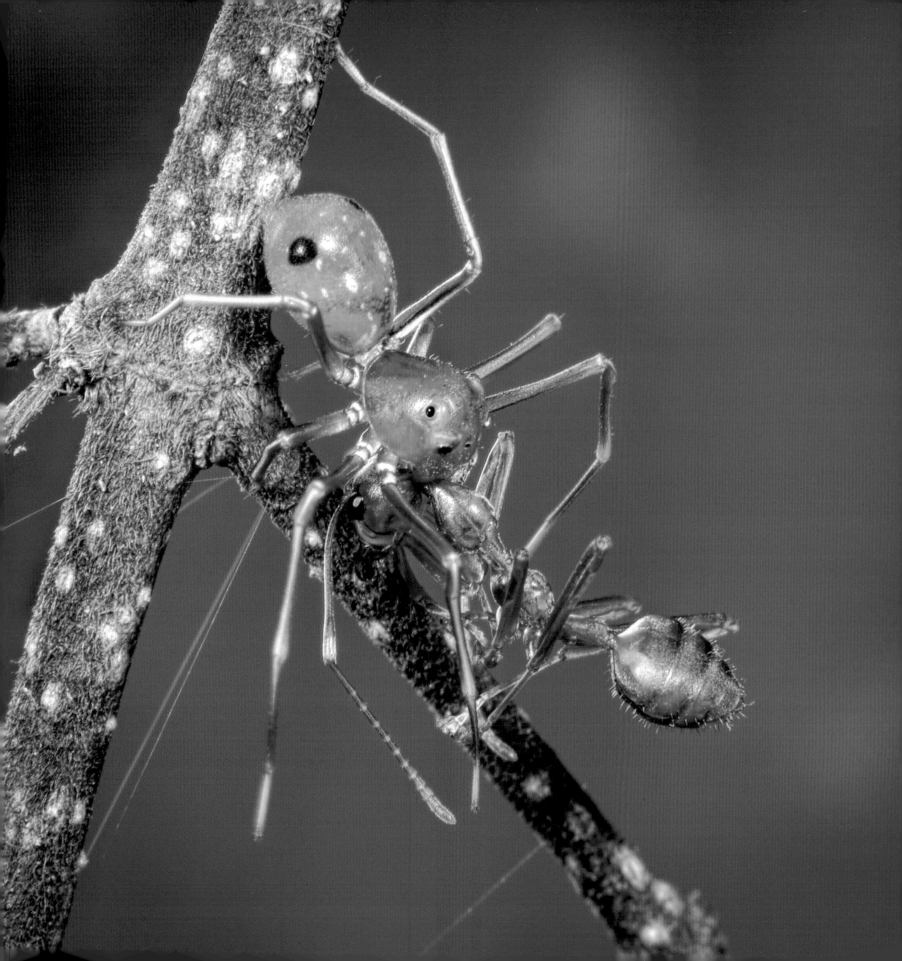

A killer in their midst

20 X LIFE-SIZE

This Weaver Ant Mimicking Spider (*Amyciaea albomaculata*) is an aggressive mimic of Weaver Ants (Oecophylla smaragdina). It matches the ants in its colour and shape and even has two 'eye spots' on its abdomen. The spider hunts by dangling down on a silken thread adjacent to an ant trail and behaves like an injured ant. When a concerned ant comes over to investigate, it is snatched up and taken away to be eaten.

A wasp or not?

4 X LIFE-SIZE

While the disguise of this Clearwing Moth (*Carmenta* sp.) isn't perfect, it is close enough in appearance to a wasp to provide it with the protection it requires to be active during the day, when most moths are hiding from visual predators.

THE PRETENDERS

The model and the mimic

6.5 X LIFE-SIZE

Leptomyrmex sp. (at right) are long-legged tropical ants that rapidly run up and down tree trunks. By mimicking these ants, baby Spiny Leaf Insects (*Extatosoma tiaratum*) (at left) are able to get from their hatching point on the ground and into the trees without being eaten by birds. They look and behave like the ants for the first few days of life and then gradually change to use camouflage as their main form of protection.

MINIBEASTS

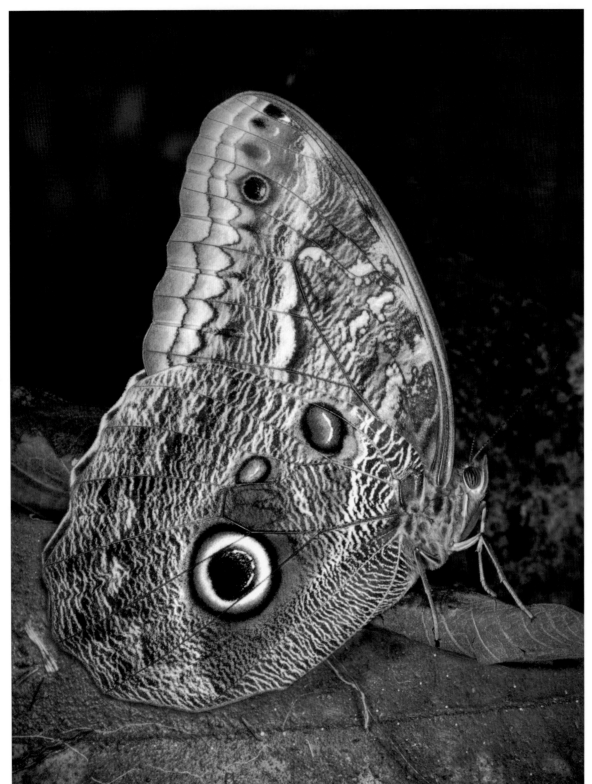

A face in the forest
1.5 X LIFE-SIZE
The giant 'eye spots' of Owl Butterflies (*Caligo* spp.) are thought to deter predators, who think they are looking at the face of a large animal. This type of deception to deter predators is a common defence for minibeasts, and many butterfly and moth species have evolved such patterns.

Wasp envy
6.5 X LIFE-SIZE
While this animal looks very much like a wasp, it is not related at all. It is a Mantispid (Neuroptera), an insect in the lacewing family. It cannot sting and is an example of Batesian mimicry. Many predators would avoid it due to its wasp-like colouration and shape.

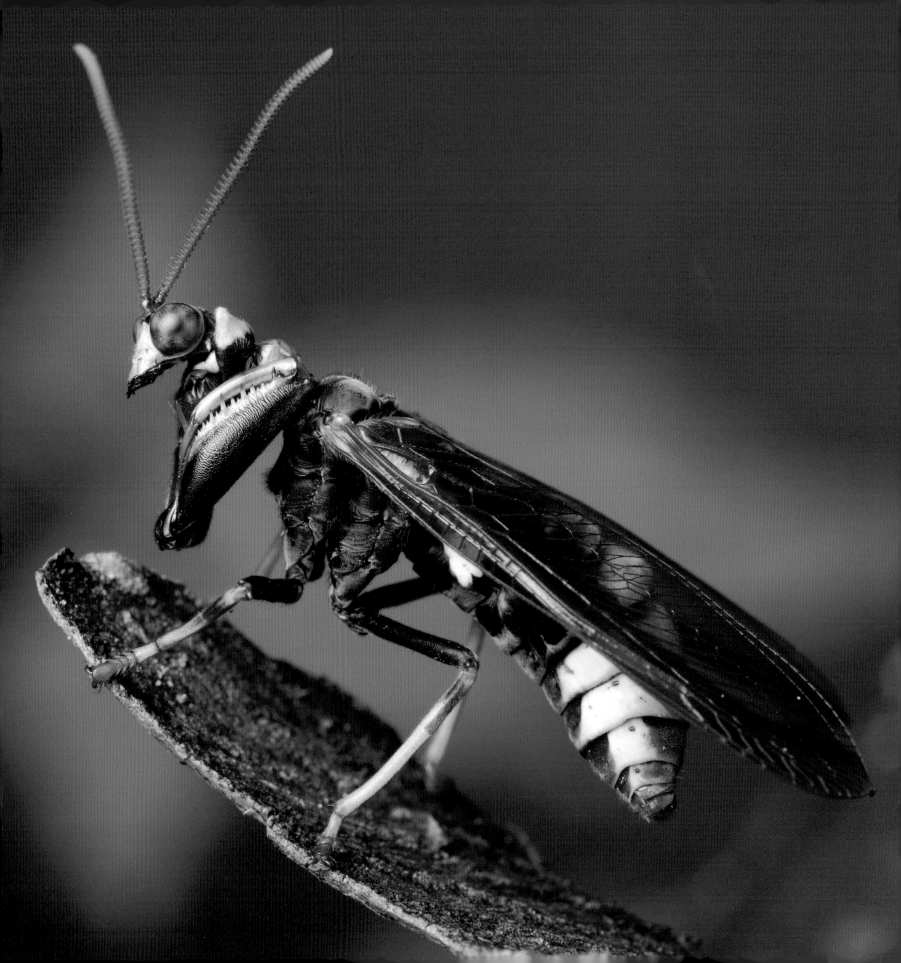

10
THE MATING GAME

Sex. It's a big part of minibeast life, and while its aim is to ensure survival, it can also end in tragedy. Passing on genes to the next generation is the goal that the nymphomaniacal participants in the fantastic world of minibeasts seek to achieve.

While not all minibeasts reproduce sexually, those that do have some intriguing ways of doing so. First, there's the task of ensuring you are hooking up with a member of your own species. It's something we may take for granted. However, in the world of invertebrates there are many species that look and behave in very similar ways. Spending time courting the wrong female could end disastrously for an animal with a short lifespan — and for some that is a mere few days. But minibeasts have evolved a plethora of ways to avoid this, some of which are simply mind blowing.

Humans are no strangers to the use of perfumes to attract a potential mate. Similarly, minibeasts use chemicals called pheromones which are relatively unique to each species and allow males to track down sexually active females of their own species. The use of pheromones is widespread and is used by crawling arachnids such as spiders, through to flying insects such as moths. Pheromones are commonly used as initial attractants, often by females, and are particularly useful for species without good vision. They are also very useful when airborne as they can attract the attention of mates from considerable distances, and allow them to follow the scent to its source.

For those minibeasts with good vision, colour and shape recognition may play a big role in mate identification and selection. Jumping spiders are extremely visual, and much of their courtship involves ritualized dancing — leg waving, fancy sidesteps and, in the case of the Peacock Jumping Spiders (*Maratus* spp.), the flashing of amazing abdominal colours and patterns. These are all integral parts of their courtship. Even though to us the various species may look similar, their courtship dances are distinct, and a willing female will reject any suitor not conforming to the required choreography.

Sound and vibration are also used extensively as sexual attractors and selectors in the invertebrate world. Well known insects such as crickets, katydids and cicadas create sounds to attract mates. In this case it is the males making the effort in the hope that a female will hear and come to them. Females will select the males based on the sounds they are producing.

Some male minibeasts have gone a step further and present their potential partner with food gifts to seal the deal. In some cases, they provide her with valuable nutrients to aid the development of the offspring. Along with their sperm, many katydids provide a nutrient-rich package that the female consumes after mating. Male Scorpionflies and Hangingflies (Mecoptera) provide food gifts or share their saliva to prove their worth.

In extreme cases of giving, the 'gift' may be the life and body of the male himself. This is the case with Widow Spiders and some praying mantises. The male is eaten by his partner after (or sometimes during) mating — the ultimate sacrifice! All in the name of reproduction.

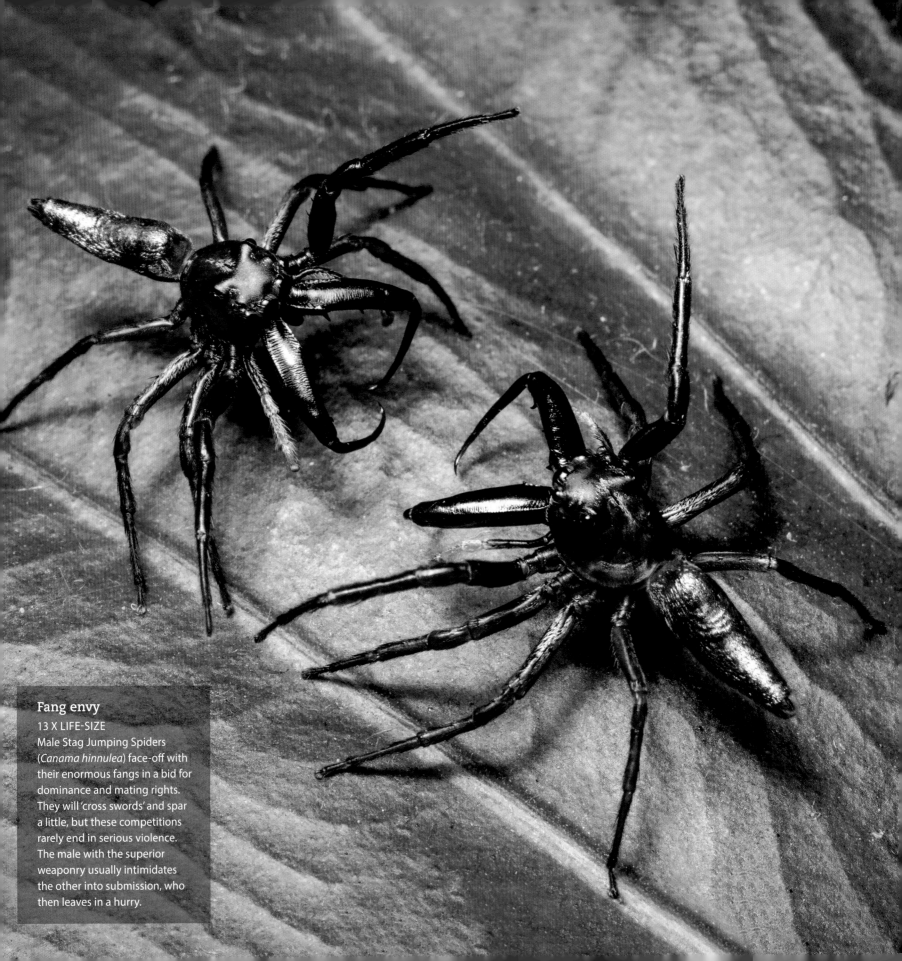

Fang envy

13 X LIFE-SIZE

Male Stag Jumping Spiders (*Canama hinnulea*) face-off with their enormous fangs in a bid for dominance and mating rights. They will 'cross swords' and spar a little, but these competitions rarely end in serious violence. The male with the superior weaponry usually intimidates the other into submission, who then leaves in a hurry.

Raspy cricket style
2.5 X LIFE-SIZE
A pair of Raspy Crickets (Gryllacrididae) in the act of mating — the male is transferring a sperm package (spermatophore) to the female. This pair is being a little extra creative with a no-handed approach to their coupling.

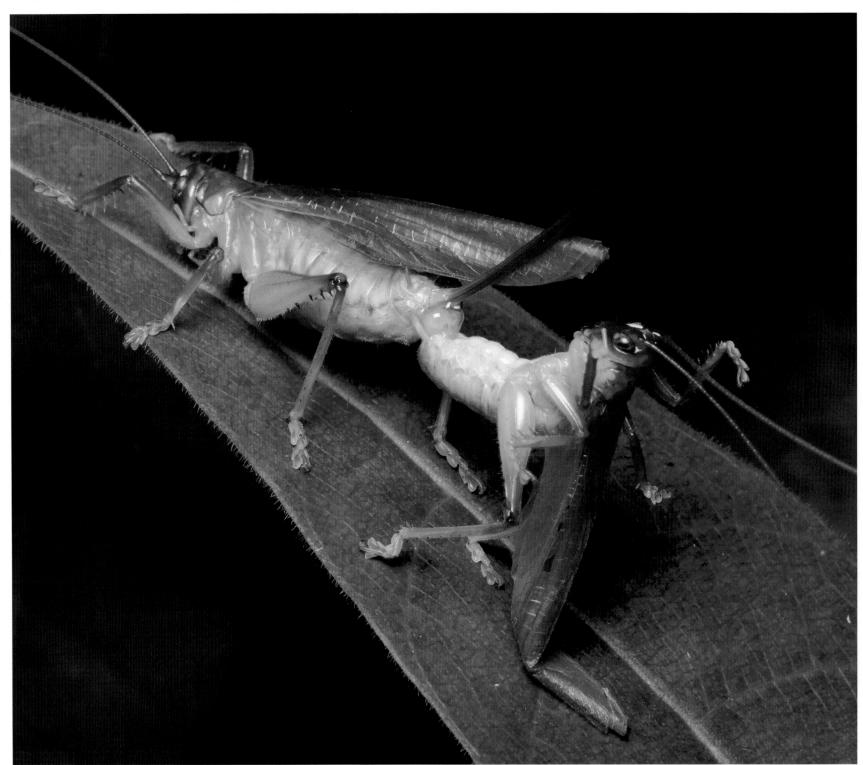

A nuptial gift
4 X LIFE-SIZE

The spermatophore transferred to the female Raspy Cricket (Gryllacrididae) during mating contains an edible gift called a spermatophylax. She consumes this jelly-like substance and it provides her with nutrients which assist her to develop healthier eggs.

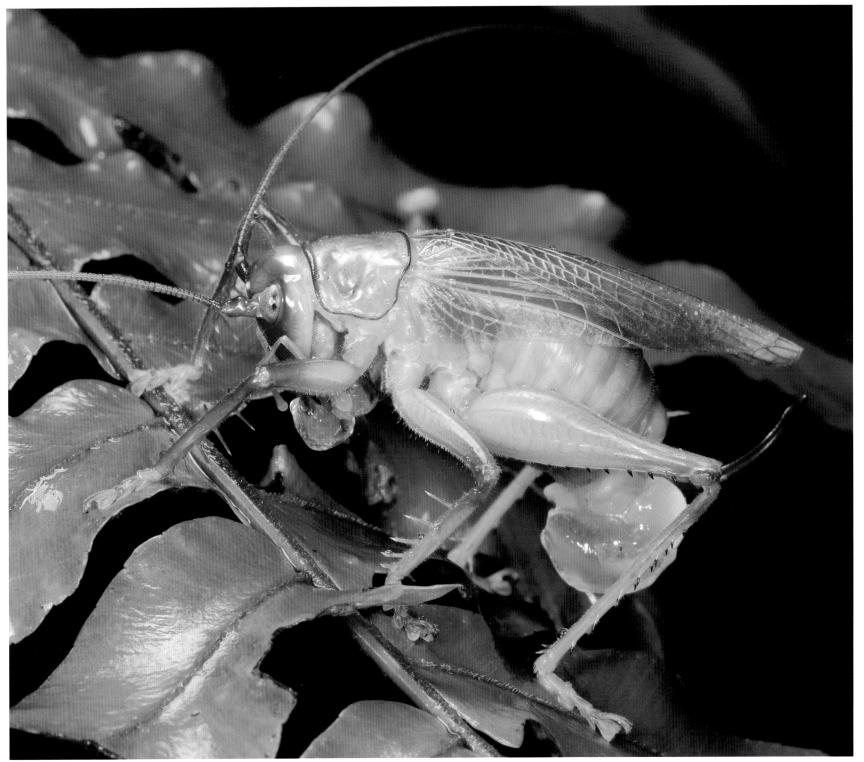

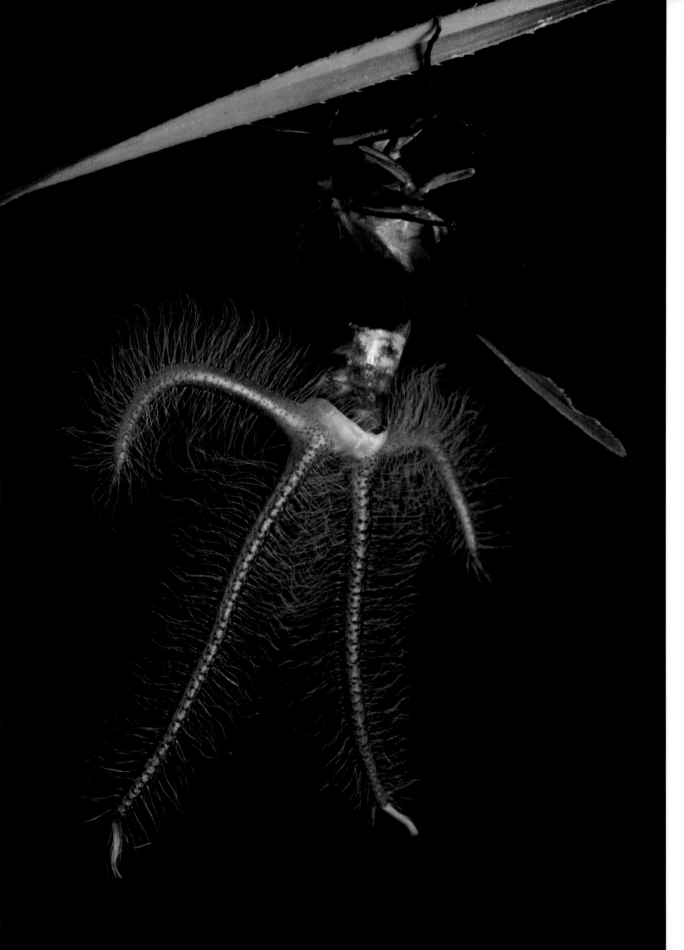

←
Putting it out there
5 × LIFE-SIZE
This bizarre-looking scene is a male moth (*Creatonotos gangis*) releasing pheromones via structures called coremata. The airborne hormones attract nearby females as part of courtship. The coremata are retracted into the moth's abdomen when not in use.

→
Three's a crowd
4.5 × LIFE-SIZE
When fertile female beetles release pheromones it can attract a crowd. This female Christmas Beetle (*Anoplognathus* sp.) has two males attempting to mate with her, although the male in the middle might not be impressed. Competition is usually a good thing in the natural world, as it ensures the fittest and healthiest individuals get to pass on their genes.

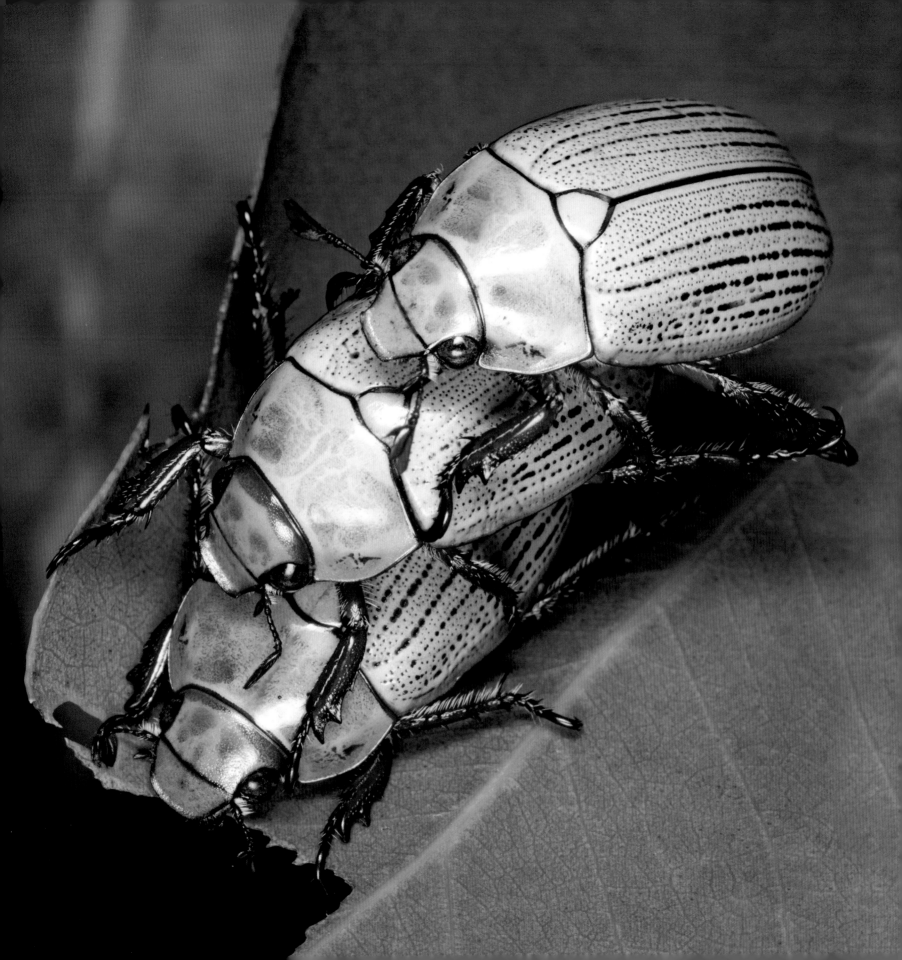

Getting your head bitten off
2 X LIFE-SIZE

Literally losing your head during mating is possible in the world of praying mantises, but such behaviour doesn't occur within all species, and even with those that do, it doesn't happen every time. This male *Hierodula majuscula* has taken one for the team. His body will complete the task at hand despite his obvious loss, and the female will consume the rest of him afterwards. In this case he has ensured she is well fed, which in turn provides his future offspring a greater chance of survival.

Mere male
4 X LIFE-SIZE
The female Golden Orb-weaving Spider (*Nephila pilipes*) dwarfs its tiny male counterpart. Despite being barely a mouthful, the male must take care not to be eaten. He lightly binds the female with fine silk lines across the junction point in her body. Studies have shown that this behaviour has a calming effect on the female; it makes her more receptive to mating and less likely to eat him. The value of a good back massage can't be overstated!

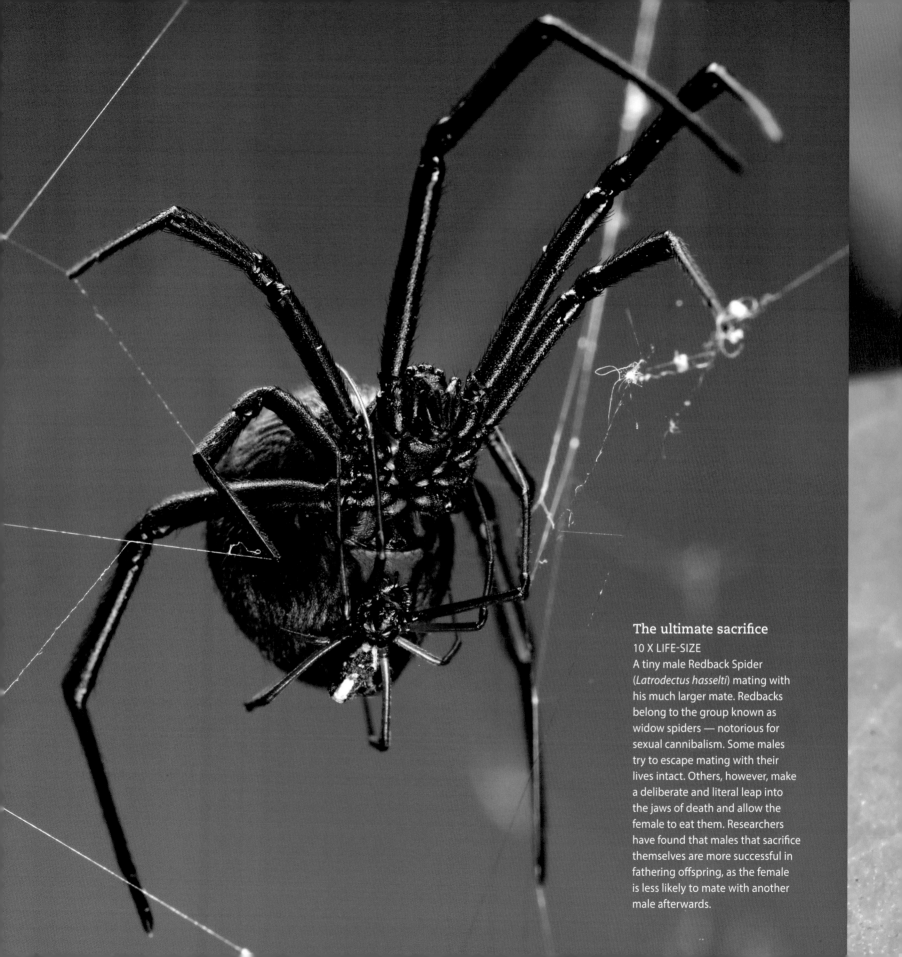

The ultimate sacrifice
10 X LIFE-SIZE
A tiny male Redback Spider (*Latrodectus hasselti*) mating with his much larger mate. Redbacks belong to the group known as widow spiders — notorious for sexual cannibalism. Some males try to escape mating with their lives intact. Others, however, make a deliberate and literal leap into the jaws of death and allow the female to eat them. Researchers have found that males that sacrifice themselves are more successful in fathering offspring, as the female is less likely to mate with another male afterwards.

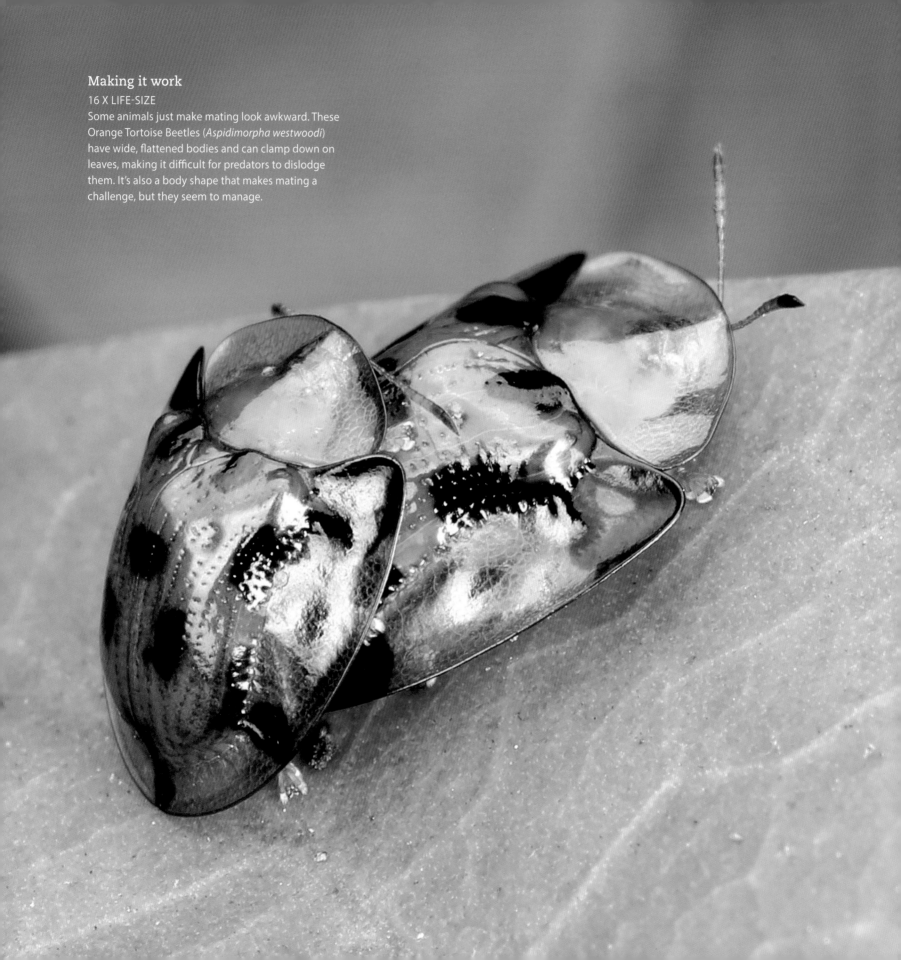

Making it work

16 X LIFE-SIZE

Some animals just make mating look awkward. These Orange Tortoise Beetles (*Aspidimorpha westwoodi*) have wide, flattened bodies and can clamp down on leaves, making it difficult for predators to dislodge them. It's also a body shape that makes mating a challenge, but they seem to manage.

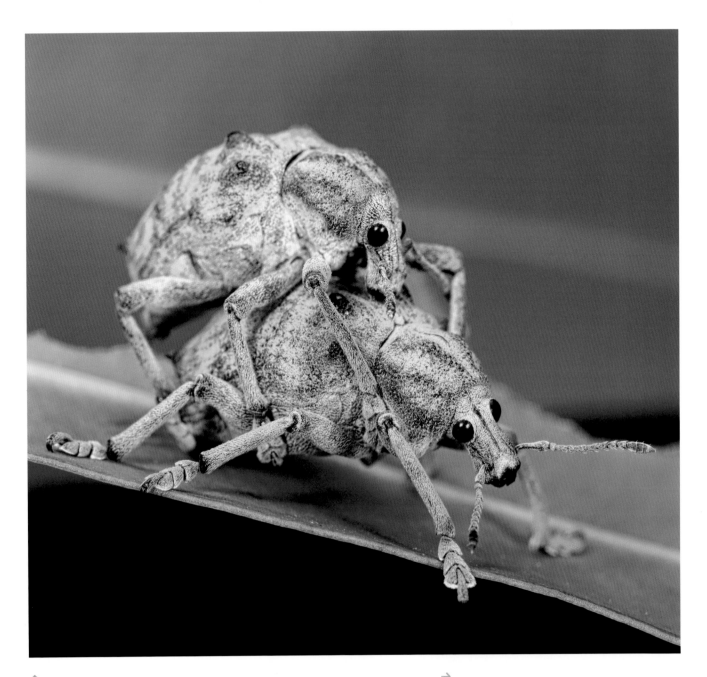

↑
Holding on
6.5 × LIFE-SIZE
A male weevil (Gonipterini) has found his mate and is secure on her back. During breeding season, pairs will often spend long periods of time linked together. The males, having found a receptive female, are keen to hold on to their catch.

→
Scorpion courtship
10 × LIFE-SIZE
These 'kissing' scorpions are locked together and performing a mating dance called the 'promenade à deux'. The male locks pincers with the female and then shuffles back and forth to find a suitable position to place his sperm package (spermatophore) upon the ground. He then progressively manoeuvres her until she can pick it up. In some species, the male actually stings the female, seemingly to pacify her.

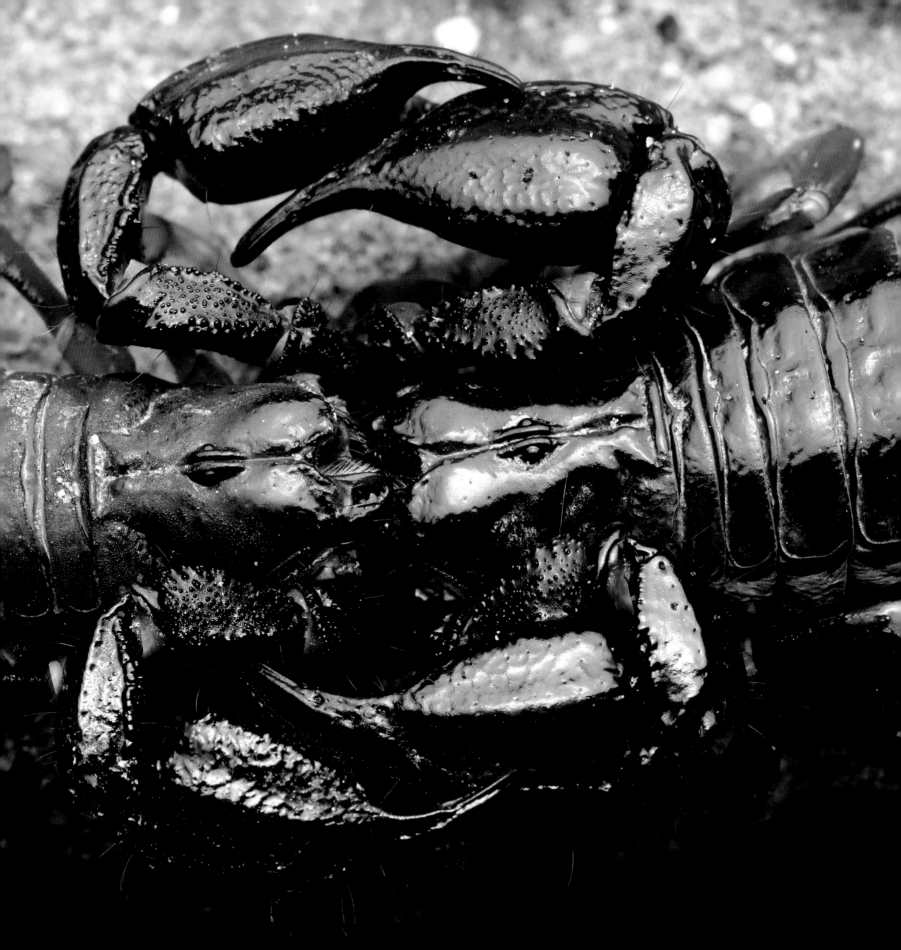

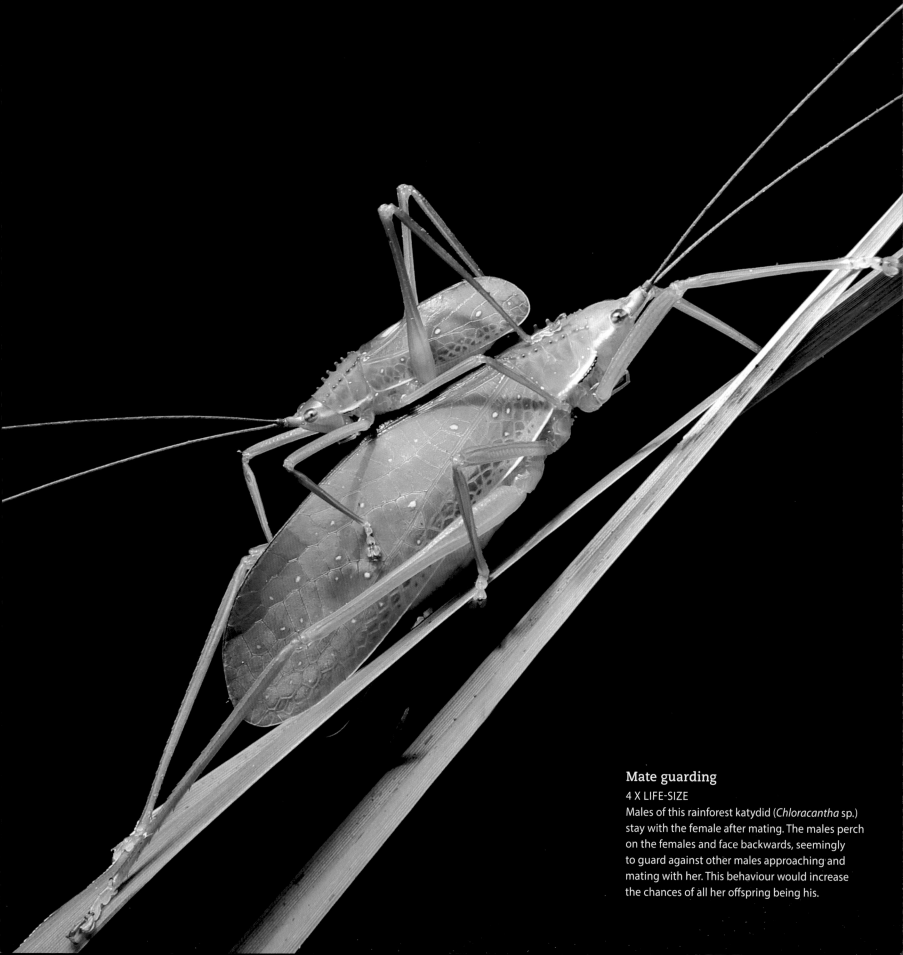

Mate guarding
4 X LIFE-SIZE
Males of this rainforest katydid (*Chloracantha* sp.) stay with the female after mating. The males perch on the females and face backwards, seemingly to guard against other males approaching and mating with her. This behaviour would increase the chances of all her offspring being his.

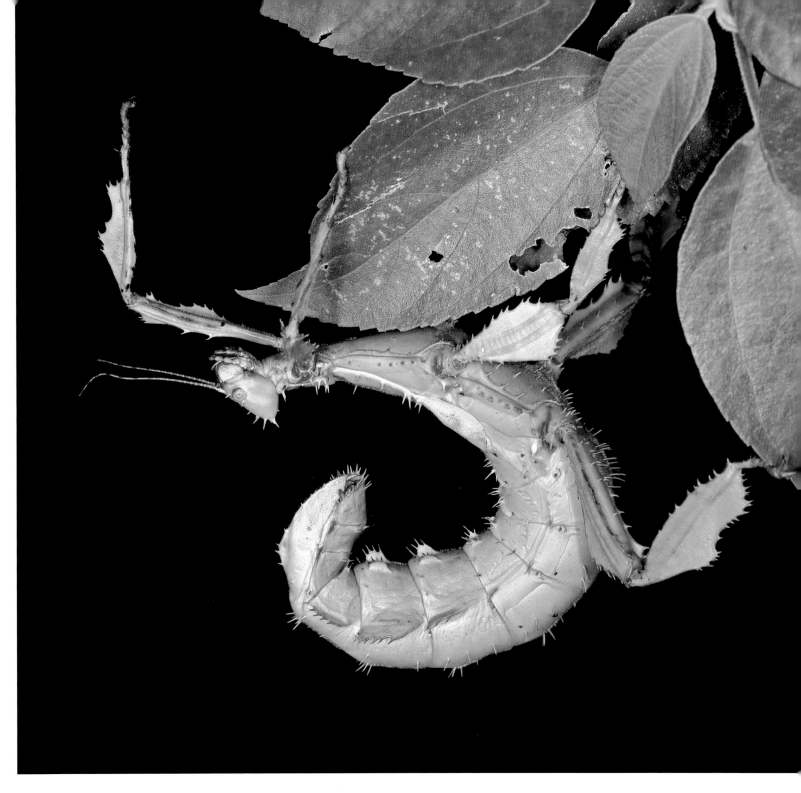

Males need not apply

1.3 X LIFE-SIZE

This adult female Spiny Leaf Insect *(Extatosoma tiaratum)* is literally an egg factory, laying several fertile eggs each day, yet she has never been mated or had any contact with a male. These insects are parthenogenetic — they can produce fertile offspring without being mated. In this case the offspring will all be female. While there are many complex ways in which parthenogenesis works, essentially females are still able to reproduce in the absence of males, a process widespread in the minibeast world.

11

THE NURSERY

Minibeasts begin life in extremely diverse and fascinating ways. Some lay eggs, some give birth to live young, but it is often what happens after the 'delivery' process that is truly amazing.

Many of the large animals we are most familiar with give birth to live young, particularly the mammals, and thanks largely to birds most people are very familiar with the egg-laying process. While most minibeasts do, more or less, reproduce in these two basic ways, many have evolved their own unique methods of reproduction which may be a source of fascination, amazement and in some cases, grotesque repulsion.

Various sucking bugs (Hemiptera) lay neat clusters of hard-shelled eggs on leaves and other surfaces. With some species the mother stays and guards them, while others simply wander off and leave the survival of the eggs to chance. The resultant hatchlings are generally self-reliant and miniatures of the parents in both form and behaviour.

Most phasmids (stick and leaf insects) toss their hard-shelled eggs from the tree tops. The well-camouflaged eggs land on the ground and, with luck, will not be found by anything that will eat them. While most species incubate for at least three months, many have a diapause, which acts to halt development in the case of unfavorable temperatures and other aspects of the weather. This prevents the babies (nymphs) all hatching and dying in adverse conditions. Another quirk of phasmid eggs is their relationship with ants. Some ants routinely collect phasmid eggs, which mimic the plant seeds they normally collect. The eggs are then stored safely underground, which protects them from surface-dwelling predators such as small mammals.

Not all eggs are protected by hard outer coverings. Delicate eggs certainly require some form of protection from dehydration and predators. Soft-bodied invertebrates such as snails and slugs lay their eggs in moist areas in the soil and beneath rocks and logs to protect them against desiccation. Crickets and katydids use specialized structures called ovipositors to drive their rice grain-like eggs into the soil or beneath bark. Spiders encapsulate their eggs in silken egg sacs of all shapes, sizes and colours. Some guard them fiercely, while other species leave them to hatch on their own. Baby spiders, known as spiderlings, may remain with their mother for a period of time after hatching or may simply take to the air using silk strands to fly in a process called ballooning.

Various species of solitary wasps paralyze another minibeast to use as a 'preserved' food supply for their offspring. These wasp species usually specialize in using one kind of minibeast as a 'host', often a spider or a caterpillar. The female wasp lays an egg on the paralyzed host animal and stores it in a burrow or within a purpose-built mud chamber. After hatching, the maggot-like wasp larva has an all-you-can-eat buffet until it is ready to pupate. Even more morbid, some wasps lay eggs on a living and mobile invertebrate host. The larva feeds on the unlucky creature from an unreachable position on its body, gradually draining its reserves. When the host finally dies, the larva consumes the body before pupating into an adult wasp.

Scorpions give birth to live young and exhibit a surprising level of parental protection for the first few weeks of the babies' lives. The mother scorpion carries her young around on her back for this brief period until they are ready to take on life as independent predators. If she encounters them again after they leave, chances are she will eat them.

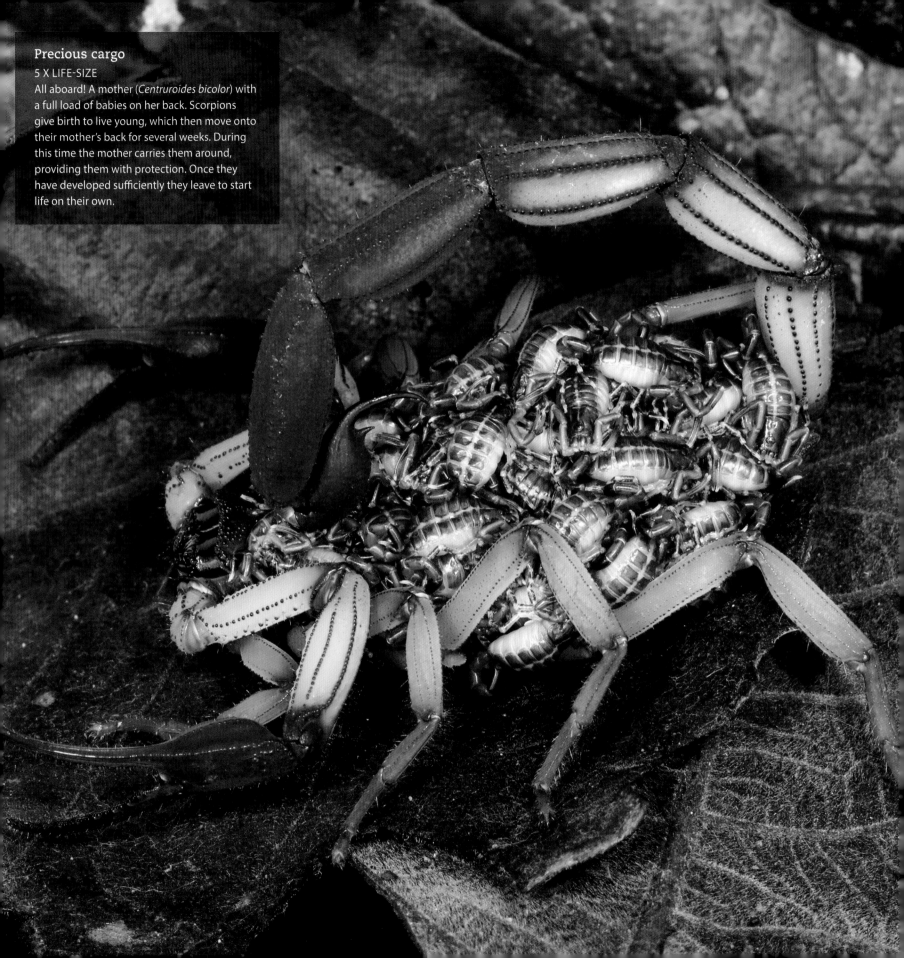

Precious cargo
5 X LIFE-SIZE
All aboard! A mother (*Centruroides bicolor*) with a full load of babies on her back. Scorpions give birth to live young, which then move onto their mother's back for several weeks. During this time the mother carries them around, providing them with protection. Once they have developed sufficiently they leave to start life on their own.

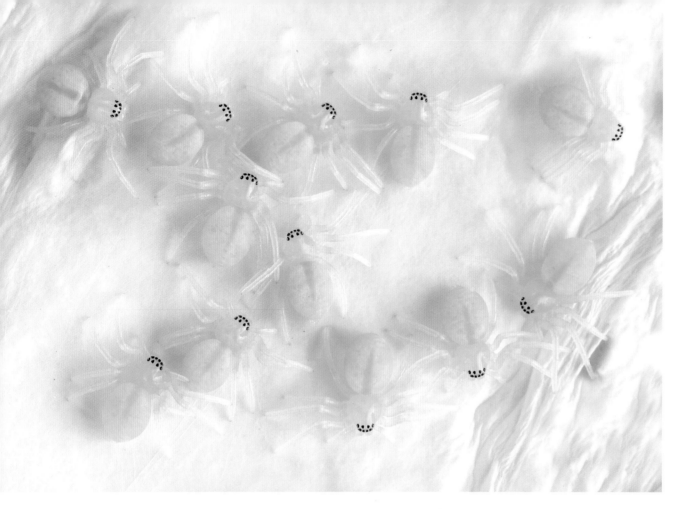

← **Badge spiderlings**
10 X LIFE-SIZE
Hatchling Badge Huntsman Spiders (*Neosparassus* sp.) upon their white silk egg sac, each one only a few millimetres in length. Young spiders are often quite different in appearance to the adults. By the time these spiders mature they will be brown and relatively hairy.

← **A balancing act**
10 X LIFE-SIZE
This female Daddy Long-legs Spider (*Micromerys gurran*) has her eggs tethered in a row with silken lines and held by her fangs. She will remain holding them like this for several weeks until they hatch.

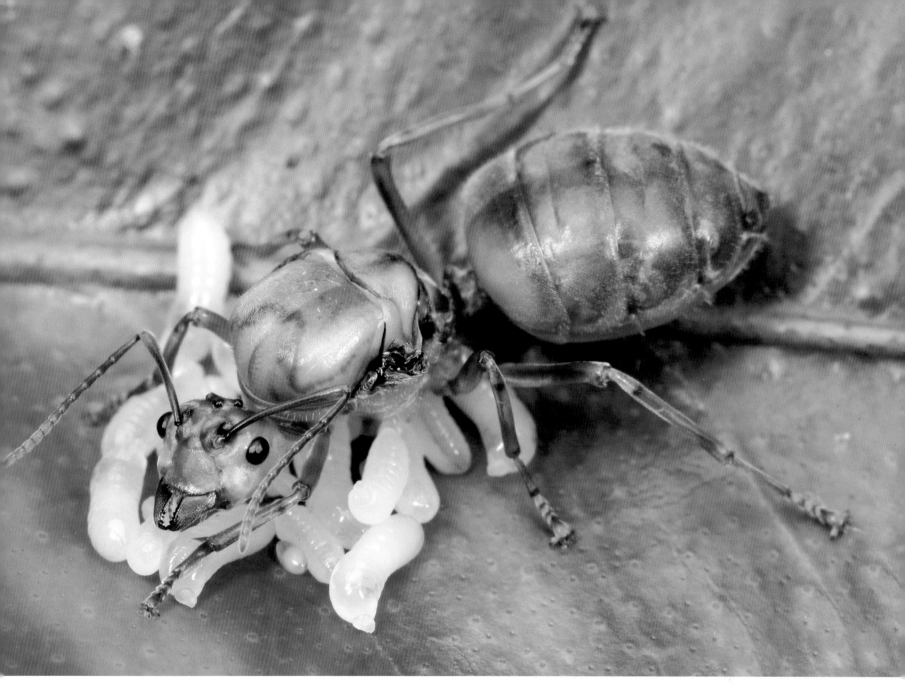

↑
A new queen
10 X LIFE-SIZE
Even massive ant colonies have humble beginnings. The new queen Weaver Ant (*Oecophylla smaragdina*) is guarding her first precious brood of larvae. She will feed them herself with oral secretions until they pupate into adult worker ants. After that, they will take over and begin tending to her and building nests.

THE NURSERY

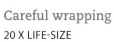

Careful wrapping
20 X LIFE-SIZE
Most spiders protect their eggs in silken cases called egg sacs. Egg sacs vary immensely in shape, size and colour within the 40,000 species of spiders throughout the world. This female Graceful Thief Spider (*Argyrodes gracilis*) is guarding hers while suspended by silk threads.

Mantis hatchlings
PHOTO 1: 2 X LIFE-SIZE;
PHOTO 2:10 X LIFE-SIZE
Baby praying mantids hatching. Mantids typically hatch en masse from a specialized egg case called an ootheca. The young emerge as worm-like larvae on silken strands, then moult their exoskeletons almost immediately, becoming functional miniature mantids. Soon after, they begin to disperse to begin life as individual hunters.

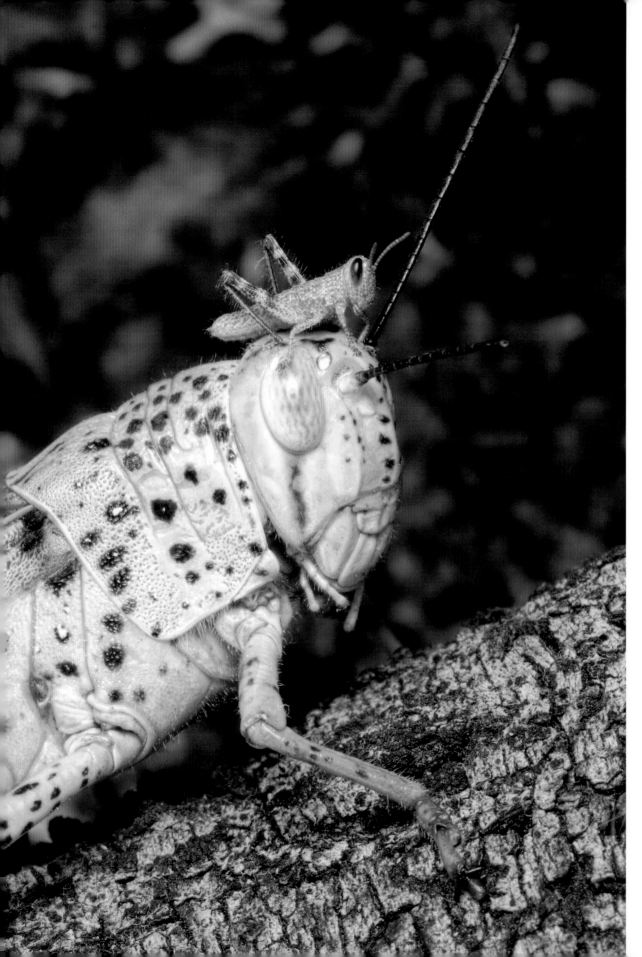

←

Grasshoppers
4 X LIFE-SIZE
Hatchling grasshoppers (*Valanga irregularis*) look like miniatures of their parents, but lack wings. There is no parental care in this group, and while hatchlings may mix with adults of their own species, their parents will usually have moved on or lived out their lives.

→

Popping out for a swim
20 X LIFE-SIZE
A tiny baby Giant Water Bug (*Lethocerus insulanus*) breaks out of its egg. The mother lays the eggs on objects overhanging the water, so the hatchlings simply drop in once they are free of the egg case. Females lay around 80 eggs in a batch, but very few hatchlings will survive to maturity.

Doting parents
2.5 X LIFE-SIZE
Baby Giant Burrowing Cockroaches (*Macropanesthia rhinoceros*) are born live and stay with their parents for around a year. The parents tear up pieces of dead eucalyptus leaves as food for their young.

THE NURSERY

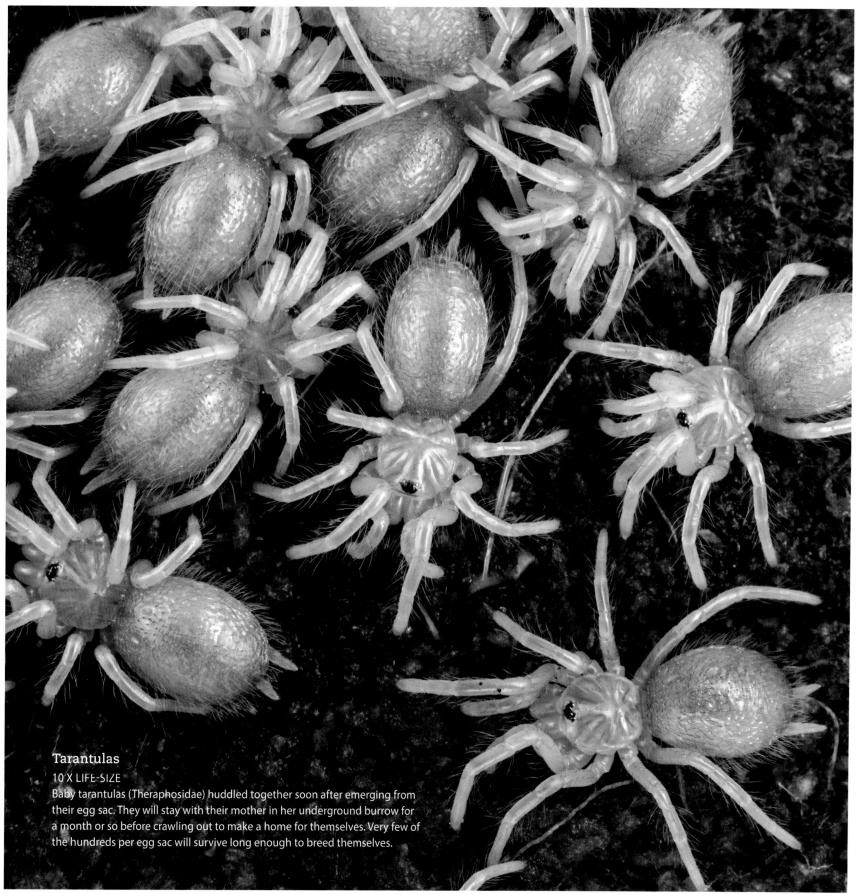

Tarantulas
10 X LIFE-SIZE
Baby tarantulas (Theraphosidae) huddled together soon after emerging from their egg sac. They will stay with their mother in her underground burrow for a month or so before crawling out to make a home for themselves. Very few of the hundreds per egg sac will survive long enough to breed themselves.

12

THE UNDERWORLD

In moist, dark tunnels and burrows, hidden from the light and right below our feet exists a secretive world of invertebrates. Some are minibeasts that live their whole lives underground or below rocks and logs. Others are waiting for the cover of darkness before emerging to the surface to forage. Many of these species perform the important roles of decomposition, recycling nutrients back into the soil and enabling plants and entire forests to continue growing. Others are hunters with attributes and behaviours that would put many of the creatures in Hollywood horror movies to shame.

Living underground certainly has its benefits. The temperature is more stable and the extremes of both cold and heat can be avoided, but it does have an array of other challenges. As such, these creatures are often vastly different in appearance than the above-ground species we are more familiar with. Fine, delicate features are often impractical for an underground life, where they could easily be damaged. Instead, many subterranean minibeasts have powerful, chunky bodies suited to digging, while others are streamlined for a life of sliding through tunnels.

Not all of these underworld characters remain in their earthy habitats their entire lives. A great many beetle species begin life as larvae feeding below ground on roots or within rotting logs and compost. After sufficient growth time they pupate, finally emerging as adult beetles. The adult stage is usually the briefest period of their lives, but the part we are most familiar with. Cicada nymphs also live secretive lives underground. While some species spend a year below the surface, others can spend a staggering seventeen years underground before finally coming to the surface to mature and breed.

Social insects such as ants excavate huge areas underground to form stable environments to store food, raise their young and to provide security for their colonies. While insects such as these are relatively familiar to us due to their foraging activities above ground, their homes also provide habitat for some lesser known minibeasts. Various beetles, wasps, mites and even caterpillars live within ant nests, sometimes as infiltrators, feeding on the ants' food reserves and sometimes the ants themselves.

One of the major challenges faced by many subterranean species is flooding. Many have evolved ways in which to survive being inundated by water. Ants and termites have numerous chambers which form air pockets when the ground becomes flooded. Burrowing spiders in flood-prone areas have hairy bodies that trap air and form a protective bubble, preventing them from drowning.

Despite their amazing adaptations and survival abilities proven over millions of years, this hidden world of minibeasts is not invincible. One of the biggest threats these small underground creatures face is human-driven habitat destruction. Land clearing and other changes to land use, including the effects of chemicals, may severely impact these important animals. Although they live below ground, changes to the environment above them can have drastic effects on their ability to survive.

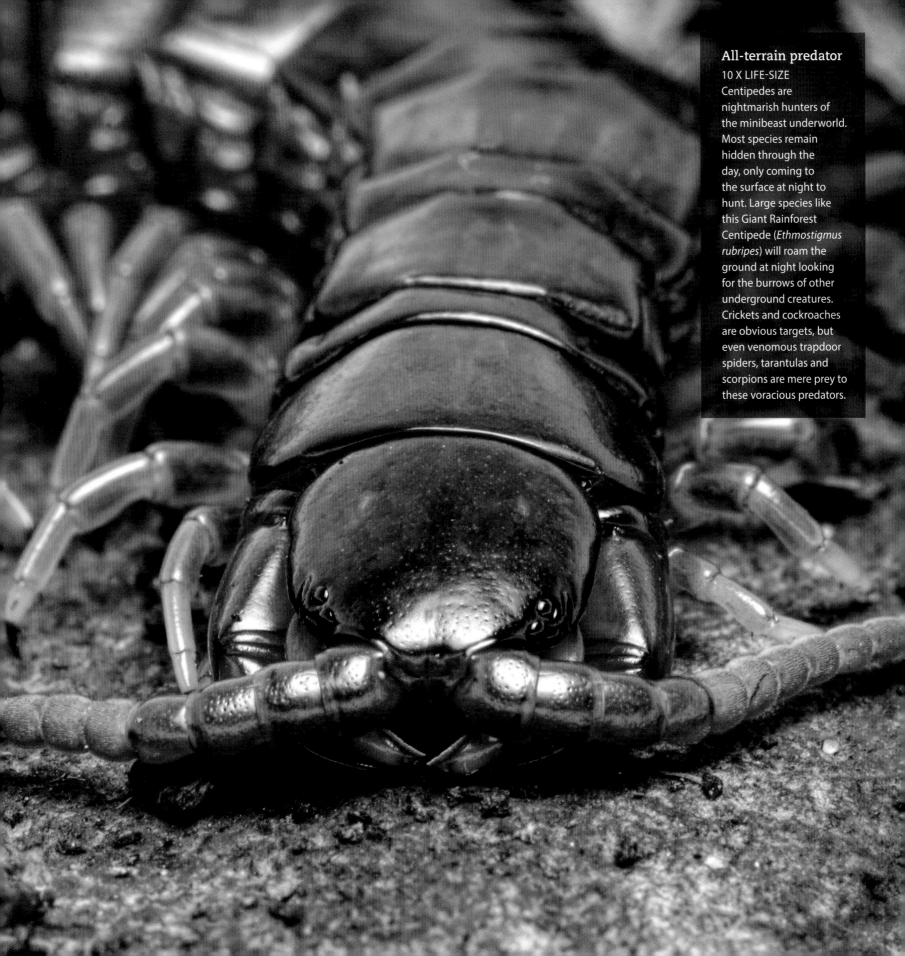

All-terrain predator
10 X LIFE-SIZE
Centipedes are nightmarish hunters of the minibeast underworld. Most species remain hidden through the day, only coming to the surface at night to hunt. Large species like this Giant Rainforest Centipede (*Ethmostigmus rubripes*) will roam the ground at night looking for the burrows of other underground creatures. Crickets and cockroaches are obvious targets, but even venomous trapdoor spiders, tarantulas and scorpions are mere prey to these voracious predators.

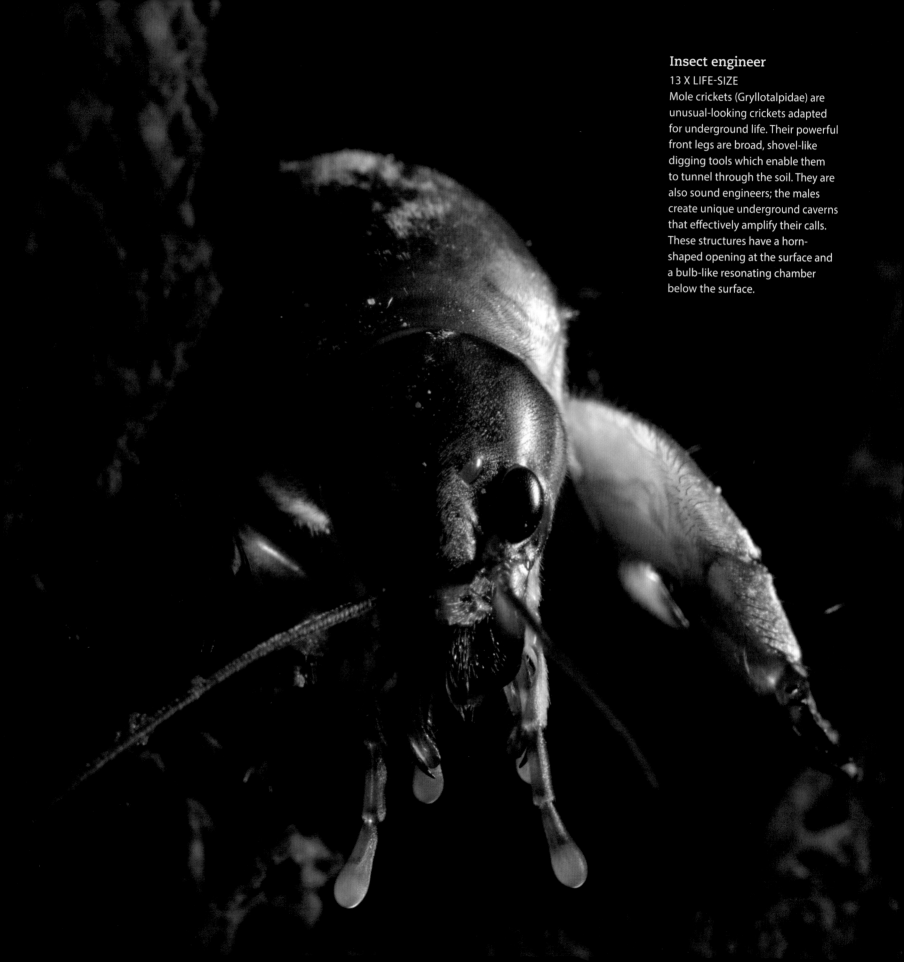

Insect engineer
13 X LIFE-SIZE
Mole crickets (Gryllotalpidae) are unusual-looking crickets adapted for underground life. Their powerful front legs are broad, shovel-like digging tools which enable them to tunnel through the soil. They are also sound engineers; the males create unique underground caverns that effectively amplify their calls. These structures have a horn-shaped opening at the surface and a bulb-like resonating chamber below the surface.

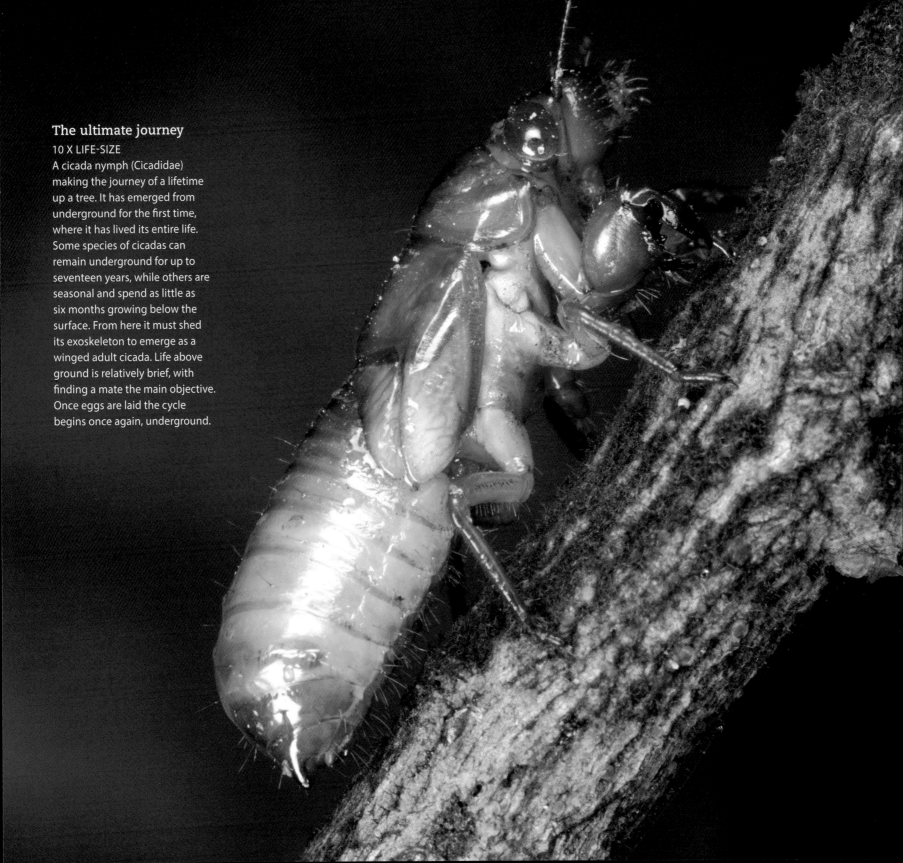

The ultimate journey
10 X LIFE-SIZE
A cicada nymph (Cicadidae) making the journey of a lifetime up a tree. It has emerged from underground for the first time, where it has lived its entire life. Some species of cicadas can remain underground for up to seventeen years, while others are seasonal and spend as little as six months growing below the surface. From here it must shed its exoskeleton to emerge as a winged adult cicada. Life above ground is relatively brief, with finding a mate the main objective. Once eggs are laid the cycle begins once again, underground.

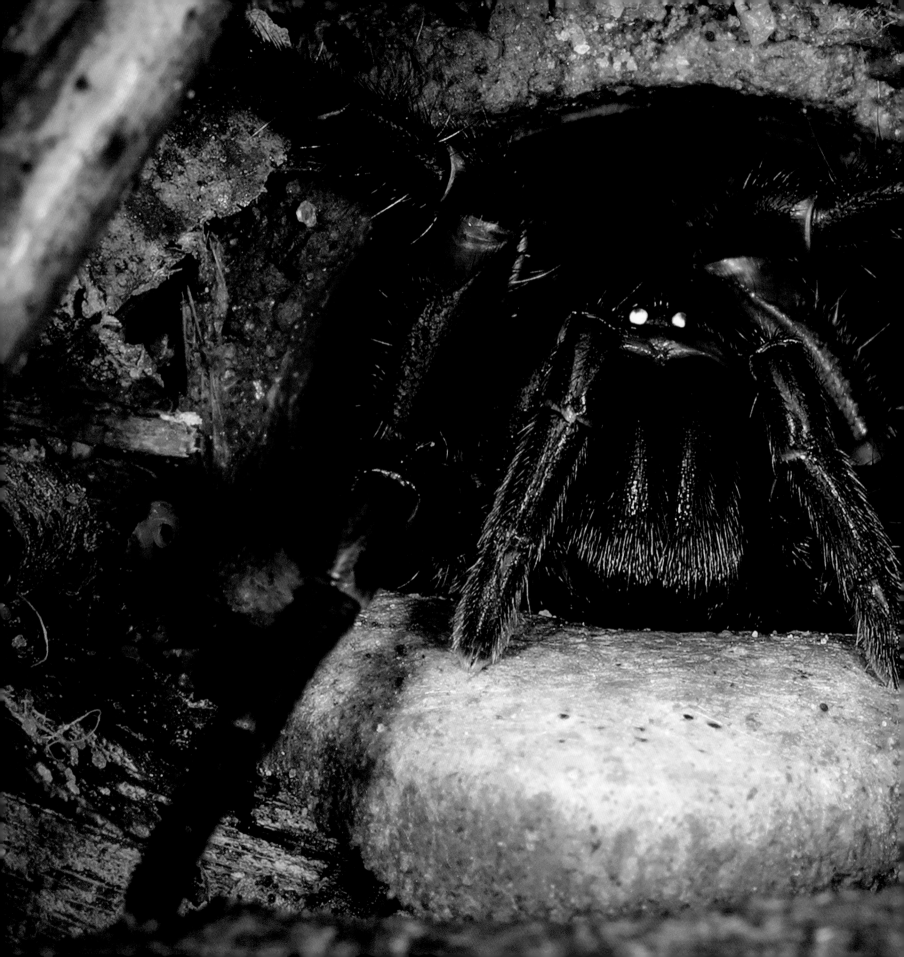

THE UNDERWORLD

Sudden ambush
10 X LIFE-SIZE
Imagine walking along and, without warning, being suddenly and violently dragged down a pitch-black tunnel to impending doom. Trapdoor spiders are ambush hunters that do exactly that to their prey. Some species like this one (Barychelidae) have hinged doors on their burrows, while others hunt from an open hole. They are very sensitive to vibration and can detect the footsteps of a cockroach approaching. The thunderous vibrations of human footsteps, however, is enough to send them fleeing to the bottom of their burrow.

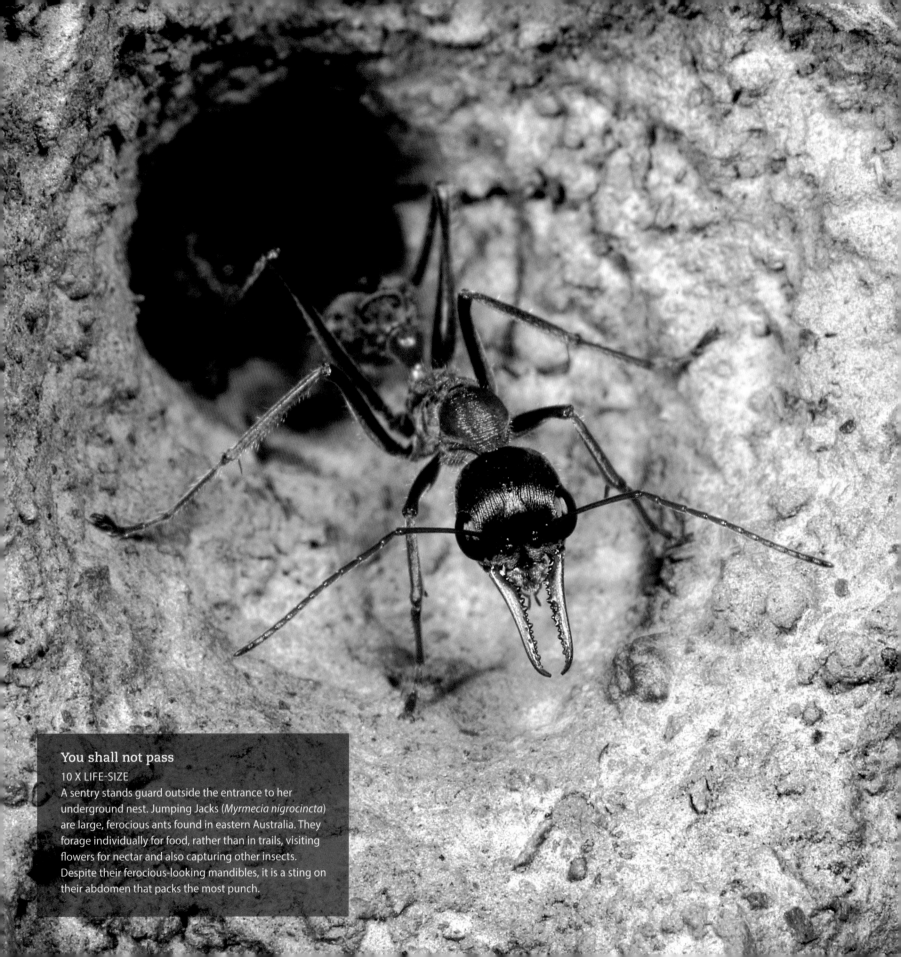

You shall not pass
10 X LIFE-SIZE

A sentry stands guard outside the entrance to her underground nest. Jumping Jacks (*Myrmecia nigrocincta*) are large, ferocious ants found in eastern Australia. They forage individually for food, rather than in trails, visiting flowers for nectar and also capturing other insects. Despite their ferocious-looking mandibles, it is a sting on their abdomen that packs the most punch.

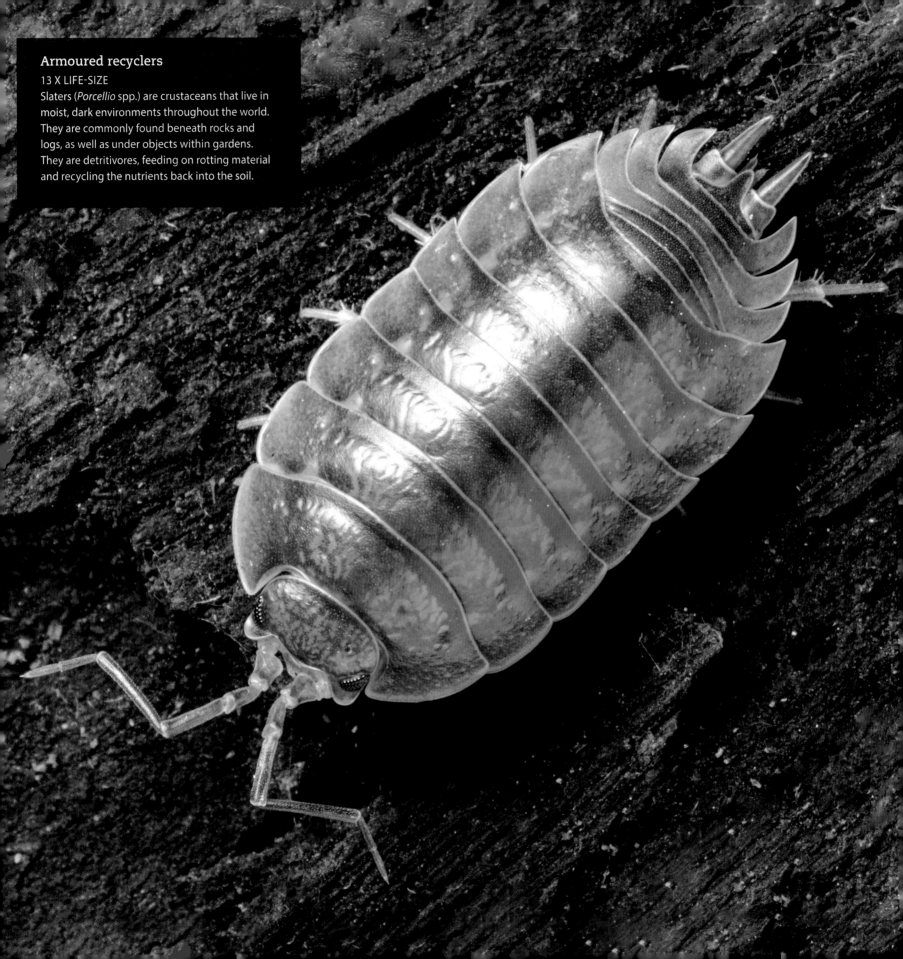

Armoured recyclers
13 X LIFE-SIZE
Slaters (*Porcellio* spp.) are crustaceans that live in moist, dark environments throughout the world. They are commonly found beneath rocks and logs, as well as under objects within gardens. They are detritivores, feeding on rotting material and recycling the nutrients back into the soil.

A shadowy hunter
3 X LIFE-SIZE
The silken underground lair of one of the world's most venomous minibeasts. The Sydney Funnel-web (*Atrax robustus*) lives beneath rocks and logs and in cracks in the earth, and hunts other small invertebrates that wander past its home. It detects its prey via silk trip lines that radiate from the burrow entrance. Despite their lethal potential, no one has died from one of these spiders since the antivenom became available in 1981.

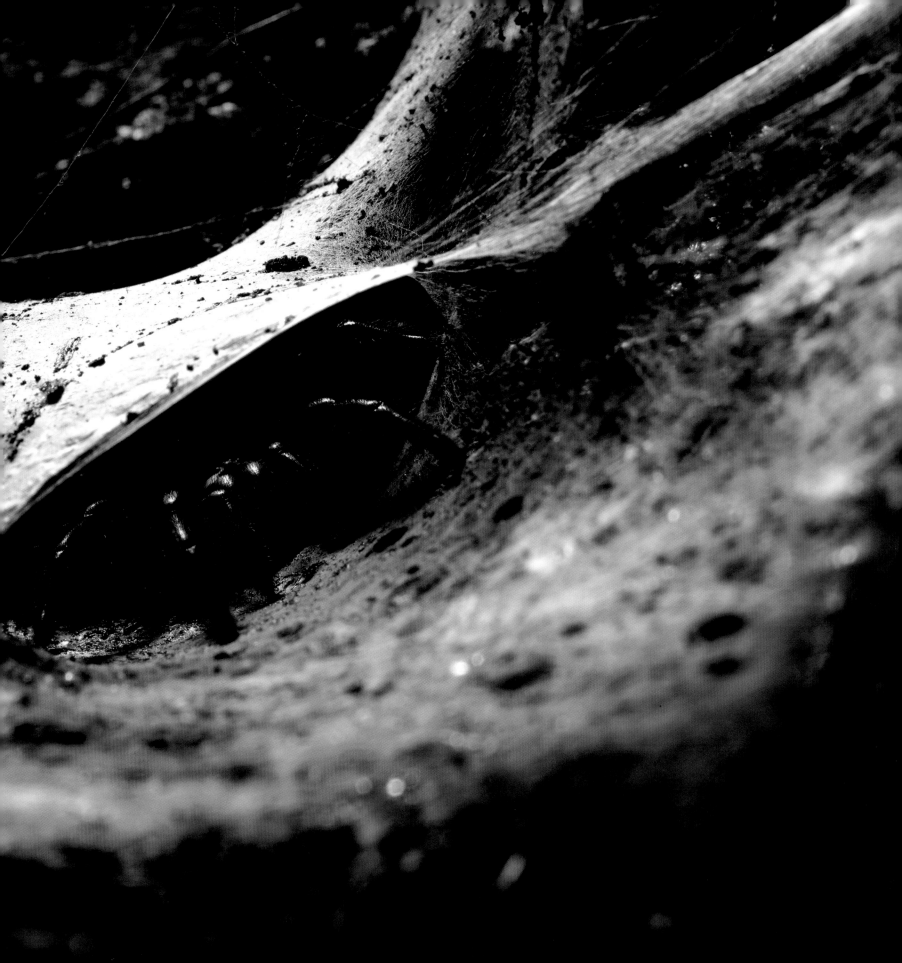

←
Critical influence
10 X LIFE-SIZE

Termites (Isoptera) are often looked upon as simple pests; however, the reality is very different. Throughout the world, massive volumes of these tiny animals are the foundations of diverse ecosystems. Studies are revealing that they are the true kings of the African savannahs, with more influence on the health of the ecosystems than large iconic animals such as lions and elephants.

→
Unique predators
10 X LIFE-SIZE

These velvet assassins cruise the dark, moist, concealed reaches of the minibeast world. Velvet Worms (Onychophora) represent a unique group of invertebrates, having a soft, flexible, somewhat velvety exoskeleton, and up to 43 pairs of legs. They capture prey by spraying it with twin streams of sticky glue, which is propelled through nozzles on the Velvet Worm's head.

13

TEAM MINIBEAST

As our world becomes ever more complex with rapid leaps in technological development and constant advances in our scientific understanding, it also becomes clear that we cannot solve all our problems by ourselves. The early peoples of the globe looked to nature for help and established close relationships with animals. However, many of these links have been lost over time. Today we are beginning to rekindle our connections and relationships with nature, but in far more complex ways than before. We are looking to nature to help solve our problems, cure our diseases and inspire our designs, and minibeasts are at the very heart of this new age of discovery.

The invertebrate world is a wealth of biological accomplishment in a wide range of areas: biomechanics, engineering, chemistry, navigation, communication and networking are just a few. These animals have overcome problems of mobility, can navigate with incredible precision, and have chemicals and compounds within them that could revolutionize our way of life.

While the field of robotics continues to make rapid advances, developers are now looking at minibeasts as models on which to base their new designs. Minibeasts are of particular interest due to their unique movement, stability and ability to access hard to reach areas. Many robotics development teams are focusing upon cockroaches, for example, modelling their capacity to move rapidly and effectively over difficult terrain types. One particular research group at the University of California, Berkeley, is developing search-and-rescue robots based on American Cockroaches (*Periplaneta americana*). These cockroaches, like many others, have the ability to squeeze through very small spaces and still maintain mobility. Robots like these could be critical in finding survivors trapped in disaster debris.

Robotic flight developers are creating miniature drones modelled upon dragonflies and finding many advantages over fixed-wing helicopter and quadcopter designs.

Bioprospecting is becoming big business. This is essentially searching for species from which medicinal drugs and other commercially useful compounds can be obtained. Venomous invertebrate species are high on the hit list and there are already plenty of components showing massive potential. Research conducted at the University at Buffalo on spider venom is showing promising results in the treatment of muscular dystrophy. Elsewhere, research is examining spider venoms to treat chronic pain and even erectile dysfunction. A peptide in centipede venom may have the potential to be a more effective pain killer than morphine. Scorpions too are being studied. One breakthrough has found that the venom molecules bind to brain tumour cells and, with the help of a fluorescent dye, can assist surgeons to differentiate tumours from healthy brain tissue.

Have you ever held a slug and then struggled to get the slime off your hand? Specialized surgical adhesives are being developed based on slug mucus. Such is the properties of the mucus, these adhesives would enable the closing of incisions and wounds in difficult-to-treat organs like the heart and liver, even while moving or covered in blood.

Spider silk has been the focus of study for a long time due to its incredible strength, elasticity and lightweight properties. While researchers haven't yet been able to replicate it, they are getting closer and the materials developed may have applications in the aeronautical, surgical and medical fields, and as protective wear such as helmets and bullet-proof vests.

The world of minibeasts no doubt has enormous potential and keeping them thriving on this planet alongside us is definitely in our best interests.

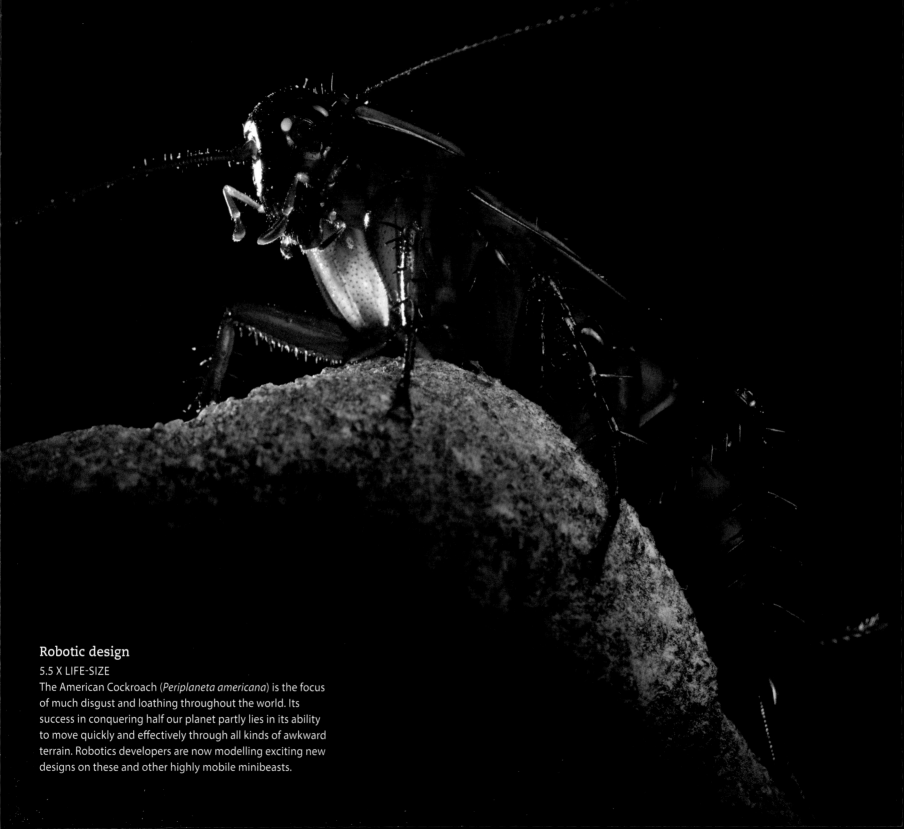

Robotic design

5.5 X LIFE-SIZE

The American Cockroach (*Periplaneta americana*) is the focus of much disgust and loathing throughout the world. Its success in conquering half our planet partly lies in its ability to move quickly and effectively through all kinds of awkward terrain. Robotics developers are now modelling exciting new designs on these and other highly mobile minibeasts.

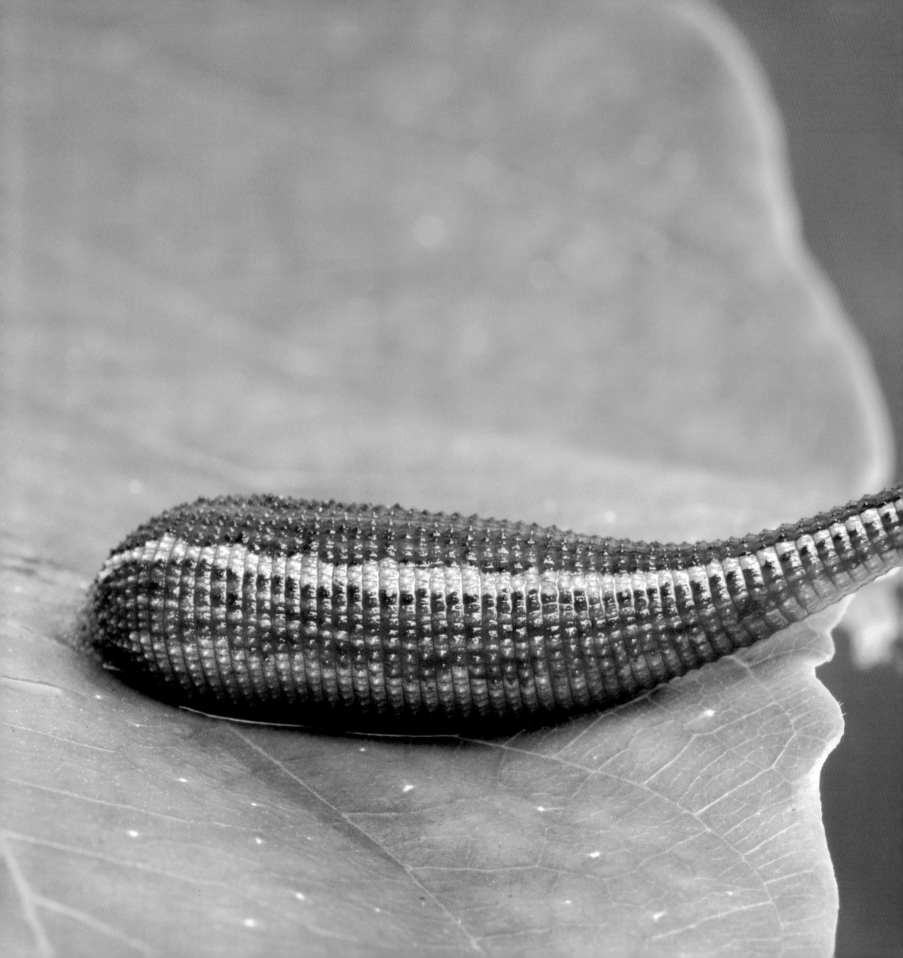

TEAM MINIBEAST

Medical marvels
10 X LIFE-SIZE
In the past, leeches (Hirudinidae) were used in conjunction with the primitive and naive medical technique known as blood-letting. Today, leeches are used with more effective medical procedures. They are utilized in plastic and reconstructive surgery to stimulate blow flow in small vessels. The anticoagulant chemical — hirudin — produced by leeches is used to treat inflammation and is being examined as a systemic anticoagulation. Many other substances produced by leeches are being examined for medicinal benefits, too.

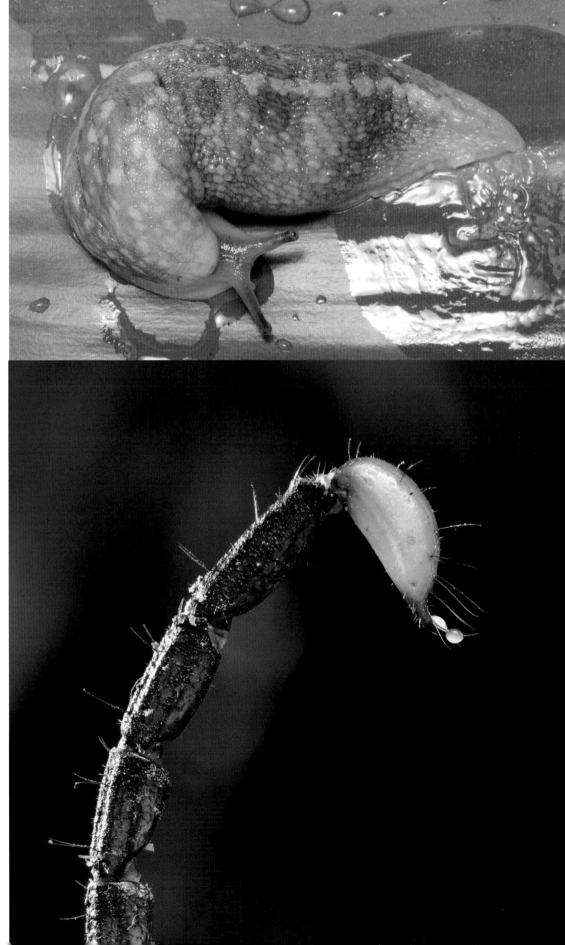

←
Sticky benefits
3 X LIFE-SIZE

The sticky properties of slug slime are now being taken from the garden to the operating theatre. Researchers are trialling the use of slug-inspired surgical adhesives that can repair incisions and wounds to very delicate tissue where suturing is very difficult and other methods of binding do not stick.

←
Medical venom
10 X LIFE-SIZE

Drops of scorpion venom bead around the sting of a scorpion. While the venoms of some scorpions can be lethal, the chemical components may have some redeeming properties. Studies have found venom molecules bind to brain tumour cells, assisting surgeons to identify them. Research into scorpion venoms continues, and with over 1700 species around the world, there are real possibilities for more medical applications.

→
Liquid gold
20 X LIFE-SIZE

A drop of one of the world's most deadly spider venoms glistens on the fang of this Sydney Funnel-web (*Atrax robustus*). Venoms are a cocktail of chemicals and the various components have vastly different effects. A significant amount of research is being conducted into the venom of this and many other venomous spiders, with the potential to treat muscular dystrophy and chronic pain among the outcomes so far.

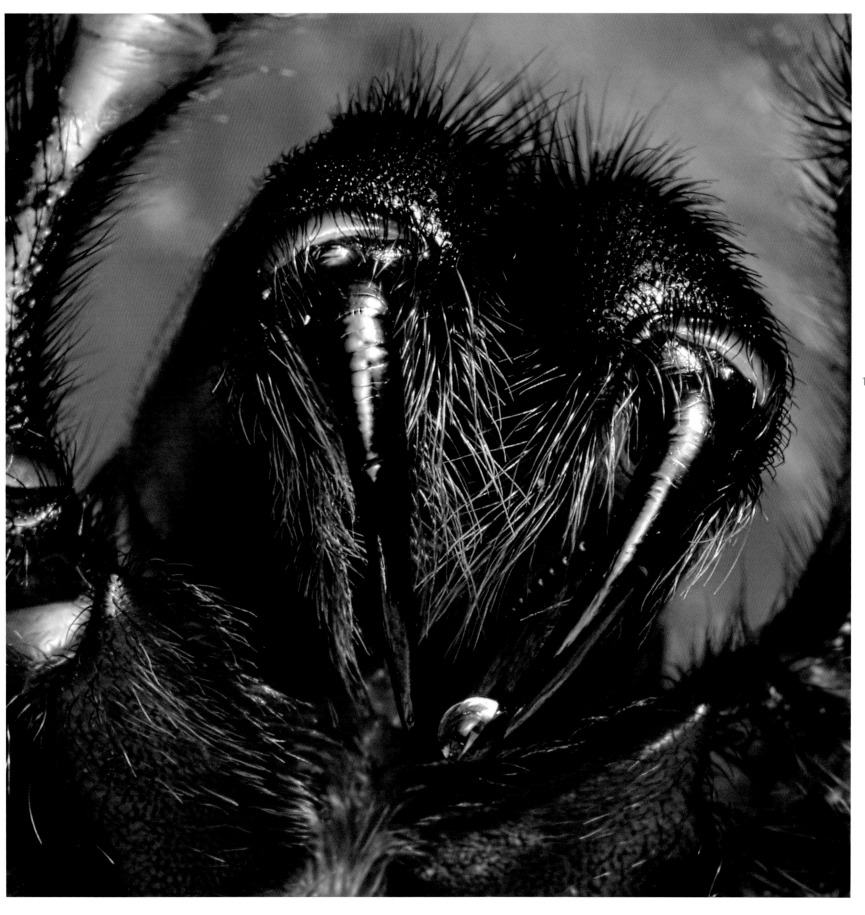

INDEX

Incredible silk
4 X LIFE-SIZE

Spider silk has incredible properties. It is exceedingly strong — weight for weight it is stronger than steel — yet very elastic. While different spiders produce different types of silk, each species of spider can produce multiple types depending on its immediate requirements. The Redback Spider (*Latrodectus hasselti*) produces very strong cable-like silk, as well as a glue-like liquid silk that it uses to bind its prey. Research continues into this diverse substance, with many future applications possible.

A
Acauloplacella sp. 90–91
Amblypgid 68–69
Amegilla sp. 62
American Cockroach 152, 153
Amyciaea albomaculata 110
Anisoptera 18–19, 60–61
Anoplognathus sp. 56–57, 120, 121
antennae 13
Apis mellifera 9, 55
aquatic living 92–101
Arachnoscelis feroxnotha 32
Aradidae 86, 87
Argyrodes gracilis 134, 135
Argyroneta aquatica 92
Arkys lancearius 46
Army Ant 17
Asilidae 57
Aspidimorpha westwoodi 44, 125
Assassin Bugs 18
Assassin Flies 57
Atrax robustus 10, 11, 14, 148–149, 156, 157
Atta cephalotes 18
Austrocarausius mercurius 88

B
Badge Huntsman Spider 132
Banded Huntsman 21
Bark Scorpion 10, 11
Barychelidae 144–145
Batesian mimicry 102
beetles, ability to transform 36
Belostoma sp. 94, 95
bioprospecting 152
Bird-dropping Spider 104
Biroella sp. 74
Bittacidae 116
Blaberus sp. 70–71
Black Rattle Ant 106–107
Blue-banded Bee 62

C
Cairns Birdwing Butterfly 63
Calcarifera ordinata 49
Caligo spp. 114
Callirhipis sp. 13
camouflage 24, 80–91
Canama hinnulea 117
Caribidae 23
Carmenta sp. 111
Celaenia excavata 104
centipedes 141
Centruroides bicolor 73, 130, 131
Cerambycidae 37, 74–75
Chloracantha sp. 128
Christmas Beetle 56–57, 120, 121
cicada nymph (Cicadidae) 143
Cicadellidae 26, 27
Cicindela sp. 14, 15
Clearwing Moth 111
climate change 10
colour, uses of 24, 31
Copiphorini 72
Cosmophasis bitaeniata 103
Cotton Harlequin Bug 25
Crane Fly 58
Creatonotos gangis 120

D
Daddy Long-legs Spider 132
Damselflies
 gills in tail 97
 wings 56
Deinopidae 22
Dermaptera 53
Dinothrombium sp. 35
Diptera 58–59
Diving Beetle 95
Diving Bell Spider 92
Dolomedes sp. 96
dragonflies
 eyes 18–19
 flying speed 54
 moulting 40
 wings 60–61
dung beetles 36
Dysphania numana 27, 28
Dytiscidae 95

E
Earwig 53
ecdysis process 38
Eciton burchellii 17
Edessa rutomarginata 32
eggs, laying and care 130–139
elytra (outer wings) 36
Eriophora fuliginea 27
Ethmostigmus rubripes 11, 141
Extatosoma tiaratum 87, 102, 112–113, 129
eyes
 dragonflies 18–19
 false 114
 praying mantis 64
 snails 20
 Wolf Spider 78, 79

F
faces 64–79
fangs, Sydney Funnel-web 14
feet, able to walk on ceilings 12
Flame-bellied Orb-weaving Spider 27
Flat bug 86, 87
flies, wings 58–59
flying speeds 54
Four O'Clock Moth 27
Four O'Clock Moth caterpillar 28

G
Gasteracantha fornicata 46, 48
Gastropoda 20
Gerridae 98–99

Giant Burrowing Cockroach, live young 138
Giant Cockroach 70–71
Giant Rainforest Centipede 11, 141
Giant Rainforest Mantis 65
Giant Swallowtail caterpillar 83
Giant Velvet Mite 35
Giant Water Bug
 hatchlings 136, 137
 underwater living 92
 underwater predators 100
gills 97
Golden Orb-weaving Spider 123
Gonipterini 126
Graceful Thief Spider 134, 135
grasshopper hatchlings 136
Green Jumping Spider 77
Grey Tiger Beetle 14, 15
Gryllacrididae 40, 118, 119
Gryllotalpidae 142
Gyrinidae 12, 93

H
Hangingflies 116
Harvestman 52, 53
Helea sp. 40, 41
Hexacentrus mundurra 63
Hierodula majuscula 65, 122
Hirudinidae 154–155
Holconia murrayensis 21
honeybees 9, 55
horns 17
horseflies 54
hoverflies 104
Hybomitra hinei 54

I
invertebrates, decline in number 10
Isoptera 150, 151

J
jaws, power of 17
Jumping Jacks 146
Jumping Spider 103
jumping spiders 66, 67, 77, 109, 116, 117

K
katydids
 ant-mimicking 108–109
 Balloon-winged Katydid 63
 Candy Cane Katydid 32
 Conehead Katydid 72
 elongated head and body 67
 Gum-leaf Katydid 78
 Leaf-mimic Katydid 85
 Leaf-winged Katydid 84, 85
 mating 128
 Rainforest Tree Katydid 44
 Umbrella Katydid 90–91
Kurandoptera purpura 108–109

L
lacewing, larva 42, 50, 51
Latrodectus hasselti 124, 158
leaf insects 88–89
Leaf-cutter Ant 18
leafhopper 26, 27
leeches 154–155
Leptomyrmex sp. 112–113
Lethocerus insulanus 136, 137
Lethocerus spp. 92, 100
Lichen Huntsman 80, 81
Living Twig 88
Longicorn Beetle 37, 74–75
Lycoidae 78, 79

M
Macropanesthia rhinoceros 138
mandibles 23
Mantisipid 114, 115
Maratus spp. 24, 35
Mastigaphoides sp. 84, 85
mating rituals 116–129
Mecoptera 116
Megacrania batesii 11
metamorphosis 10, 36, 38–41
Micrathena sexspinosa 46, 47
Micromerys gurran 132
millipedes 2, 3, 29, 43
Mimetica sp. 85
mimicry 102–115
minibeasts, what they are 9
mole crickets 142
Monkey Grasshopper 74
Mopsus mormon 77
Moss Mantis 82, 83
moulting 9–10, 40
Myrmarachne sp. 109
Myrmecia nigrocincta 146

N
Neosparassus sp. 132
Nephila pilipes 123
nest building 12
net-casting spiders 22
Neuroptera 114, 115
Northern Emperor Moth
 caterpillar 74
 no mouth 68
Nursery Web Spider 91

O
Odontomachus spp. 16, 17
Oecophylla smaragdina 133, Frontispiece
Oecophylla spp. 12
Onychophora 151
Opiliones 52, 53
Orange Baboon Tarantula 30, 31
Orange Tortoise Beetle 44, 125
Ornithoptera euphorion 63
Osmylops sp. 42, 50, 51
Owl Butterflies 114

P
Pandercetes gracilis 80, 81
Papilio cresphontes 83
Papilio ulysses 32, 33
Paratropes sp. 31
Peacock Jumping Spider 34, 35
Peacock Spider 24
Peppermint Stick Insect 11
Periplaneta americana 152, 153
Phalacrognathus muelleri 4, 5
pheromones 102–105, 116
Phricta spinosa 44
Phylium spp. 88–89
Phyllium monteithi 10, 11
Pie-dish Beetle 40, 41
pincers 53
Pisauridae 91
Polydesmida 29
Polyrhachis australis 106–107
Polyura sempronius 50
Pond Skaters 98–99
Porcellio spp. 147
Portia fimbriata 66, 67
praying mantises 8, 9
 eyes 64
 hatchlings 135
 mating 122
Pseudocanthops sp. 82, 83
Pseudorhynchus lessonii 67
Pterinochilus murinus 30, 31
pupation 38, 39

R
Rainbow Stag Beetle 4, 5
Raspy Crickets 40, 118, 119
Redback Spider 124, 158
Red-legged Stink Bug 32
Reduviidae 18
Rhinoceros Beetle 16, 17
Rhinocricidae 2, 3, 43
robotic design 152

S
scents 32, 102–105, 116
Scorpionflies 116
scorpions
 faces 73
 live young 130, 131
 mating 126, 127
 venom 156
sensory hairs 21
sex/sexual cannabalism 116–129
Six-spined Spider 46, 47
slaters 147
sleep 62
slug mucus 152, 156
snails, eyes 20
Solifugid (Solifugae) 76, 77
spider silk 152, 158
Spiny Leaf Insect 87, 102, 112–113, 129
Spiny Orb-weaver Spider 46, 48

Stag Jumping Spider 117
stick insects 88
stinging defence 49
stridulation 63
Sydney Funnel-web 10, 11, 14, 148–149, 156, 157
Syntherata escarlata 68, 74
Syrphidae 104

T
Tailed Emporer caterpillar 50
tarantulas 139
Tectocoris diophthalmus 25
termites 150, 151
Terpandrus woodgeri 78
Theraphosidae 139
Tiger Huntsman 6–7
Tipulidae 58
trapdoor spiders 144–145
Trap-jaw Ant 16, 17
Triangular Spider 46

U
Ulysses Butterfly 32, 33
underground living 140–151
underwater living 92–101

V
Valanga irregularis 136
Van der Waals force 12
Velvet Worms 151
venom, medical uses 156

W
Water Bug 94, 95
water spiders 96, 100
Water Striders 98–99
Wattle Cup Moth caterpillar 49
Weaver Ant 12, 133, Frontispiece
Weaver Ant Mimicking Spider 110
weevils, mating 126
Whip Spider 68–69
Whirligig Beetle 12, 93
wings 36, 54–63
 butterflies 44, 45, 63
 flies 58–59
Wolf Spider 78, 79

X
Xylotrupes ulysses 17

Z
Zygoptera 56, 97

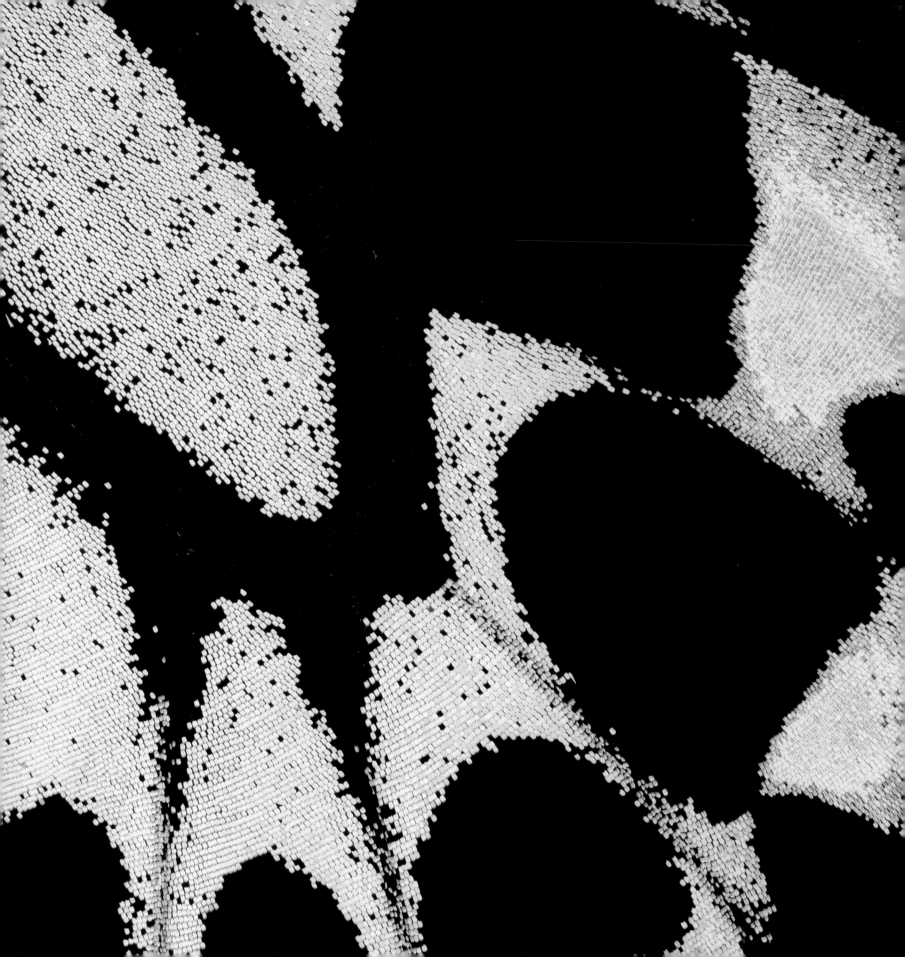